PRINTS AND DRAWINGS

Cathy Leahy
Alisa Bunbury
Maria Zagala
Nicholas Williams
Irena Zdanowicz
Kirsty Grant

PRINTS AND DRAWINGS

IN THE INTERNATIONAL COLLECTIONS OF THE NATIONAL GALLERY OF VICTORIA

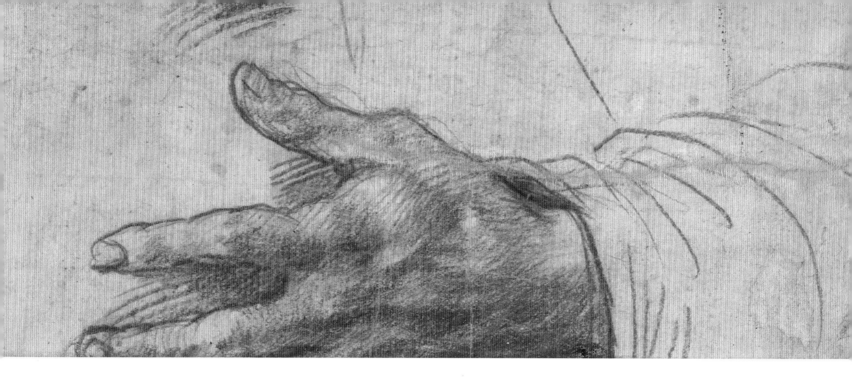

© National Gallery of Victoria 2003

Published by the National Gallery of Victoria
PO Box 7259
Melbourne Vic. 8004
Australia

Printed in Australia

National Library of Australia Cataloguing-in-Publication data:

Prints and drawings in the international collections of the National Gallery of Victoria

ISBN 0 7241 0229 9.

1. Drawing. 2. Prints. 3. National Gallery of Victoria
I. Leahy, Cathy. II. National Gallery of Victoria

769

Note to the reader
The works in this handbook are arranged in a broadly chronological sequence. Foreign language titles for individual works are given in English first, followed by the original title. For series, portfolios and publications, the foreign language title precedes the translation.

Standard catalogue raisonné references for the works have been included, where these exist. For prints, state information has been given in Roman numerals following the catalogue raisonné number; brackets around the Roman numerals indicate that the source for the state information is other than the catalogue raisonné cited. Edition information has been provided, where known.

Dimensions of works are given in centimetres, height preceding width. For drawings, sheet dimensions only are cited, except in those instances where a drawing is laid down, and support sheet dimensions are also cited. For prints, image and/or plate dimensions precede sheet dimensions. Numbers in parentheses at the conclusion of captions are National Gallery of Victoria accession numbers.

Editing Beryl Hill
Design Kai Brethouwer
Publications Officer Judy Shelverton
Photography NGV Photographic Services
CTP and Printing Penfold Buscombe

This page: Andrea del Sarto (Italian, 1485–1530), *Study for St John the Baptist*, *c.* 1517. Verso: Study of hands. Red chalk, 38.5 x 18.8 cm (irreg.). Freedberg, pp. 67, 84; Shearman, pp. 364–5. Felton Bequest, 1936 (351-4) (detail).

Contributors:
Alisa Bunbury (AB) is Curator of Prints and Drawing, National Gallery of Victoria
Kirsty Grant (KG) is Curator of Prints and Drawings, National Gallery of Victoria
Cathy Leahy (CL) is Senior Curator of Prints and Drawings, National Gallery of Victoria
Nicholas Williams (NW) is Exhibition Officer at Artspace Mackay, Mackay
Maria Zagala (MZ) is Assistant Curator of Prints and Drawings, National Gallery of Victoria
Irena Zdanowicz (IZ) was Senior Curator of Prints and Drawings from 1981–2001, National Gallery of Victoria

Acknowledgements
The researching and writing of this handbook has involved all the curators in the Department of Prints and Drawings – Cathy Leahy, Alisa Bunbury, Maria Zagala and Kirsty Grant. Irena Zdanowicz, former Senior Curator of the department, also wrote on seven of the Dutch works, as well as kindly agreeing to read the completed manuscript at short notice. We are indebted to her for the many improvements she suggested, and for her advice on numerous issues. Nicholas Williams, a former curator in the department, also contributed ten entries to the publication. In preparing the publication we are also indebted to, and wish to acknowledge, the pioneering research on the collection of the former Senior Curators of the department: Dr Ursula Hoff, Sonia Dean and Irena Zdanowicz.

We would also like to thank the following individuals who generously answered queries and provided information that assisted in the preparation of several of the entries: Dr Holm Bevers, Kupferstichkabinett, Berlin; Fiona Brown, University of Melbourne; Kathan Brown, Crown Point Press, San Francisco; Dr Susan Dackerman, Baltimore Museum of Art; Dr Stefaan Hautekeete, Royal Museum of Fine Arts of Belgium; Dr Edgar Munhall, Curator Emeritus, The Frick Collection, New York; Tobias B. Nickel, University of Hamburg; Dr Joaneath Spicer, Walters Art Museum, Baltimore; Dr Bronwyn Stocks, Monash University, Melbourne; Dr Charles Zika, University of Melbourne; and Dana Rowan for editorial assistance.

Cathy Leahy, Senior Curator

Cover: Anthony van Dyck (Flemish, 1599–1641; worked in England), *Self-portrait c.* 1626–32. Etching, 24.6 x 15.7 cm (plate); 24.7 x 15.9 cm (sheet). Mauquoy-Hendrickx 4 i/vii. Everard Studley Miller Bequest, 1959 (142A-5) (detail).

Title page: Master of the E-series Tarocchi (Italian, active *c.* 1465), *Prime mover (Primo mobile)*, plate 49 from the *E-series Tarocchi, c.* 1465. Engraving, 18.2 x 10.1 cm (image and sheet). Hind I. 240.49a. Felton Bequest, 2002 (2002.415) (detail).

Facing page 6: Pablo Picasso (Spanish, 1881–1973; worked in France), *The pose of the model,* 1926. Pen and ink, 29.1 x 37.8 cm. Zervos VII.44. Felton Bequest, 1948 (1852-4). © Pablo Picasso, 1926/Succession Picasso. Licensed by VISCOPY, 2003 (detail).

CONTENTS

This handbook is one of a new series of publications that celebrates the opening of our refurbished galleries at St Kilda Road, NGV International. Each of these volumes explores a different aspect of the National Gallery of Victoria's international collections, highlighting not only the richness and diversity of our holdings, but also the extraordinary generosity of the patrons and supporters who have presented so many masterpieces to the NGV over the years.

The international holdings of the Prints and Drawings department are one of the great collection highlights of the National Gallery of Victoria. Comprising nearly 16,000 works, this collection spans the period from the mid-fifteenth century to the present day, and is known internationally for its core holdings of Dürer prints, old master Italian drawings, Rembrandt prints and Blake watercolours. The collection was founded in 1891–92 when a series of significant acquisitions brought old master and contemporary prints of the highest aesthetic and historical significance into the Melbourne collection for the first time. Key prints by Dürer, Rembrandt and van Dyck were acquired at the famous 1891 Seymour Haden sale in London, forming the nucleus of the important collections of these artists' work that have been subsequently assembled. The acquisition at the same time, of nineteenth century and contemporary prints by Whistler, Haden, Klinger and Meryon established the broad span of the Gallery's collecting activity right at the very inception of the collection. We continue to this day to buy both in the old and modern master, as well as the contemporary, fields.

More than any other event, the foundation of the Felton Bequest on the death of Melbourne businessman Alfred Felton in 1904, transformed our ability to acquire master drawings and old and modern master prints of the highest quality. The appointment of German-trained Dr Ursula Hoff as head of the Prints and Drawings department in 1943 brought a new focus and rigour to our collecting of works on paper, and the Print Room has been ever since a major focal point in the life of the NGV.

The department's broad collecting activity is reflected in two recent acquisitions featured in this handbook – the rare and beautiful early Italian Renaissance engraving, *Prime mover, c.* 1465, and Damien Hirst's *Last Supper®* series of screenprints, 1999. The *Prime mover* engraving is acclaimed as one of the most significant early examples of the new art of copperplate engraving made in Italy in the fifteenth century. It is, now, the earliest print in the Gallery's collection, where it joins a small but extremely fine group of Italian Renaissance engravings and woodcuts.

At the other end of the spectrum, the *Last Supper®* screenprints by British artist, Damien Hirst, are a major addition to the Gallery's collection of contemporary works on paper. Cool in style and sardonic in humour, these prints brilliantly encapsulate Hirst's ongoing concerns with death, medicine, religion and belief systems. Other notable additions to the collection in recent years include Picasso's commanding colour linocut of 1956, *Portrait of a young woman, after Cranach the younger, II*, Louise Bourgeois's *St Sébastienne*, 1992 and William Kentridge's imposing charcoal drawing, *Herbaceous border*, 1995. One of the most recent and significant additions to the collection, which arrived just in time for inclusion in this handbook, is Rembrandt's *St Francis beneath a tree, praying*, 1657 from the collection of James Fairfax. One of two Rembrandt etchings donated to the Gallery, this rare print of the artist's only portrayal of the saint is a superb example of his late style. We hope that the new Robert Raynor Gallery, specifically dedicated to exhibitions drawn from our extensive holdings of International Prints and Drawings, will continue to place these collections at the forefront of visitors' experience of NGV International.

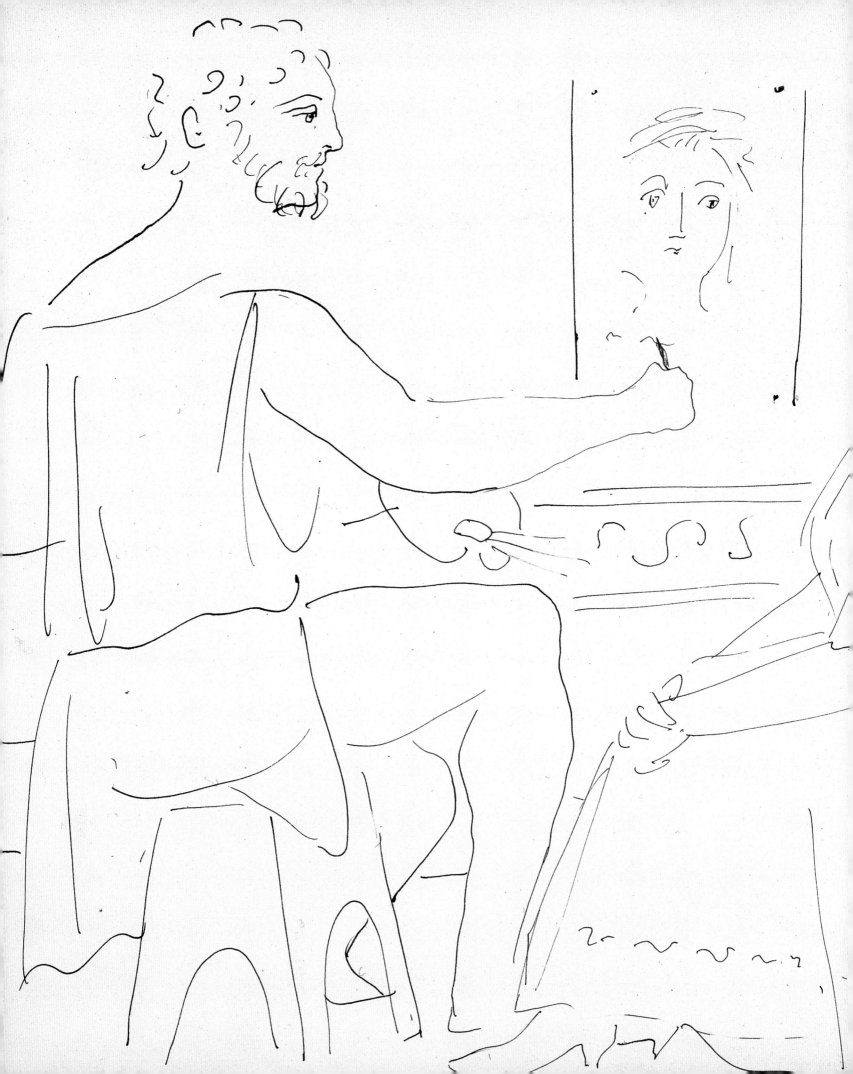

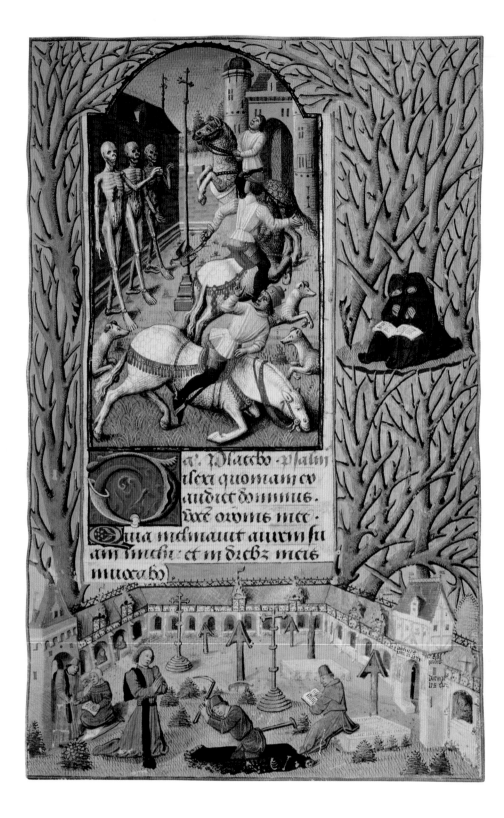

Books of Hours were popular devotional manuscripts used by the laity in the late medieval period for personal prayer and meditation. So named because they comprised texts to be recited daily at each of the eight canonical hours, these manuscripts included the Hours of the Virgin, a calendar of saints' feasts, and numerous offices, psalms, prayers and suffrages, some of which were standard inclusions, while others varied according to local customs and the owner's spiritual needs. Usually small and easily portable, the manuscripts were often illustrated with decorations that ranged from simple and minimal ornamentation to the elaborate illuminations found in volumes created for the aristocracy and royalty.

This book is one of the finest examples of the mature style of Maître François, a leading French illuminator of the second half of the fifteenth century, whose workshop was in Paris. His illustrations are accompanied by borders of decorative foliage, populated with biblical stories and scenes of rural and courtly pursuits, as can be seen in the hunting scene surrounding the *Nativity*. These were painted by an unknown assistant, while the Latin text was written by a professional scribe, Jehan Dubrueil. The inclusion of saints associated with the diocese of Angers suggests that the original unknown owner lived there. The book is now named after its nineteenth-century owner, the 1st Earl of Wharncliffe.

One of the most spectacular illuminations in the manuscript introduces the Offices of the Dead, a text that was read in supplication for one's own soul and in prayerful vigil on behalf of deceased loved ones. The inset miniature illustrates a popular French story of the Three Quick and the Three Dead, in which three noblemen, while hunting, are terrified by the apparition of three decaying corpses. The turmoil created by their appearance contrasts with the calm and contemplative images of burial and prayer in the lower border, and the black-cowled professional mourners hovering in the remarkable framing device of intricately woven bare branches. Each of these beautifully drawn and composed elements served to remind the book's owner of the transience of life, and the need for repentance, worship and pious deeds in order to achieve salvation.

Maître François and workshop
French active *c.* 1460–1480

The Nativity (above)
folios 34 verso and 35 recto

The Three Quick and the Three Dead (left)
folio 78 recto

in *The Wharncliffe Hours c.* 1475
black, blue and red inks, opaque colour, gold paint and gold leaf on parchment
17.8 x 12.8 cm (page size)
Manion & Vines 78
Felton Bequest, 1920 (1072-3)

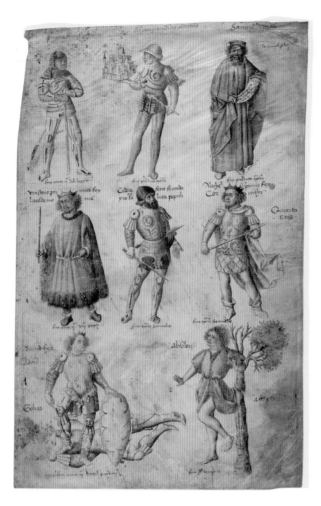

Unknown artist
Italian or French
active mid 15th century
Eight famous men: Pyrrhus, son of Achilles; Ascanius, son of Aeneas; the Prophet Samuel; King Eurythames of Sparta; King Cordus of Athens; King Aletes of Corinth; David; and Absalom c. 1450
pen and brown ink and watercolour on parchment
31.4 x 20.5 cm (irreg.)
Felton Bequest, 1966 (1663-5)

The nine figures in this drawing represent a popular subject in the Renaissance, *uomini famosi* – famous men from classical and biblical texts. The figures here are based on frescoes by the Italian artist Masolino (1383 – after 1435) of three hundred well-known historical figures from classical history through to medieval times. This ambitious cycle was painted in the early 1430s to decorate the palace of Cardinal Orsini in Rome. Although the series was destroyed about fifty years later, knowledge of the paintings endured through written and visual records made at the time.

This drawing on parchment (specially prepared sheep, goat or calf skin) is an example of one of those records, and is thought to date from around the 1450s. The artist probably based his illustrations on a series of drawings made by Leonardo da Besozzo (active 1421–81), who may have sketched the frescoes from life. It is striking how freely the artist interpreted Besozzo's drawings (which are now in the Crespi collection, Milan). Dispensing with Besozzo's backgrounds, the artist floated his figures on the sheet, altering their expressions, costumes and gestures. His subtle additions, rendered in a restricted palette of pink, blue, olive-green and brown watercolour, have the effect of breathing life into the figures. Their haloes of frizzy hair, and the texture and weight of their garments anchor them in an observed reality. Yet the artist is not entirely consistent: he has painted the robes of King Aletes of Corinth and the Old Testament figure of Absalom in a typically Gothic way, moving as though they have a mind of their own. These incongruities attest to the pivotal historical moment when the drawing was made – in a period of transition between two artistic styles. The technique used situates the work within the illuminated manuscript tradition of the medieval period, while the realistic portrayals of the figures reflects the new concerns of the Renaissance period.

The drawing belongs to a group of nine surviving sheets drawn by the same artist, eight of which were in the collections of William Morris, C. Fairfax Murray and Sir Sydney Cockerell. Of these, two are now in the Metropolitan Museum, New York, one in the National Gallery of Canada, Ottowa, the Rijksprentenkabinet, Amsterdam, and the Ian Woodner Family Collection, New York. The whereabouts of two of the sheets is unknown, while a ninth sheet, of a different provenance, is in the Kupferstichkabinett, Berlin.

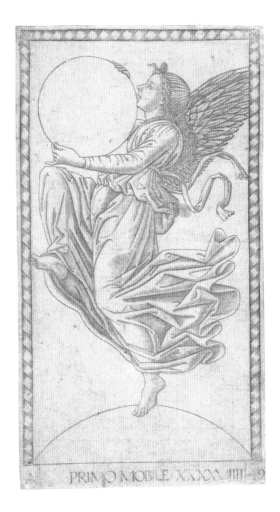

This intriguing and beautiful image is from a set of fifty prints known as the *E-series Tarocchi*, which is one of the most significant examples of early Italian engraving. The series was executed in Ferrara in about 1465, only slightly more than a decade after engraving first began to be practised in Italy.

The function and authorship of the *E-series Tarocchi* have long presented fascinating problems for scholars. Because of the similarity of certain images to cards within the tarot deck, the series was traditionally thought to be a pack of playing cards. It is now generally accepted, however, that the series is a representation of the universe that was perhaps intended as a game of instruction. The fifty prints present a visualization of medieval and Renaissance cosmography, according to which the universe was seen as a hierachically structured 'Chain of Being' that stretched from God at the summit down to the lowest human station of the beggar. *Prime mover* occupies the second-highest position in this hierarchy, and belongs to the subgroup of ten prints depicting the arrangement of the planets and celestial spheres as understood at this time. Inhabiting the ninth celestial sphere in this system, *Prime mover* draws upon the infinite energy of God, or the First Cause, to circle the earth at infinite speed and set the other eight planetary spheres in motion. To represent this cosmic force, the artist has depicted a winged figure leaping in the heavens, its pose suggestive of violent movement, and the fluttering ribbons and draperies evoking its immense speed. While the artist drew upon earlier images for many of the Tarocchi designs, there is no known precedent for this supremely graceful and elegant visualization of a cosmic idea.

The identity of the artist responsible for the *E-series Tarocchi* remains unknown, although stylistic affinities with the school of Ferrara of the period 1450–70, and the complex iconographic program, argue for an engraver closely associated with the humanist court of Borso d'Este in Ferrara. The significance of these prints for the artistic and intellectual culture of Renaissance Europe is revealed by the frequency with which they were copied in a variety of media including manuscript illumination, drawings, prints, medals, majolica and sculpture.

Master of the E-series Tarocchi
Italian active *c.* 1465
Prime mover (*Primo mobile*)
plate 49 from the *E-series Tarocchi*
c. 1465
engraving
18.2 x 10.1 cm (image and sheet)
Hind I. 240.49a
Felton Bequest, 2002 (2002.415)

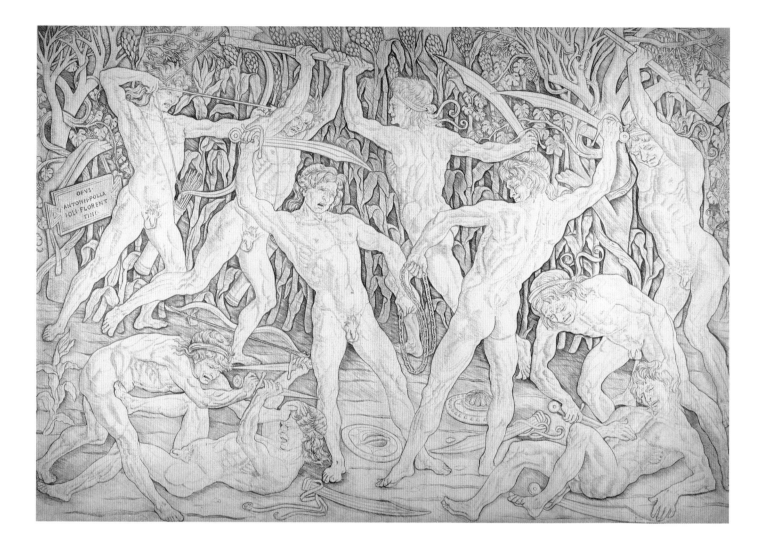

Antonio Pollaiuolo
Italian 1432–1498
Battle of the nudes early 1470s
engraving
40.4 x 57.8 cm (image and sheet;
trimmed within platemark)
Hind I.191.D.I.1 (ii/ii)
Felton Bequest, 1960 (673-5)

Battle of the nudes is Antonio Pollaiuolo's only engraving, and is one of the masterpieces of early Renaissance printmaking. An ambitious work, it was famous even in its day for the new understanding of human anatomy it so confidently portrayed. Not only is it the largest fifteenth-century engraving printed from a single plate, it is the first to bear the full signature of an artist; and it is also credited with introducing a new technique for the modelling of form.

Pollaiuolo was one of the most important artists of the early Renaissance, who, like his contemporary Andrea Mantegna, worked in a variety of media including engraving. Pollaiuolo received his earliest training as a goldsmith in Florence, and was therefore skilled in engraving on metal. This probably explains the great technical sophistication of his print. The long, parallel shading lines in the background are characteristic of the so-called Broad Manner of engraving, but the zig-zag strokes used for the definition of the complex musculature of the figures are unprecedented within the medium. This zig-zag technique also appears in some of Mantegna's plates (see *Battle of the sea gods*), although the general consensus of opinion is that it was developed by Pollaiuolo, and subsequently adopted by Mantegna. The technique became widespread from the 1480s.

The meaning of this gladiatorial combat remains uncertain despite the efforts of many scholars who have investigated ancient and classical texts. The work's emphasis upon anatomical display, diagrammatic clarity and variety of pose has suggested to some that Pollaiuolo may have intended the sheet primarily as a demonstration piece for the instruction of other artists. The work was indeed influential and copied in a wide range of media.

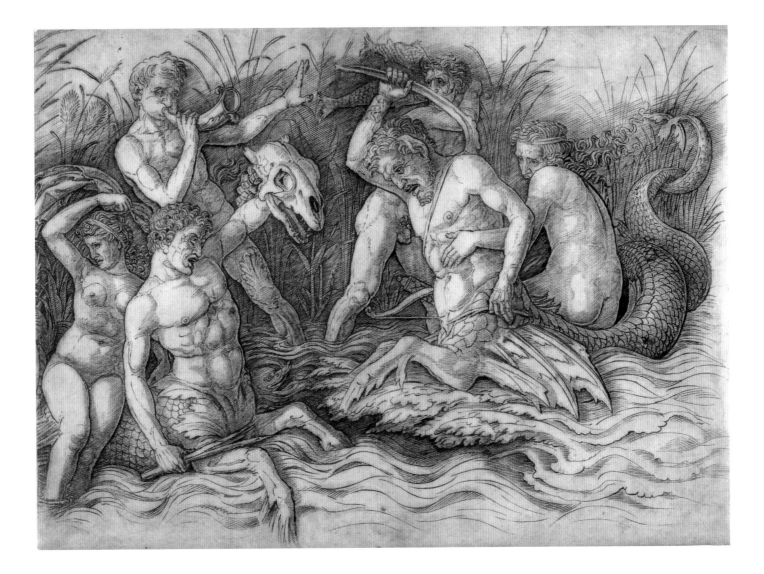

Renowned in his own lifetime, Andrea Mantegna spent most of his long career in Mantua as court painter to the Gonzaga family. Here his close association with a progressive circle of humanist scholars and antiquarians helped cultivate his knowledge of the art, literature and architecture of classical antiquity. This erudite circle would have been the primary audience for Mantegna's prints, in particular his engravings of classical subjects, of which *Battle of the sea gods* is the most significant.

Battle of the sea gods is a two-part, frieze-like print that presents a complex allegory on the subject of envy. The work combines a number of classical sources in a novel composition that epitomizes the Renaissance ideal of *invenzione* based on classical motifs and ideas. The key to the subject is in the left panel of the frieze (not held by the National Gallery of Victoria), where envy is personified as a hag, shown holding a plaque bearing her name. The unusual association of Envy with furiously battling sea gods and monsters has been explained by reference to a number of classical texts that were known in Mantua at this time. These texts tell of a race of mythical sea monsters, the Telchines, who were renowned for their envious and querulous nature. More intriguing is the fact that these mythical creatures were said to be artists, a detail of the story that may have attracted Mantegna's interest.

Battle of the sea gods is one of the most stylistically and technically advanced of the seven engravings traditionally ascribed to Mantegna. The deeply incised and widely spaced lines not only model the figures with great plasticity but, in good impressions such as this, also provide a remarkable degree of tonal modulation. While scholars continue to debate the dating, technical description and the attribution of particular plates to Mantegna, the profound impact of his engravings, for their style and their compositional inventiveness upon contemporary and later artists, is uncontested.

Andrea Mantegna
Italian 1431–1506
Battle of the sea gods: right half of a frieze early 1470s
engraving
28.9 x 39.5 cm (image);
28.9 x 39.7 cm (sheet)
Hind V.15.6
Felton Bequest, 1965 (1583-5)

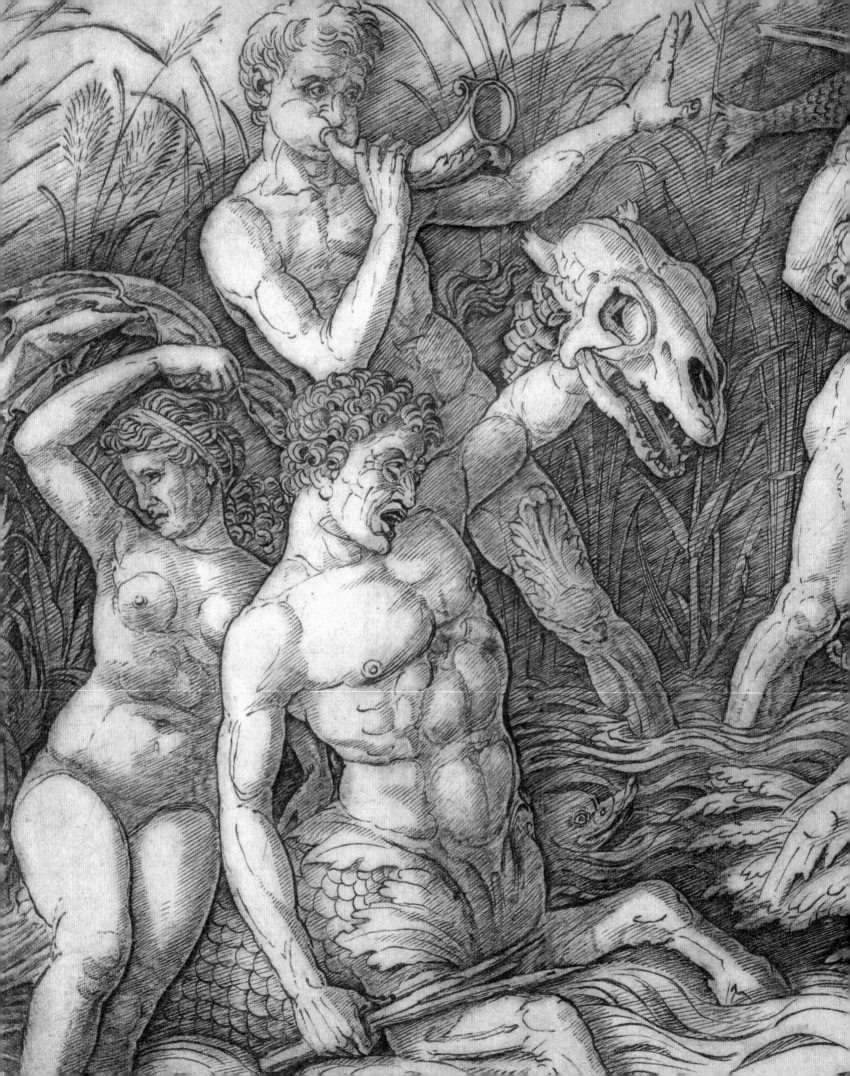

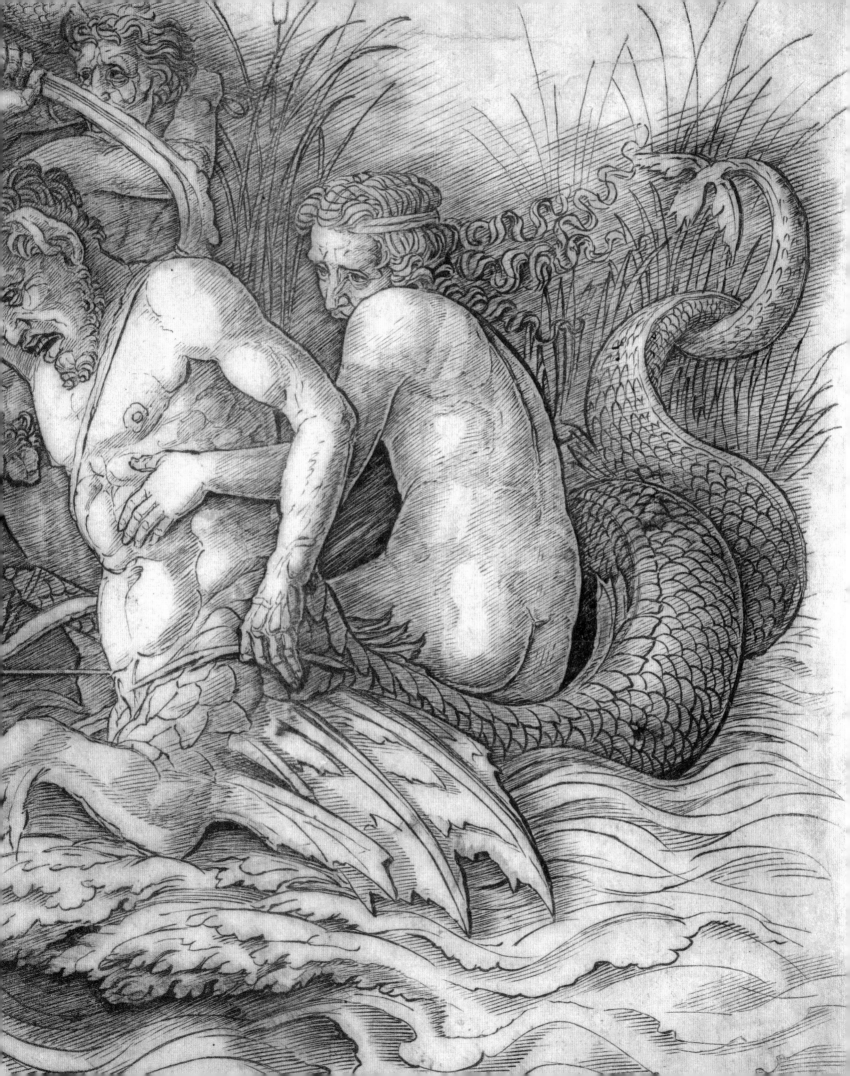

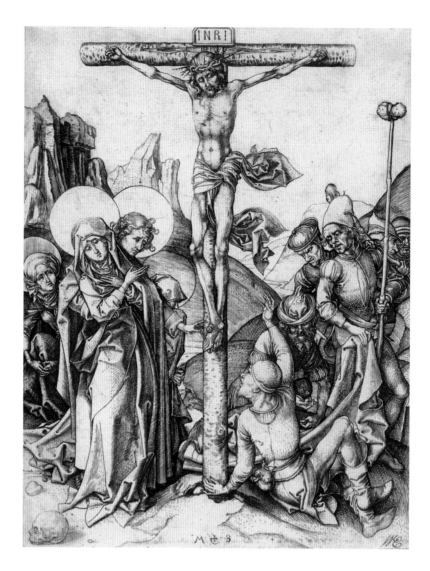

Martin Schongauer
German c. 1450–1491
The Crucifixion c. 1480
engraving
19.5 x 15.1 cm (image and sheet)
Bartsch 24; Lehrs 13
Felton Bequest, 1922 (1233-3)

Martin Schongauer was the most significant engraver in northern Europe in the fifteenth century. He worked in the Alsatian city of Colmar, in the upper Rhine region, where the earliest known engravings were produced in the 1430s. The origins of engraving are closely connected with the art of goldsmithing, as both processes use the sharp tool known as a burin to incise elaborate designs into metal, and the earliest engravers probably trained as goldsmiths. Schongauer was the first engraver known to have trained as a painter, and his importance lies in the new level of artistic skill that he brought to the medium from the 1470s. His engravings were highly regarded in his lifetime for their innovative compositions, their supremely refined technique and their new pictorial qualities.

Schongauer's great skill in devising complex compositions and in portraying emotions is evident in this Crucifixion scene, where the figures at the foot of the cross are divided into two distinct groups, which are marked by extreme disparity in mood. The grief of the holy mourners on the left, expressed through facial expression and evocative gesture, is contrasted with the callousness of the Roman soldiers on the right, who throw dice for Christ's clothes. The composition has a strong pictorial unity that is enhanced by the stark landscape in the background that echoes the figure groupings. Schongauer's sophisticated engraving technique and coherent tonal modelling lend his forms a sculptural quality that is new to engraving. However, the stylized drapery and the refined elegance of the slender figures identify his engravings as part of the late flowering of the International Gothic style.

Schongauer's fame was spread through his engravings, which were known throughout Europe. His work influenced many artists, most significantly the young Albrecht Dürer who, on his journeyman travels, set out for Colmar in 1492 to meet the master, only to arrive shortly after Schongauer's death.

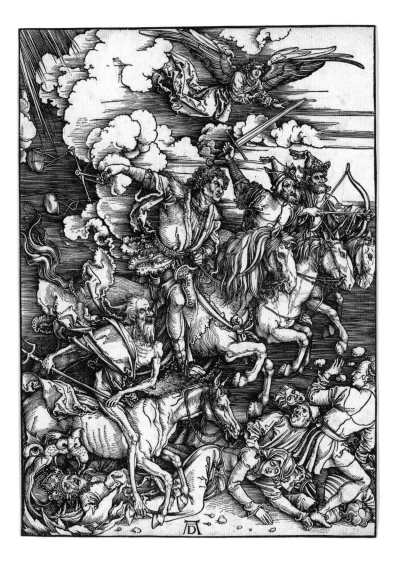

Albrecht Dürer was one of the greatest artists of the Renaissance, renowned for his exceptional artistic and intellectual abilities, and for his far-reaching influence upon contemporary, and successive, generations of artists. His life spanned late medieval, Renaissance and Reformation times, and the profound intellectual, religious and artistic changes that marked this period were reflected in his art and thinking. Dürer's traditional medieval training was transformed by first-hand contact with the art of the Italian Renaissance, and he was responsible for introducing into Germany, through his art and theoretical writings, the forms and ideals of the new Italian art. While he was acclaimed as a painter, it was Dürer's prints that secured his fame, and spread his stylistic, iconographic and technical innovations throughout Europe.

In 1495, following his return to Nuremberg from his first trip to Italy, Dürer established his own workshop, and started producing woodcuts and engravings. By 1498 he had contracted an agent to distribute his prints abroad, and in the same year he published the *Apocalypse*, a large-format book of fifteen woodcuts illustrating the *Revelations of St John the Divine*, that made him famous north and south of the Alps. The first book in Western art to be both published and illustrated by an artist, the *Apocalypse* was unprecedented for the scale of the illustrations and for their prominence over the text. Moreover, St John's fantastic visions were given a completely new and realistic visual expression. Whereas earlier German woodcuts were crudely cut with little modulation of form, Dürer introduced a new vitality and versatility to his woodcut lines that enabled them to simultaneously outline shape, model form and describe textures. Dürer's figures also evinced a new plasticity and expressiveness, and his compositions employed more convincing spatial arrangements, revealing the influence of Italian Renaissance art. These new qualities are evident in the powerful and dynamic image of the *Four Horsemen of the Apocalypse*, which shows the four apocalyptic riders – War, Pestilence, Famine and Death – riding out in a tight phalanx to unleash destruction upon the Earth.

Albrecht Dürer
German 1471–1528
The Four Horsemen of the Apocalypse c. 1497–98
from *The Apocalypse*, published 1498
woodcut
39.2 x 28.2 cm (image and sheet)
Bartsch 64, proof before text
Felton Bequest, 1956 (3538-4)

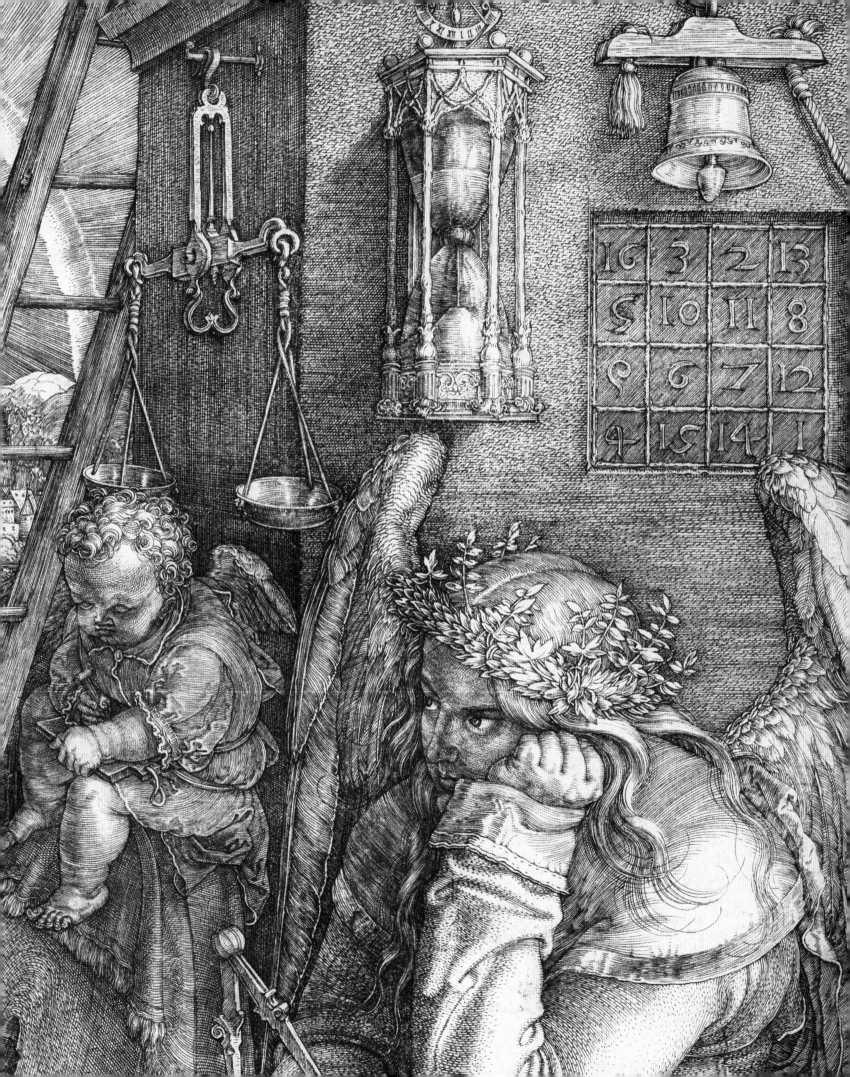

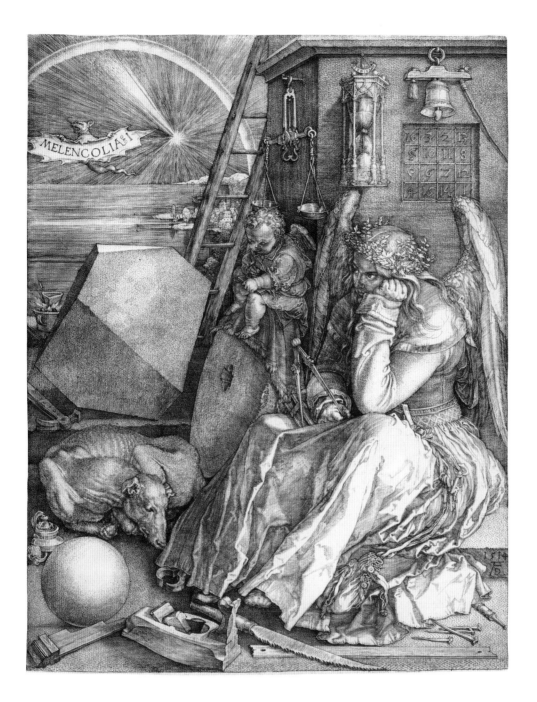

In 1513–14 Dürer produced three engravings that are renowned as his most technically refined prints, and as his greatest imaginative inventions: *Knight, Death and the Devil*; *St Jerome in his study*; and *Melencolia I*. The imagery in these prints embodies erudite concepts associated with Renaissance humanist philosophy. In *Melencolia I* the brooding winged figure, shown surrounded by unused tools and implements that are symbolic of art as a creative and scientific endeavour, has been interpreted as a personification of the artistic, melancholic temperament. The association of this temperament with creative genius was unknown in medieval times and had only recently been elaborated by the contemporary Italian philosopher Marsilio Ficino, whose theories Dürer presumably knew through his close friend, the humanist Willibald Pirckheimer. The work contains many references to the planet Saturn and to geometry that are explained by the contemporary belief that Saturn not only governed melancholics, but was also associated with geometry. This link between art and scientific investigation so crucial to Dürer's own artistic endeavours is one of the underlying themes of this complex exposition on the nature of the creative temperament. A multi-layered work, this print has been described as a spiritual self-portrait of the artist, and is acclaimed as the greatest and most influential depiction of this subject in European art. The impression illustrated here is the extremely rare first state of the print, before the number 9 in the magic square behind the winged figure was corrected.

Albrecht Dürer
German 1471–1528
Melencolia I 1514
engraving
23.9 x 18.7 cm (image);
24.1 x 18.7 cm (sheet)
Bartsch 74 (i/ii)
Felton Bequest, 1956 (3486-4)

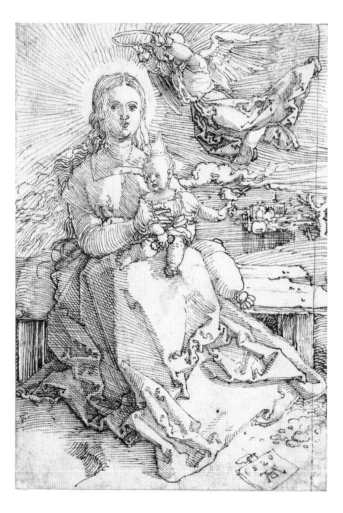

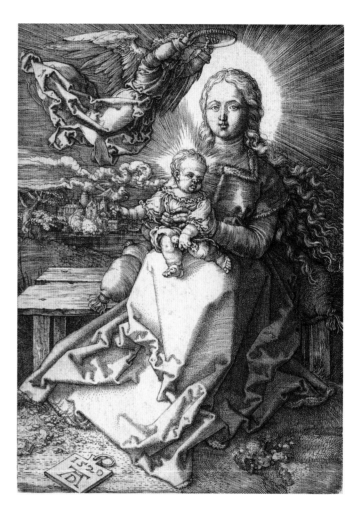

Albrecht Dürer
German 1471–1528

Madonna crowned by one angel
1520
pen and ink
13.9 x 9.6 cm (sheet)
Winkler 544
Felton Bequest, 1936 (360-4)

Madonna crowned by one angel
1520
engraving
13.7 x 9.9 cm (image);
14.1 x 10.3 cm (sheet)
Bartsch 37
Felton Bequest, 1956 (3455-4)

By 1520, when Dürer executed the engraving of the *Madonna crowned by one angel*, his style had become more austere and monumental in its forms, a change usually attributed to his crisis in faith, brought about by the Reformation and Luther's teachings. Whereas earlier Madonnas exhibit serenity and grace, engravings of this subject in 1519 and 1520 introduce a newly sombre mood, exemplified here in the glowering, dark sky. The National Gallery of Victoria owns Dürer's pen drawing for this engraving, which in its sense of lightness and airiness contrasts with the darker mood of the finished work. The drawing, the forms of which were reversed in the printing process, shows all of the compositional details fully resolved, and is a fine example of Dürer's skills as a draughtsman.

The National Gallery of Victoria has an internationally acclaimed Dürer collection. Numbering some five hundred engravings, woodcuts, books and one drawing, the collection of prints is virtually complete, lacking only three engravings that are known solely in unique impressions. The core of the Gallery's holdings is the Sir Thomas Barlow collection, acquired through the Felton Bequest in 1956, that is renowned for the outstanding quality of its impressions and for the rarities it contains.

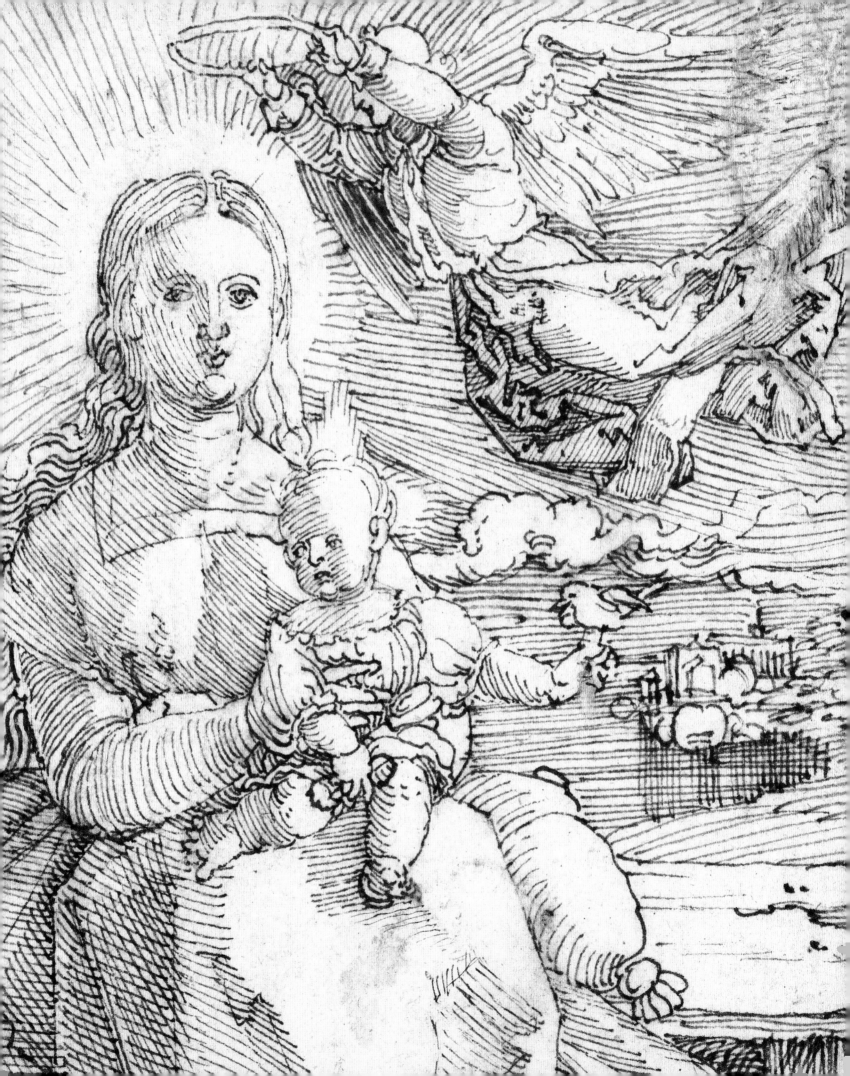

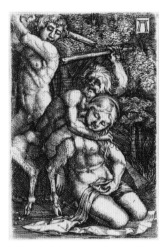

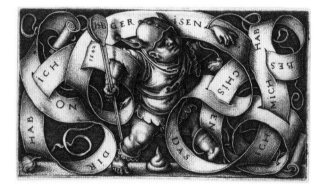

Albrecht Altdorfer
German c. 1480–1538
Satyr attacking a nymph, himself being attacked c. 1520–25
engraving
6.0 x 4.1 cm (plate),
6.2 x 4.2 cm (sheet)
Bartsch 38; Winzinger 164.a
Felton Bequest, 1950 (2272-4)

Sebald Beham
German 1500–1550
The little buffoon 1542
engraving
4.6 x 8.1 cm (image and sheet)
Bartsch 230; Pauli 234 ii/ii
Felton Bequest, 1950 (2282-4)

During the early sixteenth century a short-lived genre of printmaking was developed by a group of German artists later known as the Little Masters, named for their tiny intricate engravings. Such prints, often no more than a few centimetres in size, were clearly intended for an educated audience, who would enjoy their subtle references to little-known images from the Old Testament and to myths, allegories and historical and contemporary subjects.

Albrecht Altdorfer of Regensburg was the first printmaker to work in this format, influenced by German printmakers such as Albrecht Dürer, as well as by Italian visual and decorative arts that were arriving from the south. Around 1506 Altdorfer was inspired by small, delicately incised silver discs known as *nielli* to produce diminutive prints. He also responded directly to the work of other artists, as can be seen in *Satyr attacking a nymph, himself being attacked*, which is based on an engraving by Italian printmaker Marcantonio Raimondi. Altdorfer has reversed and tightened Marcantonio's composition, and subdued the erotic content (an aspect often highlighted by the Little Masters).

The core of the Little Masters group comprised Nuremberg artists Bartold Beham, his brother Sebald (often known as Hans Sebald) and George Pencz. The three may have trained in Dürer's workshop, and were certainly inspired by his, Altdorfer's and others' prints. Early printmaking retained many close links with metalworking and the decorative arts, and the Little Masters' prints influenced artists and craftworkers throughout Europe. Sebald Beham's *The little buffoon* exemplifies the decorative elements of such prints. A chubby child clad in a fool's costume is entwined in a flowing banderole, across which the inscription (which can be translated as various lewd puns) can be read as 'I have written on you that I have beshit myself'.

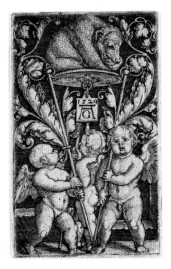

A common and more sombre theme in northern European art was the personification of Death, reminding the viewer of its ever-present and unavoidable nature. In 1540 Beham engraved the image *The lady and the fool*, in which an elegant lady strolls with her attentive lover, dressed in a fool's costume. In the following year he repeated the image, but transformed the lover/fool into Death disguised, who, like the figure in Dürer's influential engraving *The promenade, c.* 1498, displays sand slipping through an hour-glass.

Initially trained as a goldsmith, the Westphalian artist Heinrich Aldegrever produced many small ornamental prints comprising designs of entwining foliage, overflowing cornucopia and fantastic creatures. In this example, three winged genii (one atypically female) support a platter presenting a bear cub who sucks his paw, a habit thought to sustain bears through their winter hibernation. Animal imagery frequently represented human foibles or traits. Although the meaning of such symbolism is often lost, the image here may mockingly glorify gluttony and/or laziness.

Heinrich Aldegrever
German 1502 – 1555–61
Three genii with bear 1529
engraving
6.5 x 4.0 cm (plate),
6.6 x 4.1 cm (sheet)
Bartsch 231
Purchased, 1950 (2289-4)

Sebald Beham
German 1500–1550
The lady and Death 1541
engraving
7.9 x 5.2 cm (plate),
8.2 x 5.5 cm (sheet)
Bartsch 149; Pauli 150 i/iii
Felton Bequest, 1950 (2278-4)

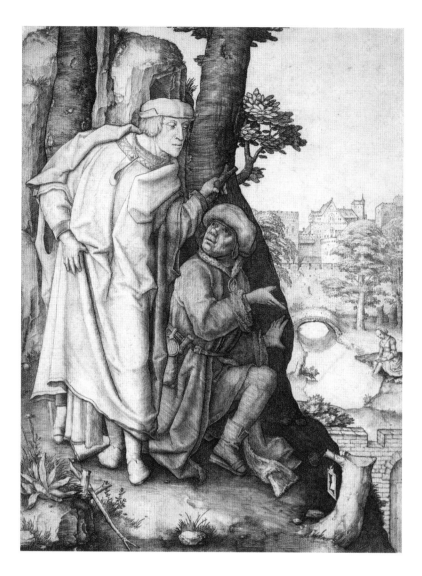

Lucas van Leyden
Dutch 1489/94–1533
Susanna and the Elders c. 1508
engraving
19.5 x 14.7 cm (image and sheet)
Bartsch 33
Felton Bequest, 1958 (3807-4)

The story of Susanna and the Elders, from the Old Testament Apocrypha (Daniel 13), was a popular theme in art during the sixteenth and seventeenth centuries. As she bathed in her secluded garden, the beautiful and devout Susanna was approached by two elders who, inflamed with lust, demanded that she sleep with them. Upon her refusal, they accused her of adultery. However, their lies were exposed at her trial by the young Daniel, and she was saved from death. Susanna's chastity and goodness made her a paragon of wifely virtues, and her story was popular among artists for its combination of moralizing sentiment and voyeuristic appeal.

Born in the western Netherlands town of Leiden, Lucas van Leyden was the first internationally acclaimed Dutch engraver. There is confusion over his birthdate, which was recorded by sixteenth-century art historian Karel van Mander as being 1494, making Lucas only fourteen when he produced this accomplished work. An earlier suggested birthdate of 1489 would make him nineteen, still remarkably young. *Susanna and the Elders* demonstrates Lucas's penchant for original interpretations of biblical scenes, particularly his habit of selecting unusual or rarely depicted moments. Rather than presenting the defenceless Susanna as the central figure, Lucas focuses on the conspirators who watch her. The entire composition serves to underline the plotting and tense anticipation in the narrative. The men are shown hiding on an outcrop, peering over the high garden wall, their bodies restrained by the dividing line of the tree trunk. The standing man's gaze, the pointing fingers, the diagonal lines created by their clothes and the curving bridge all combine to lead the viewer's eyes to the distant and unsuspecting Susanna. Lucas's prolific output was highly influential, inspiring many, from Marcantonio Raimondi in Rome (who incorporated the background from this print in his engraving *Lucretia*, c. 1511–12) to Rembrandt.

Clearly dated but unsigned, the later drawing of Susanna and the Elders was made by the same artist who was responsible for a number of designs for stained-glass windows that are signed with the monogram 'PC'. Although their attribution has been disputed, these are traditionally assigned to Pieter Cornelisz. Kunst. A painter, glass painter and designer of maps and furniture, Pieter was strongly influenced by Lucas, who was a fellow student in the workshop of Pieter's father, the painter Cornelis Engebrechtsz. Drawn some twenty years after Lucas's engraving, this drawing depicts a more conventional moment in the story, showing Susanna being approached by the elders. Interrupted in her bathing, Susanna looks apprehensive, the would-be-seducers' intentions made apparent by the suggestively placed waterspout. An unusual addition is the inclusion of the men rushing through the gate; most representations of the story depict only handmaidens who arrived upon hearing Susanna's cries. Despite the lack of a signature, this work is considered to be a finished, or presentation, drawing. As such, it is an example of the rise in the number of such works, demonstrating the increasing stature of the art of drawing at this time.

Pieter Cornelisz. Kunst
Dutch *c.* 1484–1560/61
Susanna and the Elders 1530
pen and ink
20.4 x 28.1 cm
Purchased, 1948 (1888-4)

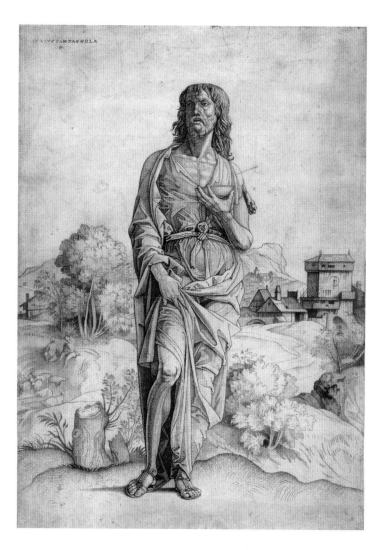

Giulio Campagnola
Italian c. 1482 – after 1515
St John the Baptist c. 1505
engraving and stipple-engraving
33.2 x 23.8 cm (image and sheet)
Hind V.201.12
Felton Bequest, 1961 (862-5)

One of Giulio Campagnola's most famous images, *St John the Baptist* exemplifies the rapid developments occurring in Italian engraving in the early sixteenth century. The statuesque figure of St John is clearly based on the distinctive work of Andrea Mantegna, the most revered artist of his time, whom Campagnola may have known in Mantua between 1497 and 1499. However, the pastoral landscape behind the figure demonstrates the influence of young Venetian artist Giorgione, with whom Campagnola possibly collaborated. A preparatory drawing for the landscape (held in the Louvre, Paris) suggests that the figure was engraved first, possibly in the 1490s, with the landscape conceived at a later date. This would explain the differing styles of engraving evident in the print. While the saint is depicted using a combination of lines and dots, with diagonal hatching employed only on the face and neck, the landscape is composed solely of delicate dots or stippling, a technique that was Campagnola's most notable contribution to the development of Renaissance printmaking. The subtle tonal effect and corresponding simplification of detail has resulted in certain elements, such as the sheep and shepherds in the background, appearing surprisingly modern in form and treatment.

Born in Padua, Campagnola lived in Venice for much of his short life. A talented musician, linguist, poet, painter, miniaturist and gemcutter as well as engraver, he associated with Venetian humanists and artists who would have appreciated and collected his sophisticated prints. Although it is uncertain whether *St John the Baptist* was published during Campagnola's lifetime, it is clearly signed, suggesting that the artist expected that his print would be seen outside his immediate circle or city. Campagnola's inspired achievements contributed greatly to Venice's rise as one of the most important Renaissance printmaking centres in the sixteenth century.

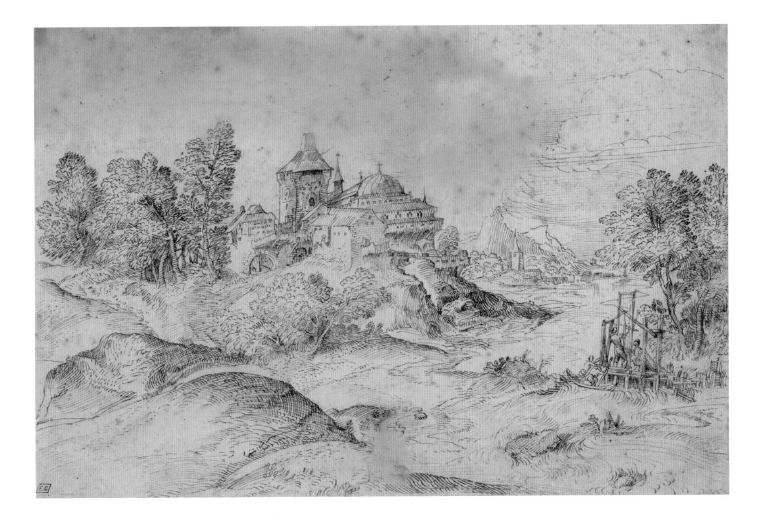

Born of German parents, Domenico Campagnola was adopted by Giulio Campagnola and worked as his apprentice, possibly from the early age of seven. Raised in Venice, he became a leading artist in nearby Padua, where he lived from about 1520. Domenico Campagnola was important in the development of the landscape genre in sixteenth-century Italy, at which time it was assuming an increasing significance and dynamism. He was especially regarded for his prolific output of decorative landscape drawings and innovative woodcuts and engravings. His enormous production of presentation drawings, for which he received praise as early as the 1530s, demonstrates an expanding market for such works. Campagnola was clearly inspired by his adoptive father, as well as by the pastoral scenes of Giorgione. The most significant influence on his development, however, was that of the arcadian landscapes of Titian. It seems likely that Campagnola had direct contact with Titian's workshop in Venice, where he may have studied and collaborated with the master.

Extensive landscape with a castle demonstrates Campagnola's accomplished draughtsmanship, and depicts one of his characteristic idyllic scenes, in which he combines individual features, which may be real or imaginary, to create an idealized landscape. The raised foreground presents a panorama of rolling hills, surmounted in the middle distance by steeply pitched and domed buildings, a fantastic castle-like amalgam of northern Italian and northern European architecture. The turbulent river, mirrored by sweeping clouds, courses around the buildings to the calm vista beyond, with jagged peaks visible on the distant horizon. The only human element is provided by the group struggling with the boat in the foreground.

Campagnola's influential drawings inspired artists north and south of the Alps, including Pieter Bruegel the elder, Agostino and Annibale Carracci, Hendrick Goltzius and Peter Paul Rubens, and Antoine Watteau in the eighteenth century.

Domenico Campagnola
Italian 1500–1564
Extensive landscape with a castle
late 1530s – early 1540s
pen and brown ink; laid down
18.3 x 27.9 cm
Purchased, 1956 (3391-4)

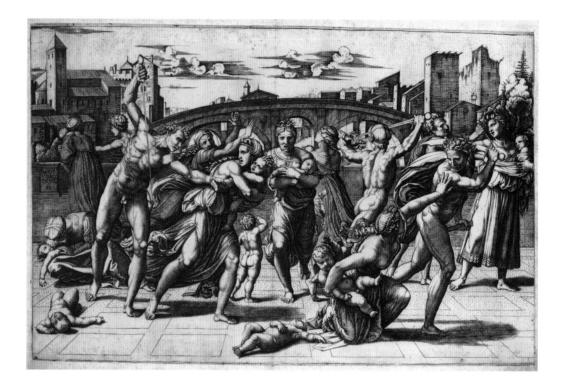

Marcantonio Raimondi
Italian
c. 1470-82–1527-34
Massacre of the Innocents
c. 1511–12
engraving
28.3 x 43.5 cm (plate);
32.3 x 44.7 cm (sheet)
Bartsch XIV.19.18 (ii/ii)
Felton Bequest, 1958
(3801-4)

Marcantonio Raimondi is recognized as having introduced a new chapter in the history of printmaking, that of the so-called 'reproductive' print. Active in Italy solely as a printmaker, Marcantonio established a successful career engraving the designs of other artists, notably those of Raphael. Inspired by the engravings of Albrecht Dürer and Lucas van Leyden, Marcantonio developed a highly systematic engraving technique that used cross-hatching, parallel lines, and flicks and dots of the engraving tool. This disciplined system of engraving enabled him to more effectively render pictorial effects and sculptural volume.

Marcantonio arrived in Rome in 1510 or 1511, and shortly thereafter began a long and productive association with Raphael. Over the ensuing decade he made about fifty engravings after Raphael's designs. Unlike later reproductive engravers, Marcantonio worked not from Raphael's finished paintings but rather from the master's drawings. There is strong evidence to suggest that Raphael occasionally made drawings specifically for Marcantonio to translate into engravings. *Massacre of the Innocents* is the most famous example of this, and the great care with which Raphael developed the composition is revealed in six extant drawings. The compositional details of the terrified, fleeing women and the executioners intent on their gruesome task are fully resolved in these drawings, although, surprisingly, not one of them shows the elaborate cityscape (which has been identified as a view in Rome) that features in the engraving. It is uncertain whether a further, now lost, drawing provided these details, or whether Marcantonio, in accordance with his established practice of combining various sources in his engravings, provided the background himself.

Marcantonio's sophisticated engraving technique, and the graphic clarity of his style enabled him to magnificently translate the powerful torsion and movement of Raphael's figures, as well as their emotional expressiveness. *Massacre of the Innocents* quickly became one of Marcantonio's most famous engravings, and was an important vehicle for disseminating Raphael's High Renaissance style throughout Italy and the North.

This is a superb, sparkling impression of this engraving.

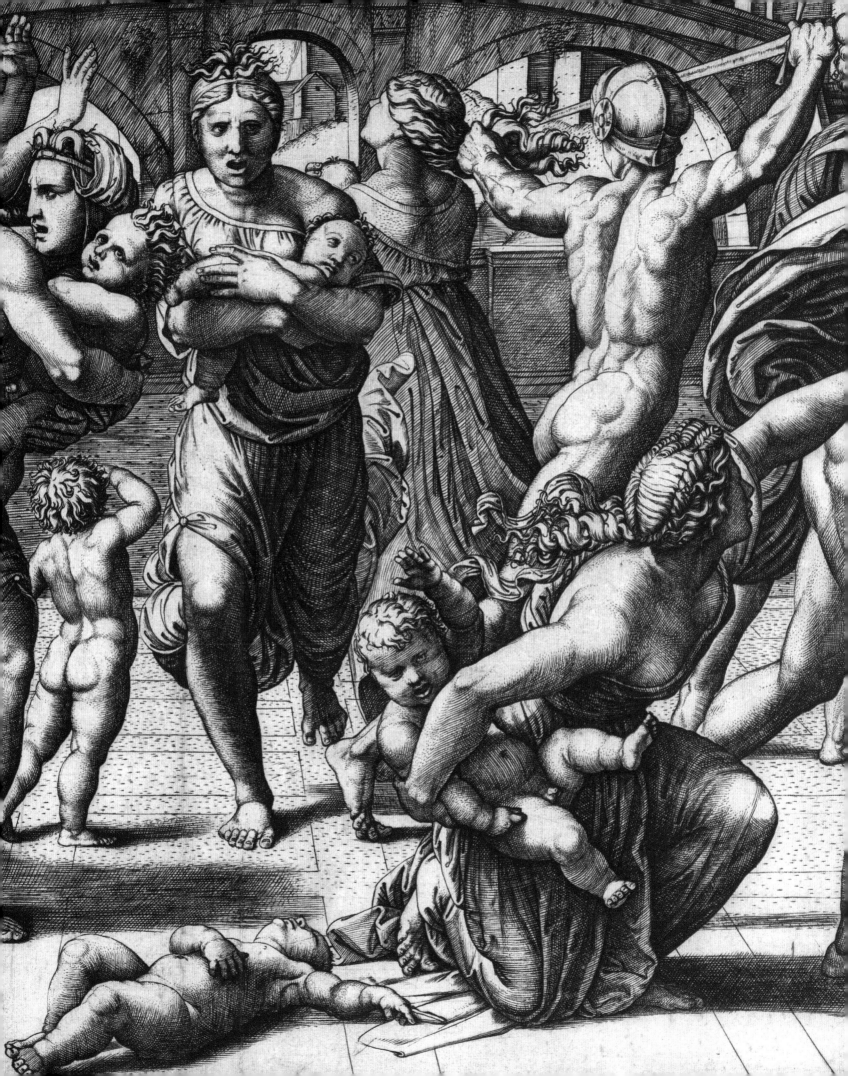

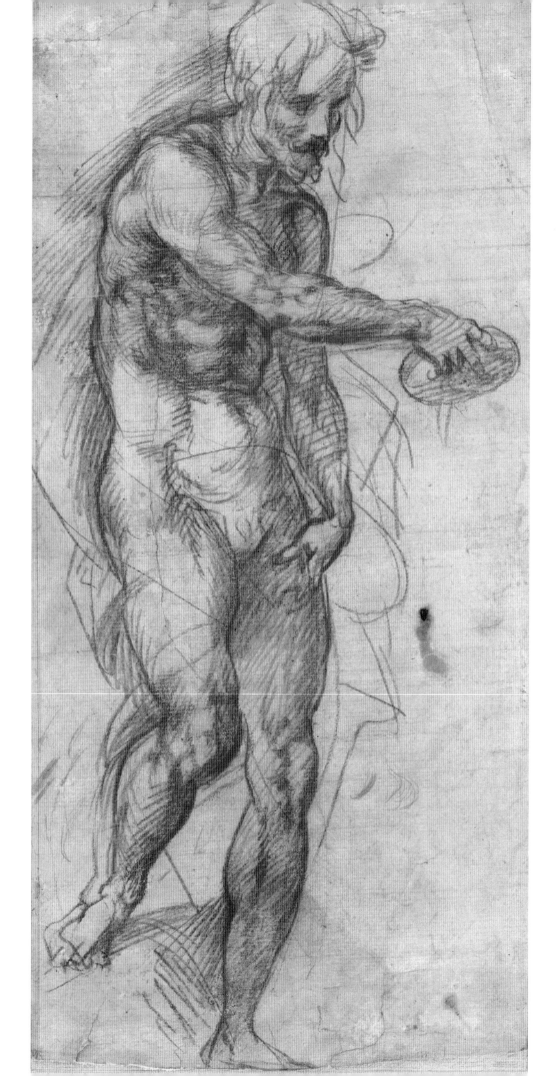

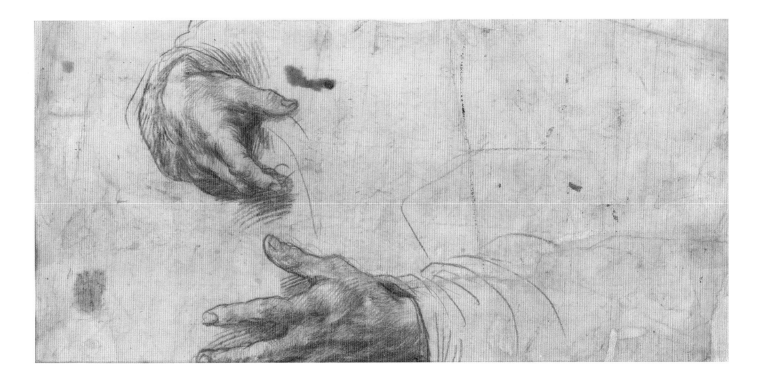

This red chalk drawing by the Renaissance artist Andrea del Sarto is a preparatory study for the figure of St John the Baptist in the fresco *Baptism of the People*, at the Chiostro dello Scalzo in Florence. Commissioned by the Confraternity of the Scalzo (the Barefoot Friars), of which del Sarto was a member, the fresco forms part of a cycle of twelve monochrome paintings illustrating episodes from the life of the saint. Completed in 1517, *Baptism of the People* depicts St John baptizing a kneeling youth, while others wait their turn. The commission, on which del Sarto worked intermittently from 1509 until 1526, became one of the most important Florentine fresco cycles of the High Renaissance.

The close correspondence between the drawing and the finished painting suggests that del Sarto made the study at an advanced stage of the design process. This is evident not only in the pose of the figure and the bearded face of the model but also in small details. Faint lines that encircle the figure in the drawing indicate where del Sarto planned to paint bulky draperies, and a stick in his left hand is transformed into a cross in the finished painting. Del Sarto probably made this drawing from a model, possibly a workshop assistant, in order to convincingly depict the figure's musculature. Areas of the body that are visible in the painting, such as the figure's torso and extended arm and lower legs are drawn with particular care.

Del Sarto may have based the figure of St John on Michelangelo's unfinished marble sculpture of *St Matthew* (Accademia delle Belle Arti, Florence), whose monumental form and dynamic pose are echoed in this sheet. Michelangelo's influence also extended to del Sarto's drawing technique: the network of hatched and cross-hatched lines creates areas of tone that, along with his emphatic outline of the contours of the figure, recall Michelangelo's celebrated *Battle of Cascina* cartoon, 1504–6 (destroyed).

Always admired for his draughtsmanship, del Sarto's prolific output ranged from small compositional sketches and individual figure studies, to detailed explorations of anatomy. An example of the latter can be seen on the verso of this sheet. The red chalk drawing of hands has been identified as a study for the figure of St Elizabeth in the *Holy Family with St Elizabeth and the infant St John* (Louvre, Paris).

Andrea del Sarto
Italian 1485–1530
Study for St John the Baptist
c. 1517
verso: Study of hands
red chalk
38.5 x 18.8 cm (irreg.)
Freedberg, pp. 67, 84; Shearman, pp. 364–5
Felton Bequest, 1936 (351-4)

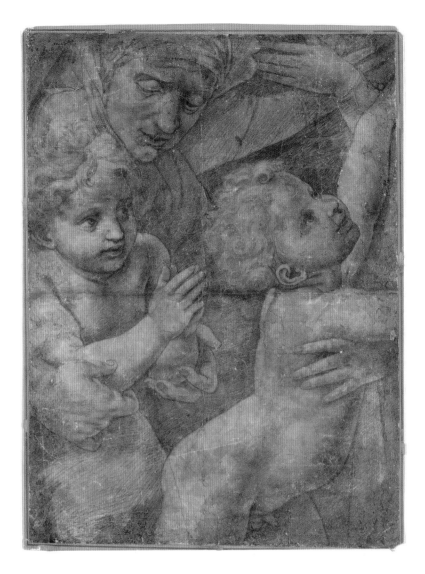

Giulio Romano
Italian *c.* 1499–1546
The Holy Family of Francis I,
St Elizabeth, St John and the
infant Christ c. 1518
cartoon fragment: black and white
chalk on prepared paper; laid down
70.6 x 52.6 cm (irreg.)
Bequest of Howard Spensley, 1939
(587-4)

This drawing is one of two surviving fragments of the cartoon used in the execution of Raphael's altarpiece of *The Holy Family*, painted for the King of France, Francis I (the other fragment is in the Musée Bonnat, Bayonne, France). The painting, now in the Louvre, was commissioned as a papal gift and sent to France in 1518. It is generally believed that Raphael assigned the project to his chief workshop assistant, Giulio Romano.

During the High Renaissance cartoon drawings were used to transfer a design onto a wall prepared for a fresco or an easel painting. They were made to the scale of the finished work, and because of their frequently large format were drawn in black chalk or charcoal, media most suited to working on a large surface. Faint indentations along the outlines of the figures in this cartoon suggest that a sharp instrument, such as a stylus, was used to transfer the design onto the canvas.

The entwined figures represent St Elizabeth holding the infant Christ, and St John. Romano's sensitive modelling of the figures, built up by a regular and assured parallel hatching technique, is evident in the careful modelling of the faces, and extends to details such as the shadows under St Elizabeth's eyes. While cartoons were primarily used to trace outlines of a design, it is striking that this drawing is concerned with the careful modelling of light and shade. At the time this new effect, called *chiaroscuro*, elicited this response from fellow artist Sebastiano del Piombo who described the painting in a letter to Michelangelo: 'They seem like figures which have been in smoke, or rather figures of iron which shine, all light and dark'. Although cartoons were often damaged or destroyed in the process of their use, the level of finish in this fragment supports the view that it was prized as a work of art in its own right. Cartoon drawings by Leonardo da Vinci, Michelangelo and Raphael reached such a level of refinement during the Renaissance that they were considered to be the height of the design process.

The refined aesthetic of Italian Mannerism is beautifully exemplified in this presentation drawing by Parmigianino. Although the subject of the drawing has been associated with the myth of Diana and Actaeon, which Parmigianino had painted a decade earlier at Fontanellato near Parma, the exact moment of the narrative has only recently been identified.

The myth, recorded in Ovid's *Metamorphoses*, tells the story of Diana, goddess of the hunt, and Actaeon, whom she transformed into a stag as punishment for having stumbled upon her while she bathed. Rather than focusing on the main narrative, Fiona Brown has recently suggested that Parmigianino took his subject from a minor part of Ovid's story, turning his attention to Actaeon's hunting companion, who is shown sounding a horn to alert his master to the stag's capture. The unsuspecting hunter does not realize that it is Actaeon himself who is being set upon by the hounds:

> his friends, not knowing what they did, urged on the ravening mob with their usual encouragements and looked round for Actaeon, shouted for Actaeon, as if he were not there, each trying to call louder than the other. They lamented that their leader was absent, and that his slowness prevented him from seeing the booty chance had offered.
> —Ovid, *Metamorphoses*, 3:242–6

The fantasy elements of the huntsman's costume and gigantic horn point to the fact that the drawing is a work of elaborate poetic invention. Parmigianino may have based the pose of the huntsman on a terracotta figure by Michelangelo in the Casa Buonarotti in Florence, which is thought to have been the model for the sculpture of David. It is clear that Parmigianino was particularly attracted to the pose, which he used in a number of drawings that explored the eroticism of the male figure.

The provenance of *Huntsman sounding his horn with a staghunt in the distance* stretches back to one of the most important collections in eighteenth-century Italy, that of Antonio Maria Zanetti, and before that, to the collection of Thomas Howard, Earl of Arundel.

Francesco Mazzola, called Parmigianino
Italian 1503–1540
Huntsman sounding his horn with a staghunt in the distance
c. 1530–39
pen and brown ink and brown wash over faint traces of black chalk; laid down
26.2 x 20.4 cm
Popham 282
Felton Bequest, 1936 (358-4)

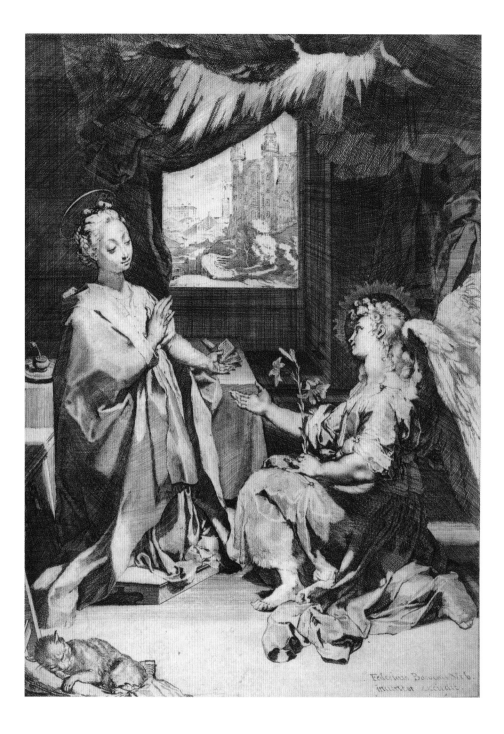

Federico Barocci
Italian *c.* 1535–1612
The Annunciation c. 1584–88
etching, engraving and drypoint
43.8 x 31.4 cm (plate);
44.4 x 31.7 cm (sheet)
Bartsch XVII.2.1 (ii/ii)
Felton Bequest, 1969 (P1-1969)

Federico Barocci was one of the most influential Italian artists of the second half of the sixteenth century, acclaimed chiefly for his religious paintings. These paintings reflected the spirit of the Counter Reformation by combining a new form of naturalism with a restrained, emotional expression and a feeling of piety. Barocci was also an important printmaker. In the 1580s he produced a small group of etchings – only four in number – that extended the artistic and expressive potential of the medium.

The Annunciation is Barocci's last etching, as well as his greatest achievement as a printmaker. It reproduces his painting of 1582–84 (Pinacoteca, Vatican), which depicts the moment, described in the Gospel of Luke, when the Archangel Gabriel revealed to the Virgin Mary that she would bear the Son of God. Barocci sets the holy scene in a domestic chamber where naturalistic details, such as the sleeping cat and the view of his native Urbino glimpsed through the window, counterbalance the miraculous encounter. The divine mystery of the moment is conveyed by the burst of light that illuminates the dark chamber and bathes the figures in a radiant glow.

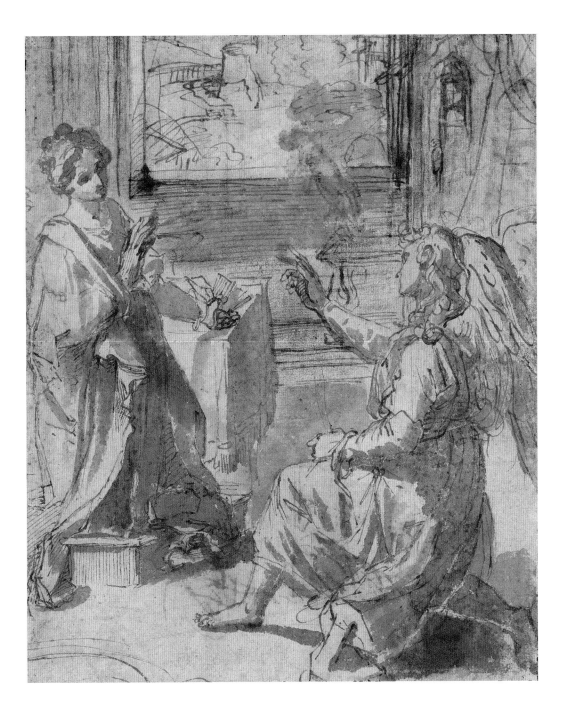

The work is a technical tour de force, remarkable particularly for its extensive tonal range – from the shadowy depths of the chamber to the silvery highlights of the Archangel's gown. Barocci was the first Italian artist to extensively use stop-out varnish and multiple bitings of the plate (see Glossary) to achieve modulated tones and intense blacks. These techniques are put to use most effectively here to describe the flash of supernatural light in the upper centre of the composition. Barocci also extended the etcher's ability to articulate different textures and surfaces by adopting the reproductive engraver's varied vocabulary of lines, from stippling to cross- and parallel-hatching.

In addition to Barocci's etching, the National Gallery of Victoria owns one of the artist's preparatory drawings for the painting of *The Annunciation*. Barocci was a prolific draughtsman who worked out the details of his paintings in numerous drawn studies. In this drawing the major details of the design are seen in their final form; however, the gestures of the Virgin and the Archangel show an earlier stage in the development of the composition.

Federico Barocci
Italian *c.* 1535–1612
The Annunciation c. 1582–84
verso: Fleeing figures
pen and brown ink and brown wash
over black chalk on tinted paper with
ruled brown ink border; laid down
25.8 x 21.2 cm
Felton Bequest, 1972 (P19-1972)

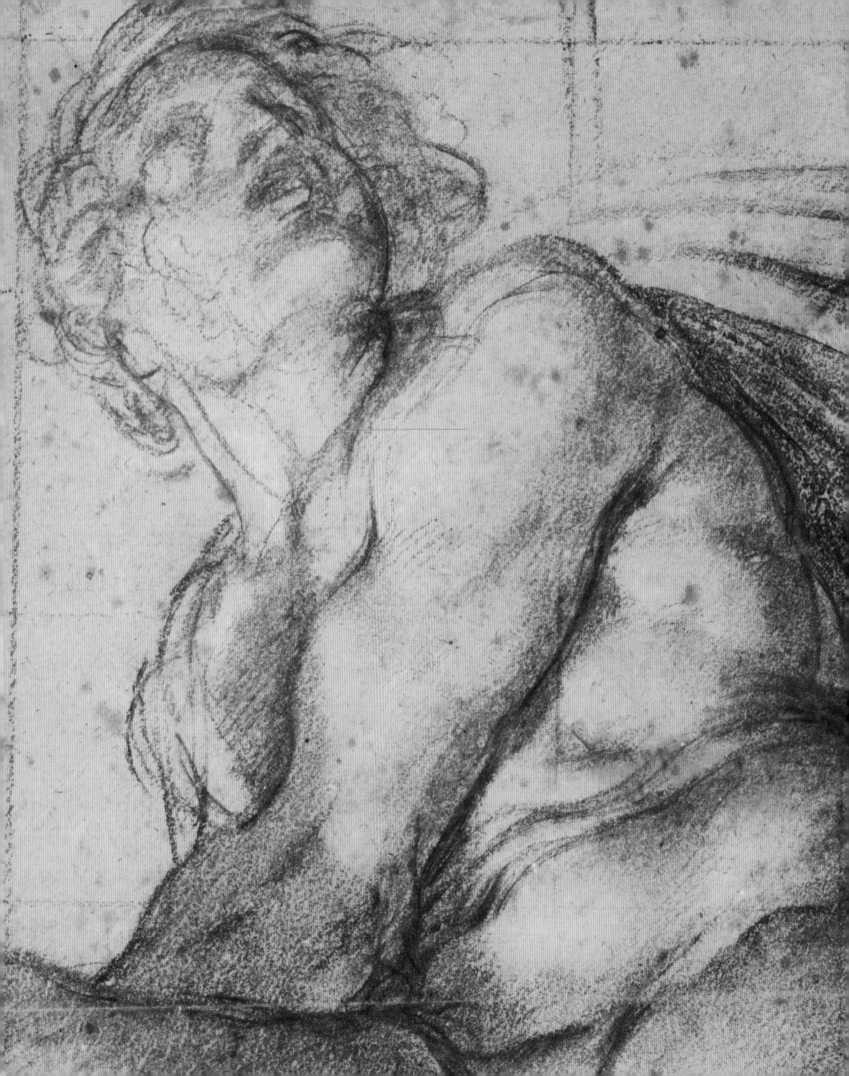

This celebrated drawing by Annibale Carracci is a study for a painted naked youth (known as an *ignudo*) to the left of the fresco *Venus and Anchises*, in the Farnese Gallery in Rome. Begun around 1597 by Annibale and his brother Agostino, the fresco cycle forms part of the decorative scheme for a room designed to exhibit Cardinal Odoardo Farnese's collection of antique sculpture. Annibale's inventive response to the commission became one of the masterpieces of Baroque art. The originality of the scheme lies in Annibale's witty engagement with the antique sculptures displayed in the room, as well as with Michelangelo's decoration of the Sistine Chapel. The monumental *ignudo* takes inspiration from both these sources, the pose of the figure being especially reminiscent of Michelangelo's Prophet Jonah.

In the drawing Annibale explores the upward play of light across the figure as it would be seen by a spectator looking up at the ceiling. The impression of the *ignudo*'s massive bulk is enhanced by this view, the body a surface of rippling muscles. Famous for his insistence on drawing from nature, Annibale most probably sketched a model from life. The physique of the *ignudo*, however, conforms to the idealized proportions of classical sculpture. Seamlessly, the artist fuses his observation from life with this recognized canon of beauty. The figure's monumentality is achieved by the most economical of means. Rapidly applied black chalk describes the contours of the model, while passages of smudged chalk convey an extraordinary sense of three-dimensionality. Varying the pressure on the chalk, Annibale achieves a range of effects, from the heavy line that defines the contour of the figure's back, to feather-light strokes for the sloping right shoulder. The character of the strokes combines with the figure's pose to give the appearance of movement, as though the escapades of Venus and Anchises, over his left shoulder, have caught his eye.

The Farnese Gallery, with its juxtaposition of sculpture and painting, provided Annibale with an ideal opportunity to explore the relative merits of painting and sculpture, which were currently being debated in artistic circles. Ultimately, the artist demonstrated, through his extraordinary skill, the primacy of painting. Annibale's skills as a draughtsman reached such a level of fluency in his preparatory studies for the ceiling decorations of the Farnese Gallery that they are considered the masterpieces of his oeuvre.

Annibale Carracci
Italian 1560–1609
Study for an ignudo 1598–99
black chalk heightened with white, squared up for enlargement in black chalk, on faded blue paper; laid down
37.7 x 32.6 cm
Purchased by the National Gallery of Victoria with the aid of a State Government Grant, 1972
(P10-1972)

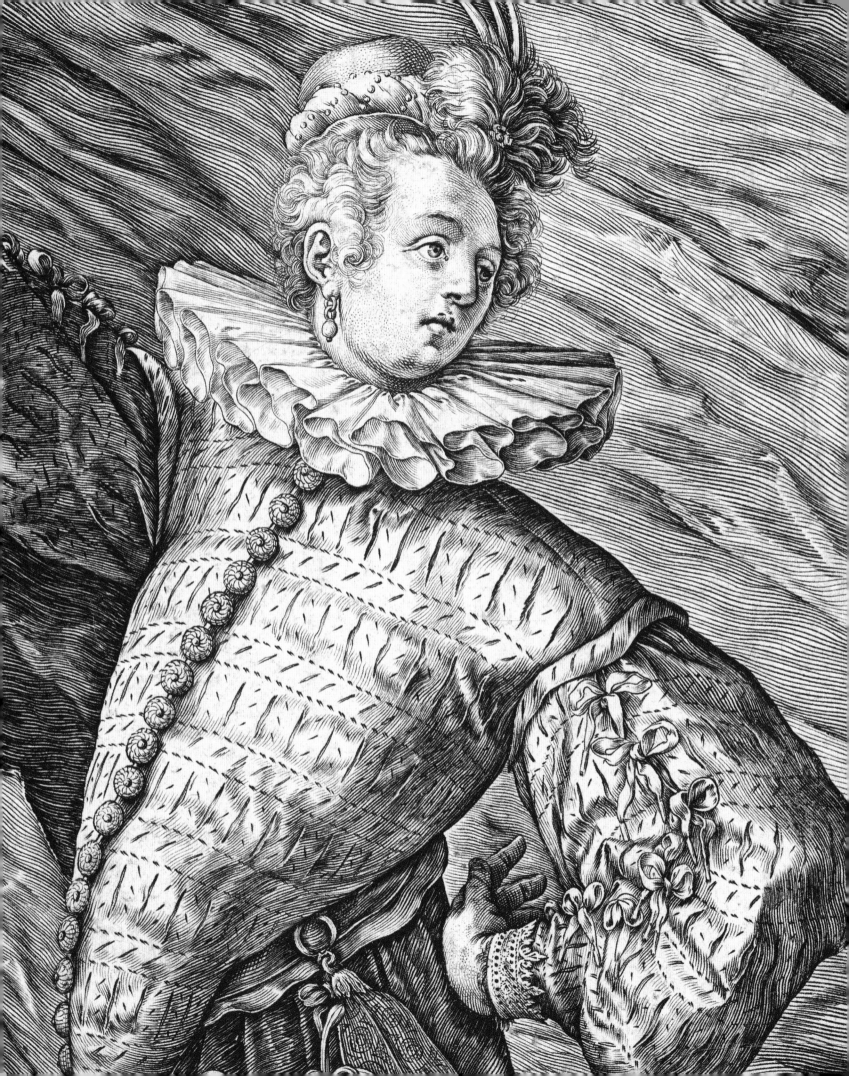

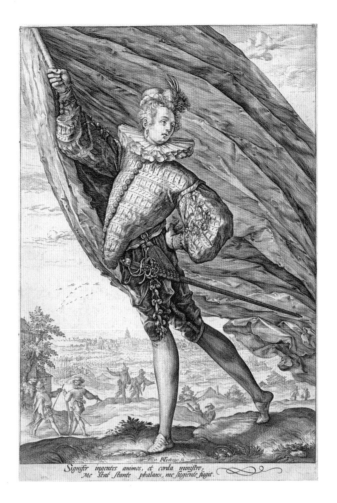

The late sixteenth century was a time of great turmoil as the wealthy provinces of the Netherlands sought to gain independence from Spain, their Catholic ruler. Ongoing military conflicts and occupation resulted in a period of unease as populations migrated, impelled by religious, political or economic circumstances. This remarkable image, known as *The great standard bearer*, is a response to a number of related factors: the military discord, the civic guards that many towns formed for their own protection, and the northern print industry that flourished as artists and craftsmen fled Spanish troops in the southern Netherlands.

Standing proudly before a military encampment, with the city of Haarlem visible on the skyline, the elegantly clad standard bearer holds aloft his enormous banner. The Latin text explains his prestigious and dangerously exposed position:

> As standard bearer, I serve valiant minds and hearts;
> when I hold steady, the phalanx holds; when I flee, so also does the phalanx.

This ostentatious image exemplifies the Mannerist style, of which Hendrick Goltzius was the principal Dutch proponent. The figure's gliding stance and twisted posture, as he turns to encourage the troops, is exaggerated by the pronounced *Gaensebauch* (goose-belly) costume and is echoed in the diagonal folds of the shimmering silk standard, so large that it billows beyond the image's border. In order to capture these qualities of texture, colour and volume, Goltzius developed an innovative technique, cutting lines that swelled or tapered according to the pressure applied to the burin while engraving the copper plate. This variation in the line's thickness permitted an unprecedented expression of three-dimensionality in printmaking, which is evident here in the folds and creases of the silk banner.

Acclaimed as the most brilliant Dutch printmaker of his period, Goltzius headed a prestigious print publishing house in Haarlem, employing many talented engravers, including his stepson Jacob Matham, Jacques de Gheyn II and Jan Saenredam.

Hendrick Goltzius
Dutch 1558–1617
The great standard bearer 1587
engraving
27.4 x 19.2 cm (image);
28.7 x 19.5 cm (sheet)
Bartsch 125
Felton Bequest, 1923
(1278.236-3)

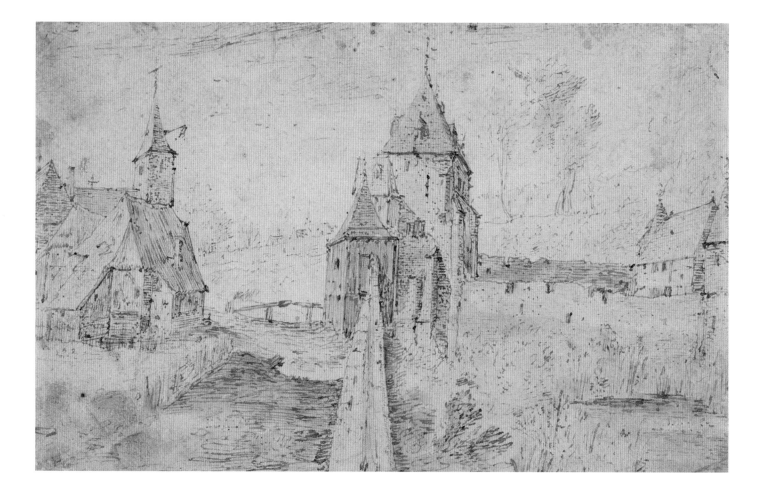

Unknown artist
Flemish active late 16th –
early 17th century
*Landscape with a roadside church
on the outskirts of a city* late 16th–
early 17th century
pen and brown ink with blue and
green washes, with ruled brown ink
border
13.2 x 20.8 cm
W. H. Short Bequest, 1958 (2-5)

The powerful perspectival rendering of the roadside parapet in the centre of this drawing compels the viewer's gaze towards the assorted buildings in the middle ground. Appearing to project vertically from the lower border, this unusual device sharply divides the drawing in two. The buildings and foreground road are depicted with a combination of long parallel lines, zig-zag strokes for the deepest shadows, and scattered stippling, which evokes both tone and texture. Pitched roofs of distant buildings and foliage are intimated with atmospheric sketchiness. The selective application of washes seen here was practised by a number of contemporary artists, although these may be later additions.

The artist of this intriguing drawing has not yet been identified. When acquired in 1958, the work was attributed to Jan Brueghel the elder. This is no longer accepted, and attributions to Roelandt Savery or his brother Jacob have been considered but also queried. Despite his anonymity, the artist responsible for the drawing was working within the Flemish landscape tradition of the time, of which Pieter Bruegel the elder was the master. Greatly inspired by his art, Pieter's son Jan and the Saverys were at times so immersed in his graphic style that their work can be difficult to distinguish.

Landscape representation as a distinct artistic genre only began in the sixteenth century, developing concurrently with a humanist curiosity about the natural world. The same period also saw an increasing appreciation of drawing as an autonomous art form, and an enthusiastic following of connoisseurs soon developed. These included the Holy Roman Emperor, Rudolf II, who was an avid collector of work by Pieter Bruegel the elder and associated Netherlandish landscape artists. Roelandt Savery was one of those who worked for many years at the imperial court in Prague. Although numerous landscape drawings, and the plethora of related prints that were disseminated throughout Europe, depicted vast, complex and often imaginative panoramas, the genre's breadth also spanned unidealized drawings of real places, such as the view recorded in this sheet, captured *naer het leven* ('after life').

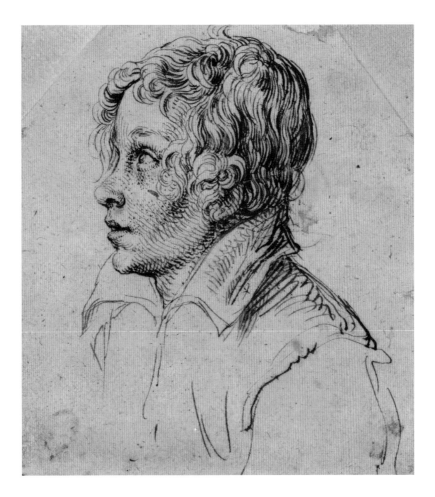

Jacques de Gheyn II was one of the most important and gifted artists working in Holland in the early seventeenth century. His career bridges the stylized forms of Mannerism, exemplified by the work of his teacher Hendrick Goltzius, and the Baroque naturalism of Rembrandt. As a draughtsman, de Gheyn was an outstanding and original talent. About five hundred of his drawings survive and they deal with a wide array of subject matter ranging from his observations of daily life and the natural world to scenes of grotesque fantasy. The artist and historian Karel Van Mander, who knew de Gheyn, wrote that he worked 'a great deal both from life and at the same time from the imagination, so as to learn to understand the rules of art'.

Born in Antwerp into a wealthy family, de Gheyn was taught initially by his father before heading for Haarlem where he was apprenticed in 1585 to Goltzius. The lasting impact of Goltzius's graphic art on de Gheyn is seen especially in his drawings. This is apparent in the regular, yet subtly modulated hatchings, and the dots and flicks of the pen seen in this sheet. Yet there is nothing laboured in the portrayal. While the carefully modelled face is seen in pure profile, the summarily drawn torso is turned towards the viewer, giving the whole a sense of animation. The spirited drawing of the hair, with its liquid curls and waves, and the varying degrees of finish in the sheet, impart a sense of spontaneity to the drawing, a quality new to Dutch art at this time.

It has been suggested that the youth portrayed here might be the artist's son, Jacques de Gheyn III, and that the drawing possibly dates from around 1608 when the boy would have been twelve. Jacques de Gheyn III was also an artist, but ceased painting on his father's death and later entered the church, becoming Canon of St Mary's Church, Utrecht. He collected paintings and owned, among other Rembrandts, the National Gallery of Victoria's *Two old men disputing*, 1628.

Jacques de Gheyn II
Dutch 1565–1629
Portrait of a youth c. 1608
pen and brown ink
12.2 x 11.0 cm
Van Regteren Altena 734
Purchased, 1958 (32-5)

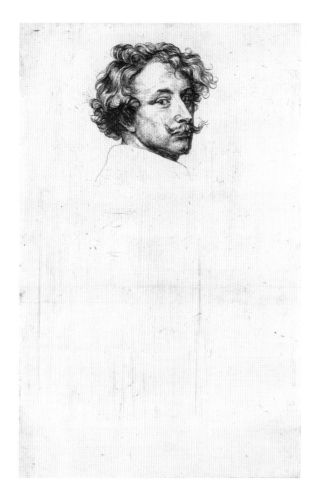

Anthony van Dyck
Flemish 1599–1641;
worked in England
Self-portrait c. 1626–32
etching
24.6 x 15.7 cm (plate);
24.7 x 15.9 cm (sheet)
Mauquoy-Hendrickx 4 i/vii
Everard Studley Miller Bequest,
1959 (142A-5)

The great seventeenth-century Dutch humanist, Constantijn Huygens wrote about Anthony van Dyck's monumental print project of portraits of famous men:

> In men's talents do they live on.
> Van Dyck preserves head and hands, saying, the rest is for death

Van Dyck embarked upon the ambitious project, the first of its kind, in the mid 1620s, and it found a receptive audience after the publisher Martinus van den Enden distributed it by 1632. Now known as the *Iconography*, after a 1759 edition, the eighty prints were the result of van Dyck's collaboration with a number of engravers who worked after his designs, including Lucas Vorsterman and Paulus Pontius. Van Dyck, however, did etch seventeen of the portraits himself, and these are remarkable for their acute observation and their spontaneous line. These portraits, mostly of fellow artists, show his sitters elegantly dressed and as distinguished as the princes, politicians, soldiers, statesman and scholars that were also represented in the series.

One of these seventeen plates was the artist's self-portrait, seen here in a first state impression, before the completion of the image. Van Dyck based his etching on a painted self-portrait from around 1630, and his work on the print is confined to the first state. This state, with its dramatic contrast between the emerging image and the blank sheet, was eagerly sought by print connoisseurs, becoming in time one of the most highly coveted of all prints. Van Dyck's self-portrait was further elaborated with engraving by Jacob Neeffs, and used as a title page for the 1645 edition of the *Iconography* published by Gillis Hendricx. Expanded to a hundred portraits at this date, the series has had a lasting influence on the art of portraiture.

The National Gallery of Victoria owns an important and complete set of the *Iconography* prints that includes rare and early states. It was formerly in the collection of Baron Horace de Landau (1824–1903) and his niece Madame Finlay.

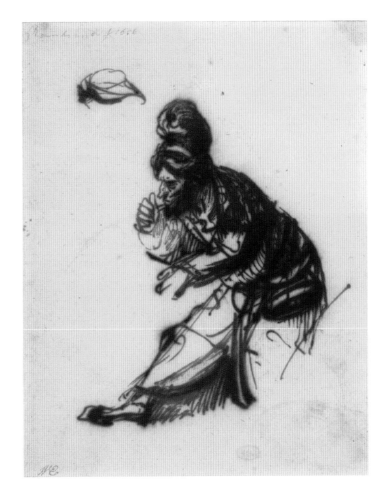

Rembrandt's drawn and etched oeuvre represents the greatest achievement in the development of the graphic arts in the northern Netherlands during the seventeenth century. This is not for any single reason but because of a combination of factors: his creative vision and imaginative drive; his powers of observation and expression; the variety of his subject matter, both mundane and literary; his mastery of technique and style; and, not least, his influence as a teacher. Rembrandt had a formidable knowledge of the history of the graphic arts, and he voraciously assembled a large and outstanding collection of drawings and prints. This collection is recorded in precise detail in the inventory of his possessions made at the time of his bankruptcy in 1656. The inventory also listed the collection of his own drawings, which were gathered together in no fewer than twenty-five albums.

While very few of Rembrandt's drawings are signed, and while the number of sheets attributed to him has waxed and waned through time, the two drawings in the collection of the National Gallery of Victoria have never been doubted. Both were made probably in the 1630s after Rembrandt had completed his apprenticeship and shifted permanently from his home-town, Leiden, to Amsterdam, where he soon established himself as the city's leading artist.

The study of a richly dressed, turbaned elder is dated for reasons of style, medium and technique to around 1638. It belongs to a select group of canonical drawings within Rembrandt's oeuvre, which are either inscribed by the artist or can be linked securely to works done in other media. The subject comes from the Apocryphal story of Susanna (Daniel 13), a faithful wife who, while bathing in the garden, was spied on by two elderly judges and who was falsely accused of adultery because she did not grant them sexual favours. The theme was popular with Baroque artists because it offered them the opportunity to depict the female nude within a dramatic narrative.

Rembrandt Harmensz. van Rijn
Dutch 1606–1669
Old man in a turban (Study for an Elder) c. 1638
pen and iron-gall ink on paper tinted with a pale yellow wash
17.3 x 13.5 cm
Benesch 1973, I.157
Felton Bequest, 1936 (357-4)

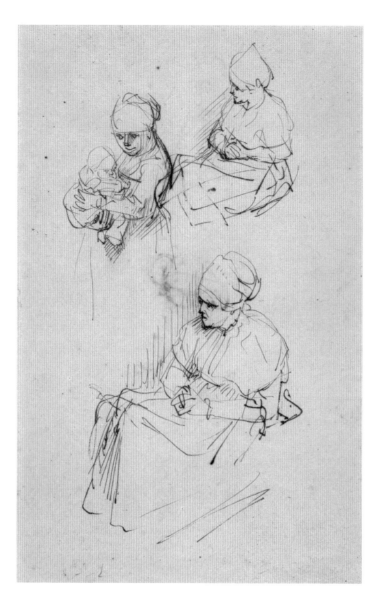

Rembrandt Harmensz. van Rijn
Dutch 1606–1669
Sheet of studies c. 1635
recto: Two seated women, another
standing with a child in her arms
verso: Young man in a turban and a
woman asleep (right)
pen and iron-gall ink
20.9 x 13.7 cm
Benesch 1973, II.194
Felton Bequest, 1936 (356-4)

Rembrandt made two paintings of the story, the first dated 1636 (Mauritshuis, The Hague), the second begun shortly afterwards, but not completed until 1647 (Gemäldegalerie Staatliche Preussischer Kulturbesitz, Berlin). The elder's profile head in the Gallery's drawing reflects his position in the earlier painting, but the pose is more closely related to the later version in Berlin. A surviving drawing after the Berlin painting by one of Rembrandt's pupils, as well as recent X-rays, show that the painting developed in three stages, the first of which showed the elder groping Susanna's breast from behind. The Gallery's drawing portrays the elder as he was depicted in the intermediate version, his left hand retracted to grasp Susanna's cloak instead of her body, his clenched right hand raised above the level of his nose. By isolating the lewd gesture with its protruding thumb, Rembrandt has given the man's malevolent expression and pose a dramatic emphasis, one not so apparent in the painting. Rubens, in his painting of the subject of c. 1609–10 (Real Academia de Belles Artes de San Fernando, Madrid) had portrayed the elders' sexual rapaciousness by showing them scrambling over a balcony to reach their defenceless prey. The pose of Rembrandt's elder is more ambiguous, suggesting solicitation as well as threat, as the figure simultaneously advances and appears to retreat. The dark, corrosive quality of the iron-gall ink that Rembrandt used in this drawing contributes to its dramatic impact, but it also endangers the physical survival of the sheet.

The *Sheet of studies* is a double-sided drawing, probably dating from the mid 1630s, and may originally have come from a sketchbook. The recto of the sheet is filled with three sketches of women done from life, a category of drawings by Rembrandt that was described in the seventeenth century as portraying 'the lives of

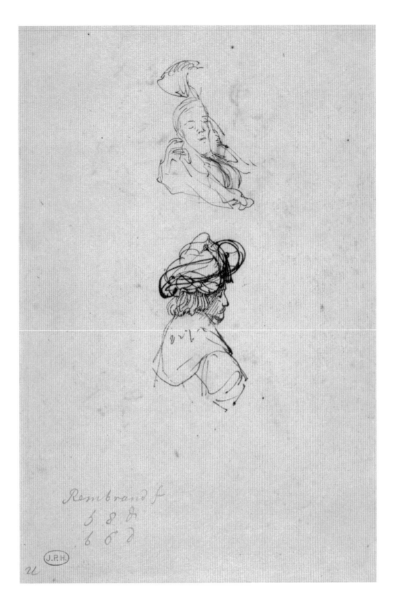

women and children'. The women's identities are unknown, although it is conceivable that the woman holding the baby might be linked to the birth of one of the van Rijns' children. The sleeping woman on the verso bears a certain resemblance to some of the depictions of Rembrandt's wife Saskia. The concise, stenographic strokes of the pen that outline the subjects reveal the artist's observant eye and his uncanny ability of recording detail and form so as to capture the lived moment. Everything is portrayed with the greatest economy of means. The source of light is masterfully suggested, not only by the hatched strokes outside, or within the subjects' contours, but also by the more strongly inflected, darker lines that suggest shadow. From this we can see that the two sketches on the right are related not only by virtue of their similar pose, but also by their shared source of light coming from the right. The woman holding the child, on the other hand, is depicted with light coming from the left, implying that its execution belongs to another moment in time. The quick, seemingly insignificant diagonal strokes in the lower right are, in fact, an essential counterweight in the composition, completing the balanced disposition of the sheet's disparate elements. Thus the appearance of informality is achieved by the artistry of the practised draughtsman.

The National Gallery of Victoria has the largest and most significant Rembrandt collection in Australia. In addition to these two fine drawings, there are two paintings and a group of over 130 etchings by the artist in the collection.

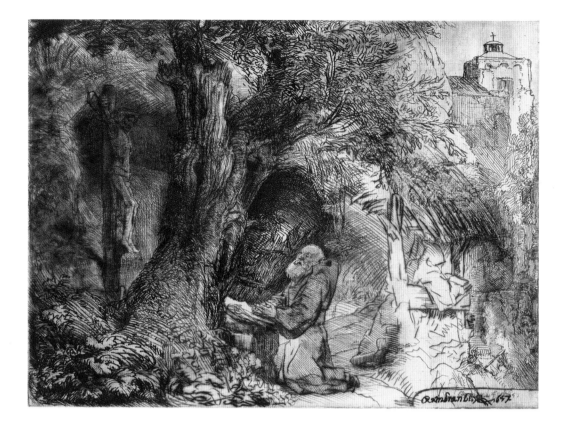

Rembrandt Harmensz. van Rijn
Dutch 1606–1669
St Francis beneath a tree, praying
1657
drypoint and etching
17.9 x 24.4 cm
Bartsch 107; Hind 292 ii/ii
From the collection of James
O. Fairfax AO, Honorary Life
Benefactor – Presented through the
NGV Foundation by Bridgestar Pty
Ltd, 2003 (2003.442)

While the life of St Francis of Assisi was a popular subject in Renaissance and Baroque art, this is Rembrandt's only portrayal of the saint. The theme is strongly associated with Roman Catholicism, so much so that it is thought that Rembrandt might have been commissioned to do it. The print was etched a year after Rembrandt had been declared bankrupt in 1656, and it is his last depiction of a saint in a landscape.

The story is told how on one occasion in 1224, when St Francis had retreated with his companions to fast and pray, he had a vision of a crucifix and subsequently found he had received the stigmata, the imprint of the wounds of the crucified Christ. While the incident of the stigmata was frequently portrayed in the art of Catholic Europe, Rembrandt avoided depicting the miraculous aspect of the story. Instead, he focused on an earlier moment showing the saint on his knees before the crucifix, with his eyes closed, in deepest prayer. In choosing to interpret the story in terms of human experience, rather than divine revelation, Rembrandt thus gave it a distinctly Protestant emphasis. The landscape setting is imaginary, combining aspects of the artist's late series of directly observed drypoint renderings of trees with the influence of Venetian landscape drawing, seen in the Italianate church in the upper right segment. It is a landscape of feeling and mood rather than observation.

The etching exists in two states, this being the final one. It is unusual in Rembrandt's oeuvre in the way that he approached it technically. His usual method was to work on the background before proceeding to the foreground, but here he reversed the procedure, focusing immediately on his main subject – St Francis praying to the crucifix, with the ancient tree and its flowering branch between them. The first state, moreover, is executed entirely in drypoint with its resulting angular contours and its characteristic deep, velvety shadows. Only later, in the second state, did Rembrandt take up the etching needle in order to add the Italianate landscape and architecture in the background and to make other adjustments to the image.

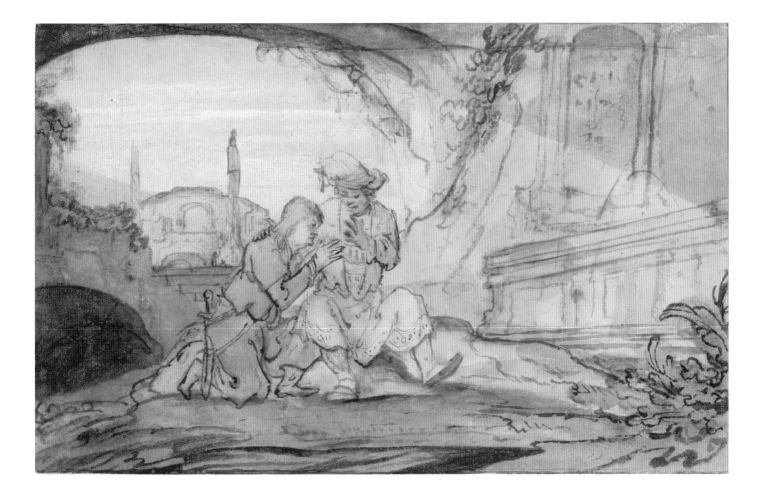

A cavernous space, with a wide arched opening overgrown with vegetation, is the setting for an encounter of two men: one, whose rich dress and elaborate turban mark him as being of high rank, and another, younger one, who wears a prominent sword, kneeling beside him. Light streams through the opening, revealing a sarcophagus at the right. In the distance is a grand, flat-domed building with minarets. The pose of the figures and their emphatic gestures suggest a comforting intimacy, or tender reconciliation. The subject is probably 'David taking leave of Jonathan' (I Samuel 20), though it has also been interpreted as 'The reconciliation of David and Absalom' (II Samuel 14). Spirited in its penwork and in the fluent, broad use of the brush, the drawing is also fully resolved pictorially, a quality emphasized by the framing lines surrounding the composition.

The architectural setting and the portrayal of the figures derive ultimately from Rembrandt's biblical compositions. Stylistic considerations, together with the pose of the figures, their dramatic relationship and aspects of their costume, suggest that the drawing was made by Arent de Gelder, Rembrandt's last pupil.

De Gelder was born in Dordrecht into a wealthy family. Around 1660 he entered the studio of Samuel van Hoogstraten, a painter and writer, who had studied with Rembrandt in the 1640s and whose teaching placed great emphasis on drawing. This included the regular practice of drawing biblical compositions, sometimes accompanied by dramatic exercises on a stage. In 1661 or 1662 de Gelder went to Amsterdam, where he studied with Rembrandt for about two years. His painting style is rooted in Rembrandt's late manner, and it remained so, since de Gelder's financial independence meant he had no need to sell his work and therefore no need to adjust his style to prevailing fashion.

**Arent de Gelder
(attributed to)**
Dutch 1645–1727
David taking leave of Jonathan, or
*The reconciliation of David and
Absalom c.* 1700
pen and brush and brown ink with
coloured washes over traces of
black chalk, touched with white
bodycolour
19.2 x 30.5 cm
Sumowski 5.1084xx
Felton Bequest, 1936 (354-4)

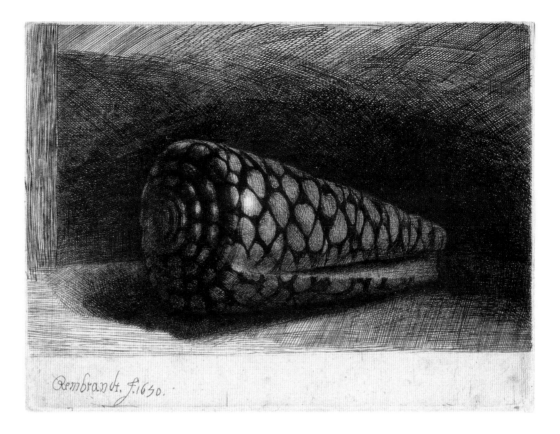

Rembrandt Harmensz. van Rijn
Dutch 1606–1669
The shell (*Conus marmoreus*) 1650
etching, drypoint and burin
9.6 x 13.3 cm (plate and sheet)
Bartsch 159; Hind 248 ii/iii
Felton Bequest, 1973 (P.5-1973)

The shell is Rembrandt's only still-life etching and one of the very few still lifes in his entire oeuvre. Made in the early 1650s, it shares with many of his other etchings of this period an interest in rendering the subject tonally. It depicts, in reverse, but probably according to the natural size of the specimen, the species *Conus marmoreus* L., a shell of Indian-Pacific origin – and therefore a great rarity at the time – which may well have been part of Rembrandt's collection. Like earlier collections, those of the seventeenth century contained not only works of art, but also natural objects, and Rembrandt's was no exception. The detailed inventory compiled in 1656 lists 'a great quantity of shells, coral branches … and many other curios' that were kept in his Art Chamber.

During the early seventeenth century, shells, like tulips, became such popular collectors' items in the Dutch Republic that they were sometimes singled out for ridicule as symbols of reckless expenditure. Yet there is nothing in this depiction to suggest that this was Rembrandt's intention. Instead, the entire focus is on rendering the subject in terms of the most subtle gradations of light and shadow.

What prompted Rembrandt to portray this exceptional subject, and why he did not take the trouble to etch the motif in reverse so that it printed in the right direction, are questions that cannot be answered conclusively. A first state, with minimal shadow, already suggests that he did not consider the motif as a scientific specimen to be set against a neutral, blank background, but an object of individual experience. In contrast to Wenceslaus Hollar, who had earlier etched similar subjects, Rembrandt's pictorial interest extended beyond the shape and the subtle chiaroscuro of the shell itself, to the surrounding space. Perhaps, as has recently been suggested, Hollar's shell might have provided Rembrandt not just with a model but with an artistic challenge to be equalled, if not surpassed.

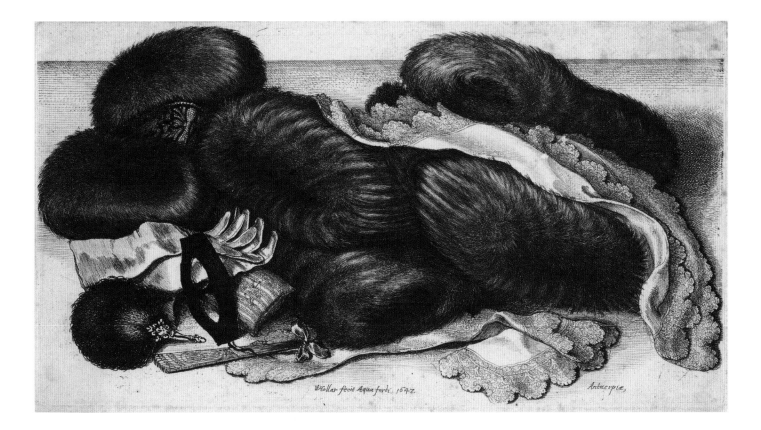

An accomplished recorder of contemporary life and scenery, Wenceslaus Hollar produced a number of printed series depicting regional and seasonal costumes, in which he explored the many fabrics and variations of clothing. This luxurious still life of fashionable women's apparel is from a series of eight prints produced by Hollar between 1640 and 1647. Including some of his best-loved works, the series depicts variously arranged compositions of sumptuous fur muffs, which women of means carried to protect their hands from the winter cold. These are among the earliest of all still-life prints, and demonstrate Hollar's superlative technical ability in representing the tempting softness of the fur.

This series comprises carefully composed textural studies, which focus usually on a single muff, occasionally contrasted with a lace-edged kerchief and a loo mask, worn to shelter delicate complexions. The most elaborate print of the series, *Muffs and other articles of dress and toilette* displays five muffs of varying furs accompanied by the elegant and expensive accessories of the day. These luxury items protected the wearer not only from the climate but also from the city's odours, as scent and potpourri were often stored in muffs and glove-tips. They were also seductive items employed for flirting with admirers, their sensuality complemented here by the glimpse of a pin cushion, holding precious pins required for dressing.

Born in Prague, Hollar grew up in the cultivated artistic milieu at the court of the Holy Roman Emperor, Rudolf II. An exceptional and prolific draughtsman and etcher, Hollar worked and travelled in Germany and the Netherlands before joining the entourage of Thomas Howard, Earl of Arundel. Through this renowned English art collector and patron, Hollar was exposed not only to Arundel's outstanding Renaissance art collection but also to the artists and literati who formed his retinue. Hollar travelled through Europe with Arundel and became one of the most significant early printmakers in England, working in London from 1636 until his death, leaving only for the period of the English Civil War and for a brief commission to the north African colony of Tangier.

Wenceslaus Hollar
Bohemian 1607–1677;
worked in England
*Muffs and other articles of dress
and toilette* 1647
etching
11. 0 x 20.3 cm (plate);
11.4 x 20.6 cm (sheet)
Parthey 1951
Felton Bequest, 1921 (1171-3)

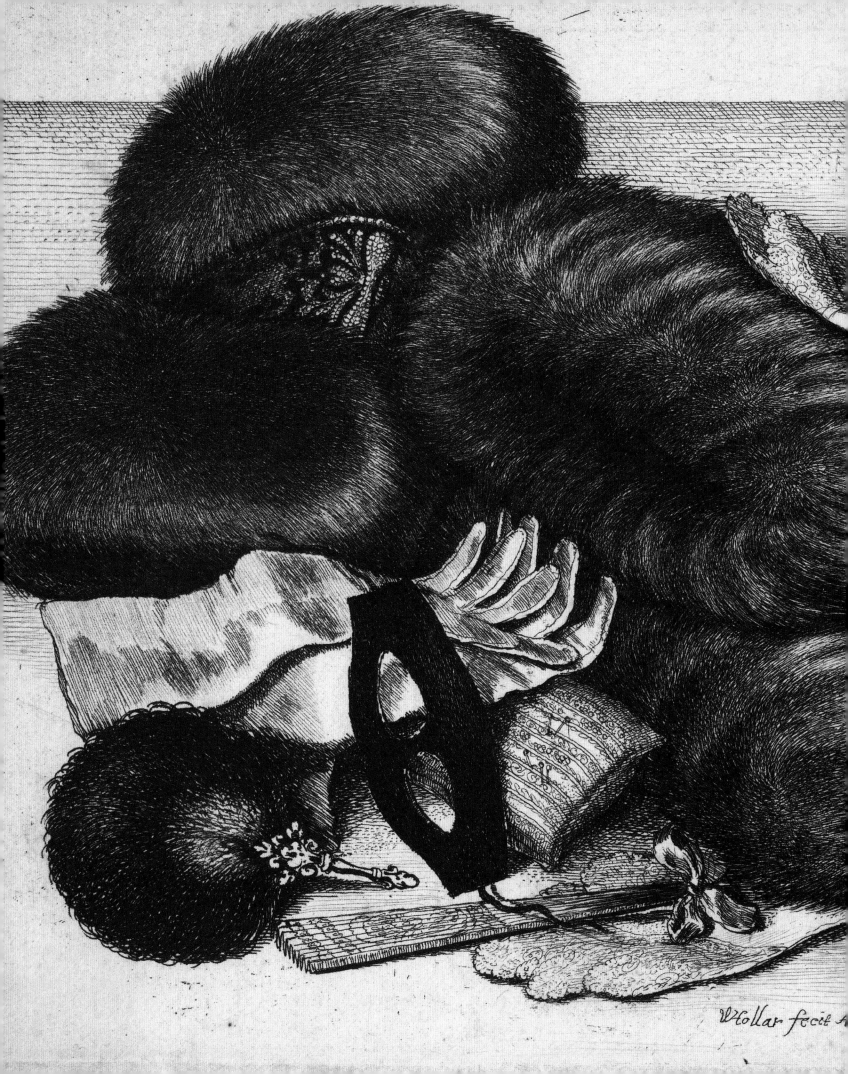

WHollar fecit A

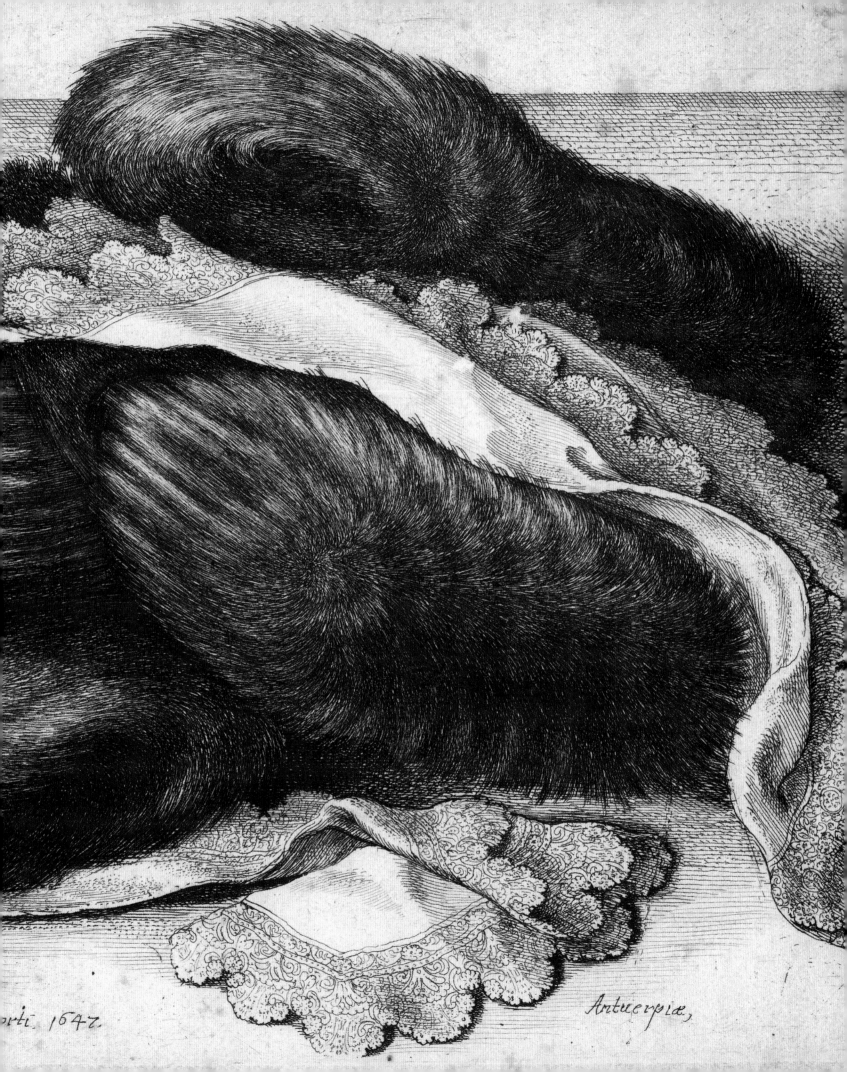

rti. 1642. *Antuerpiæ,*

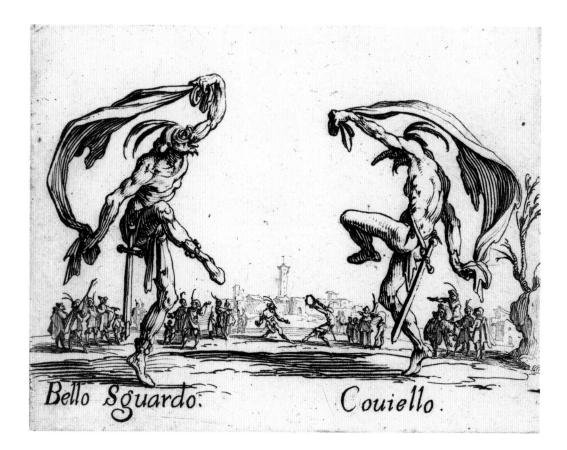

Bello Sguardo. Couiello.

Jacques Callot
French 1592–1635; worked in Italy
Bello Sguardo and Couiello c. 1621
from the series *Balli di Sfessania*
(Dances of Sfessania) *c.* 1621
etching
7.2 x 9.2 cm (plate);
9.5 x 12.0 cm (sheet)
Lieure 396 i/ii
Felton Bequest, 1958 (3804.18-4)

At the age of twenty-two, Jacques Callot was appointed court artist to Cosimo II de' Medici in Florence, a position familiar to him through his father's ceremonial involvement in the court of the Duke of Lorraine in Nancy, where he had been born. One of Callot's duties was to record the many extravagant festivities and self-glorifying spectacles staged by his noble patron. Upon Cosimo's death in 1621, Callot returned to Nancy. There he embarked upon a series of prints called *Balli di Sfessania*, which demonstrates his delight in the informal, often spontaneous, and frequently bawdy entertainment enjoyed by the masses that he had observed in Italy.

This series, comprising twenty-four plates, is traditionally thought to represent the Commedia dell'arte, popular improvisational theatre performed by travelling troupes with a stock cast of comic characters, antecedants of Pierrot, Harlequin, and Punch and Judy. It has been suggested, however, that, as the engraved title indicates, the series depicts a Neapolitan dance called the *sfessania*, which was known for its aggressive gesticulation and posturing. Certainly many of the figures are dancing wildly, as in *Bello Sguardo and Couiello*, although others seem to interact as though performing a play.

Each of the prints comprises two foreground characters situated before a fairground, framed by distant buildings. The strong sense of spatial recession is achieved not only through contrasts of scale but also through clear differentiation of tones that lighten as they proceed from foreground to background. Callot achieved this effect by repeatedly immersing the etching plate in the acid bath; he was one of the earliest artists to exploit the expressive possibilities of this practice. Similarly, he experimented with an *échoppe*, an oval-tipped tool that enabled him to create etched lines that tapered and swelled like the lines produced with an engraver's burin. Thus he was able to convincingly suggest volume, while also benefiting from etching's greater freedom. Callot's technical mastery, compositional ability and engaging originality has earnt him the reputation as one of the most inventive printmakers of the seventeenth century. These qualities are clearly apparent here in the liveliness of his costumed characters and the arabesque of their mirrored steps.

Salvator Rosa's contemporaries in seventeenth-century Italy criticized him for not being able to draw the human figure convincingly. And yet, when one looks at this sheet of studies, the artist's rapid notations convincingly convey the flutter of an angel's wings, the velocity of a falling body, and the weight of a seated figure. Rosa's pen and ink drawings have always been popular with collectors because they illustrate the process of *invenzione* – the creative act of capturing ideas on paper.

This sheet bears three sketches, one of which has been identified as a preparatory study for a painting. This is the image of the falling man on the right, which relates to Rosa's painting from the 1660s, *The death of Empedocles* (now in an English private collection). This obscure subject was described by Diogenes Laertius, a historian of the third century AD, who recounted the story of the Sicilian philosopher Empedocles who threw himself into the fire of the volcano Etna in order to prove that he was God. His mortal nature was discovered when one of his slippers was found on the mountain's rim.

The two naked figures on the lower edge of the sheet are based on Hans Baldung Grien's woodcut *The witches*, 1510, while the subject of the angel and armoured man has not as yet been identified. Despite the disparity of subjects and the swift drawing style, it is clear Rosa gave thought to the sheet as a whole. This is evident in his placement of the sketches on the page: the angel poised high on a cliff, pointing to something below; Empedocles mid-page, and mid-fall; and the fleshy nudes, sitting and standing on a surface that is the bottom edge of the sheet.

Salvator Rosa
Italian 1615–1673
Sheet of studies with a sketch for 'The death of Empedocles' mid to late 1660s
pen and brown ink
27.0 x 17.8 cm
Mahoney 80.11
Felton Bequest, 1923
(1278.733-3)

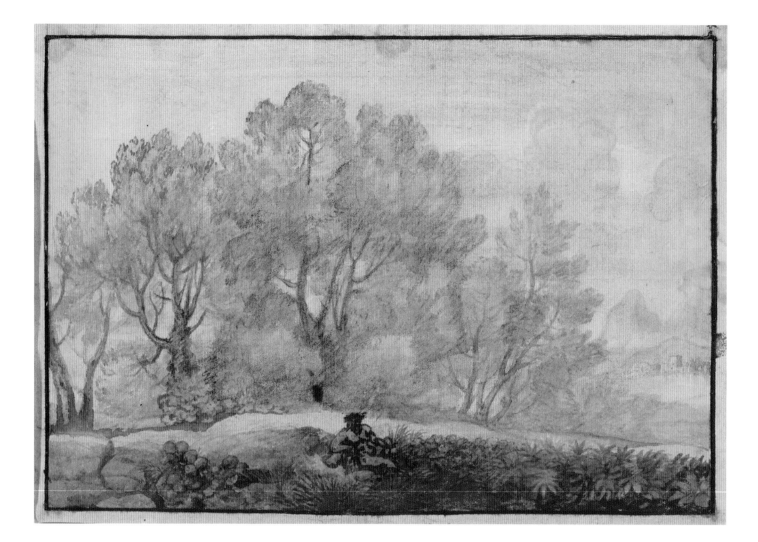

**Claude Gellée,
called Claude Lorraine**

French *c.* 1604/5–1682;
worked in Italy
A wooded landscape c. 1650–55
pen and brown ink, over traces of
black chalk heightened with white
wash on pink tinted paper
19.4 x 28.0 cm
Roethlisberger 877
Felton Bequest,1981 (P46-1981)

Claude Gellée moved to Rome from his native Lorraine around 1617, and by the mid 1630s had become the leading landscape painter there. One of the principal features of his ideal landscapes is the luminous treatment of atmosphere and light, a quality clearly present in this sheet. Probably made in the studio around 1650–55, the drawing is a work of considerable evocative power in which Claude's great feeling for the poetry of nature is combined with his observational skills. These he exercised through his constant sketching in the Roman countryside where he is also known to have made careful colour notes.

The pink colour of the prepared paper used for this drawing is suggestive of the soft light of dusk. It unifies the composition and makes the atmosphere – in a moment of great stillness – the subject of the work. In contrast to this expansive sense of air and light, the foreground is a dark, moist place inhabited by a river god. Claude articulates each blade of grass with great emphasis, and throws this highly worked, almost decorative, passage into sharp relief by a thin band of unmarked paper, which glows pink. Claude's fundamental influence on the art of landscape painting continued until the mid nineteenth century. His poetic vision found its most faithful followers among the British, and in particular in the work of J. M. W. Turner.

A wooded landscape is one of a small group of drawings the artist made on pink paper. It was part of the Wildestein Album (named after one of its owners) that consisted of sixty exemplary drawings spanning Claude's entire career. The discovery of the album in 1960 was significant not only because it shed light on Claude's diversity as a draughtsman but also for the pristine condition of the drawings, which had received little exposure to light. The album was disbound in 1970, and the present drawing was acquired through the Felton Bequest in 1981.

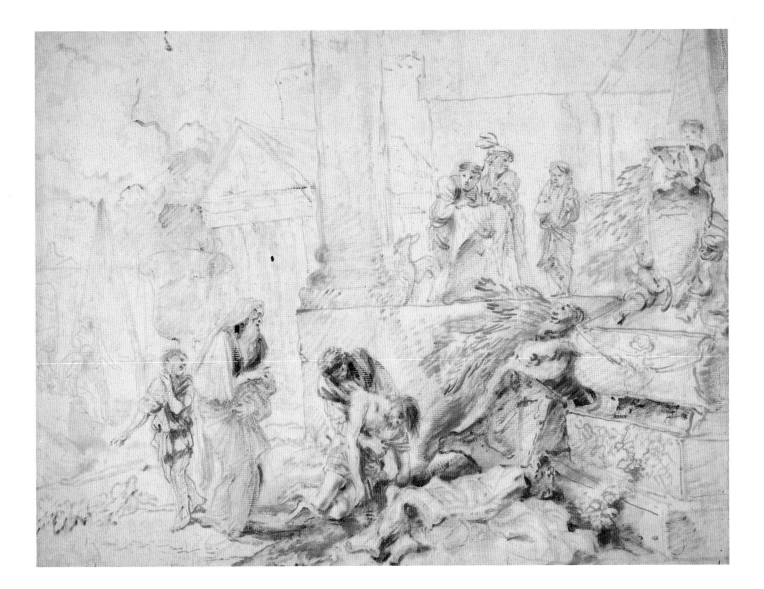

The originality and deftness of Giovanni Benedetto Castiglione's drawing style is evident in this sheet depicting a scene from the Apocryphal Book of Tobit (I:19-22). Dating from the last decade of the artist's life, the drawing shows an episode from the story of Tobit during the Jewish exile in Assyria. The bearded Tobit is shown in the left foreground directing the clandestine burial of Jews who had been killed by King Sennacherib's soldiers. In the background, two youths observe the proceedings and report to a third man, the Ninevite, who, according to the Bible, informed the King of the illegal burials taking place.

The unusual technique of the drawing, in which a paintbrush was dipped in oil and then dry pigment, was Castiglione's own invention. It suited his spontaneous drawing method that dispensed with under-drawing, allowing him to combine areas of thick, dry pigment, with passages of fluid lines. Deep pink and earthy red tones are contrasted with touches of pale blue used for Tobit and the corpse's robes. The beige colour of the unprepared sheet of paper enhances the effect of the drawing's unfinished appearance. Yet the large size of the sheet suggests the drawing was intended as an independent work of art. Castiglione drew the subject a number of times throughout his career, from the 1640s to the end of his life when he lived in Mantua, working in the service of Duke Carlo II.

Born in Genoa, Castiglione travelled widely throughout his career and spent extended periods in Rome, Bologna and Venice. He was influenced by, among others, Anthony van Dyck and Peter Paul Rubens, both of whom may have worked for a period in Genoa, and Nicolas Poussin, whose circle he came into contact with in Rome after 1632. The etchings that Castiglione made in the 1640s extended the audience for his art, and his experimentation with the printmaking medium led to his invention of the monotype technique.

Giovanni Benedetto Castiglione
Italian c. 1609–1664
Tobit burying the dead c. 1655–60
brush drawing in red and pale-blue
paint with touches of dark red and
dark brown paint on beige paper
with ruled black ink border edged
with gold; laid down
40.5 x 54.2 cm
Purchased, 1970 (P85-1970)

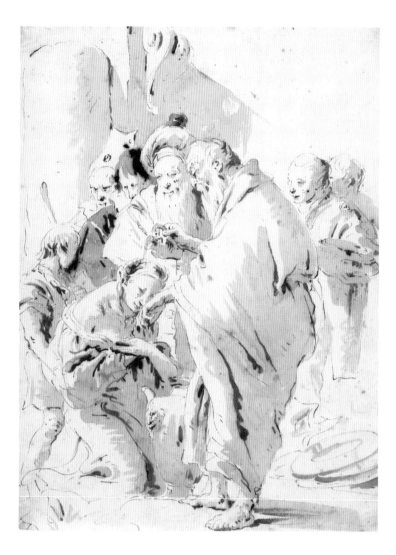

Giambattista Tiepolo
Italian 1696–1770
St Prosdocimus baptizing
St Giustina c. 1735–40
pen and bistre ink and wash
33.5 x 25.0 cm
Felton Bequest 1961 (1019-5)

Giambattista Tiepolo's drawings have been described as being so suffused with strong light that his figures squint from its intensity. Such a description seems fitting for this sheet, which depicts an unusual subject in Christian art – the baptism of a woman, most likely St Giustina. The saint had special significance in northern Italy, especially in the Veneto region where Tiepolo worked for most of his career. According to local tradition, St Peter sent St Prosdocimus to Padua in the first century to convert the ruler Vitaliano and his family to Christianity.

A drawing of the martyrdom of St Giustina in the Horne collection (Uffizi, Florence) is possibly a companion to the National Gallery of Victoria's drawing, and both belong to a group of finished drawings that the artist made in 1735–40. These two large and highly worked sheets are not connected with Tiepolo's painting projects, and it would seem that they were made as independent works of art.

The virtuosity of Tiepolo's skill is evident in the calligraphic intricacy of the figures' falling robes, which, although elaborate, never appear laboured. This quality of lightness, both of touch and in the atmospheric effects he evoked, was central to Tiepolo's approach to drawing.

Born in Venice in 1696, Tiepolo became one of the leading painters of religious and mythological subjects in eighteenth-century Italy, and the main exponent of the Rococo style in all the different media in which he worked – fresco, oil painting, etching, and drawing. The practice of drawing was central to his working method and he left a vast body of drawings, many of them preparatory sheets. Tiepolo's work for aristocratic patrons, such as the Prince Archbishop of Würzburg and Charles III of Spain, saw him travel from his native Venice to, among other places, Madrid, where he lived from 1762 until his death in 1770.

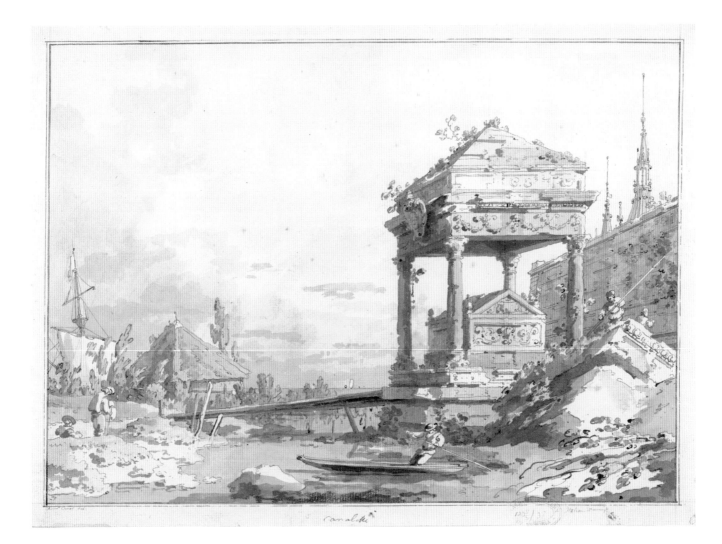

Canaletto dedicated his life to capturing the architectural splendor of eighteenth-century Venice at a time when it was a popular destination on the Grand Tour. His oil paintings and prints were eagerly acquired by visitors to the city, especially wealthy Englishmen who wished to have a memento of their Continental travels. When the tourist market for these Venetian views (*vedute*) shrank due to political conflicts in Europe in the 1740s, Canaletto moved to England where he worked on numerous commissions from 1746–55. Before his departure, he shifted his practice to drawing and etching, depicting real landscapes as well as imaginary views called *capriccios*. The genre had a particular attraction for Venetian artists, and Canaletto excelled at creating images that blurred the distinction between invention and topographical accuracy. In 1740–41 Canaletto travelled to Padua with his nephew Bernardo Bellotto, and it is possible that this drawing of an imaginary tomb by a lagoon was inspired by the drawings he made during this trip. The three spires visible on the right of the composition have been described as reminiscent of the basilica of St Antonio in Padua.

Canaletto's *capriccio* poetically contrasts a vast dilapidated Roman tomb with fishermen going about their daily routine. The melancholy atmosphere of the scene is heightened by this contrast of the living and the dead; small figures scrambling atop sunken ruins hint at the eventual disappearance of the great Roman civilization and the impermanence of their own short lives. The highly finished composition is rendered in a fluid outline of pen and sepia ink (now faded to a light orange) with three tones of grey wash. The delicacy of the drawing gives a deceptive appearance of spontaneity. Close inspection, however, reveals faintly ruled lines, indicating that Canaletto carefully worked out the primary architectural elements of the composition before he commenced drawing.

This drawing is almost identical in subject and composition to a group of moonlit scenes that Canaletto is thought to have painted at the time, two of which are in the collection of the Uffizi, Florence.

Giovanni Antonio Canal, called Canaletto
Italian 1697–1768
Capriccio: A tomb by a lagoon
1740s
pen and brown ink and grey wash over pencil, with ruled brown ink border
31.5 x 43.3 cm
Constable 1989, II.621
Felton Bequest, 1923
(1278.695-3)

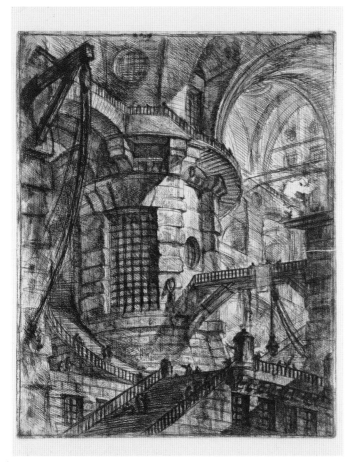

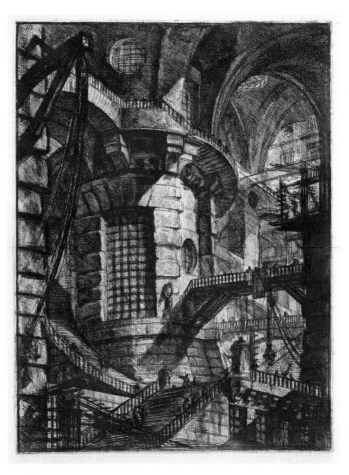

Giovanni Battista Piranesi
Italian 1720–1778

The round tower 1749–50
plate 3 from the series *Carceri*
(Prisons), first edition, 1st or 2nd
issue, 1749 – *c.* 1758
etching, engraving, sulphur tint or
open bite and burnishing
54.6 x 41.4 cm (plate);
73.8 x 53.0 cm (sheet)
Hind 1922, 3 i/iii; Focillon 26;
Robison 1986, 30 i/vi
Felton Bequest, 1921 (1137-3)

The round tower 1749–61
plate 3 from the series *Carceri*
(Prisons), second edition, 3rd issue,
mid 1760s – early 1770s
etching, engraving, sulphur tint or
open bite and burnishing
54.8 x 41.5 cm (plate);
80.9 x 56.0 cm (sheet)
Hind 1922, 3 ii/iii; Focillon 26;
Robison 1986, 30 iv/vi
Felton Bequest, 1921 (1152-3)

Upon moving to Rome in 1740, the young Venetian architect and printmaker Giovanni Battista Piranesi explored his passion for architecture in a series of etchings that would span his long career – the *Vedute di Roma* (Views of Rome), depicting the greatest buildings of both ancient and Baroque Rome. These highly finished compositions were etched with control and precision. Their disciplined line hardly anticipated the breathtaking originality of a group of fourteen etchings that he published simultaneously, in 1749–50, the *Invenzioni capric di carceri*. As the title suggests, the prints represent views of imaginary prisons, shown as vast yet claustrophobic environments that are populated by tiny figures.

Piranesi's large copperplate etchings have a freedom of line that is remarkable in the history of printmaking. The artist's innovative approach to the medium is matched by his formal investigations into the representation of pictorial space. Abandoning the accepted model of Renaissance perspective, Piranesi created compositions that revel in ambiguity rather than clarity. In the third plate of the series, *The round tower*, he uses a great number of crisscrossing staircases to create a labyrinthine environment. Archways, which seemingly stretch on to infinity, are obscured by puffs of smoke at junctions crucial to the viewer's understanding of their structure.

The increasing archeological focus of Piranesi's print publications of the 1750s influenced his reworking of the *Invenzioni capric di carceri* plates in the following decade. His exploration in 1756 of the engineering feats of the ancient Romans in *Le Antichità Romane* (Roman Antiquities) and his interest in the materials used in their construction are evident in the second edition of the series, which he republished with a new title, *Carceri d'invenzione* (Imaginary Prisons), in 1761. Substantially reworking the images, he transformed the loose, lightly etched prints into darker images full of shadows. Emphasizing the monumentality of the architecture, he also added chains, torture instruments and prisoners. These turned the elusive sense of terror in the first edition into something more explicit in the second edition. The National Gallery of Victoria has two complete sets of the first and second edition of the *Carceri*, both of which were published in the artist's lifetime.

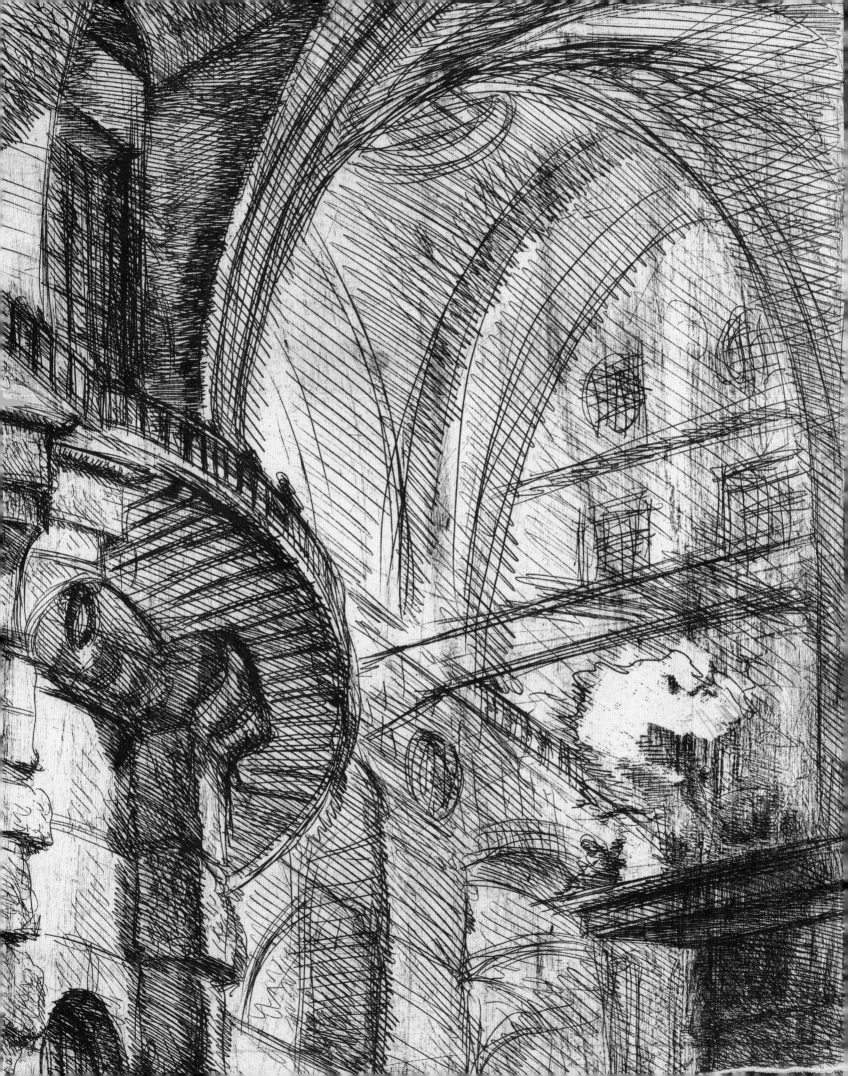

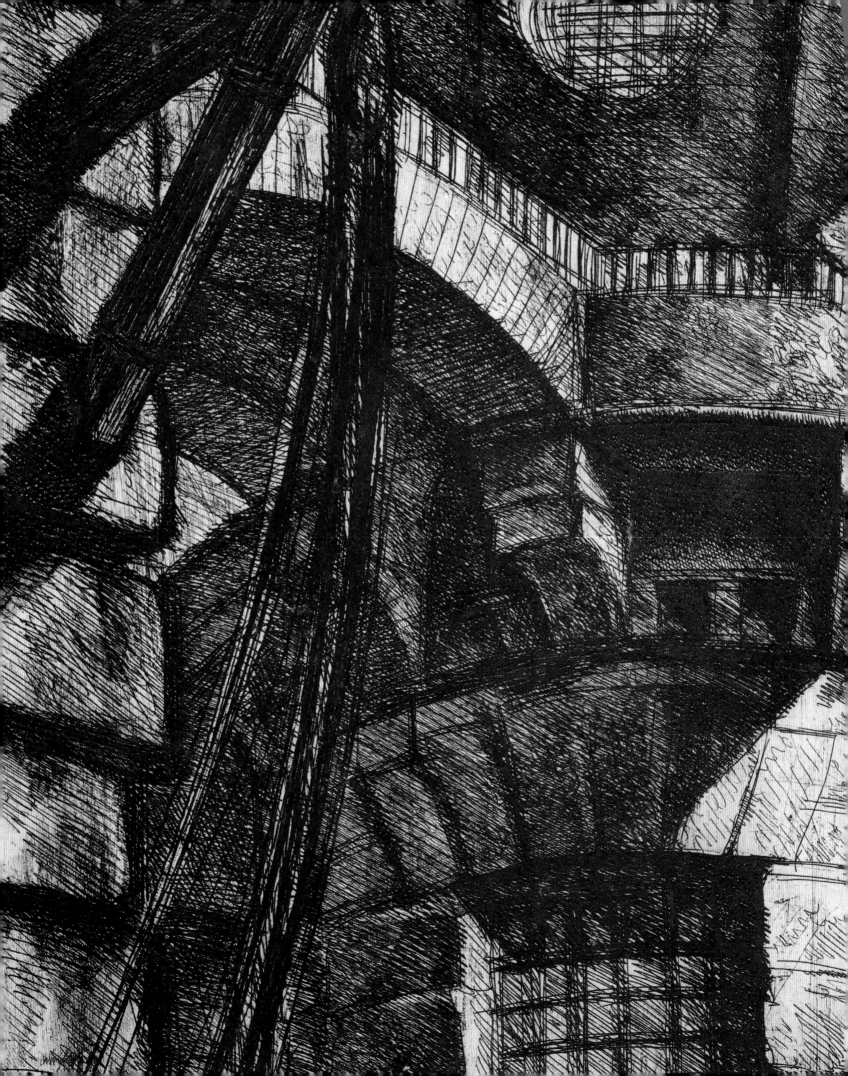

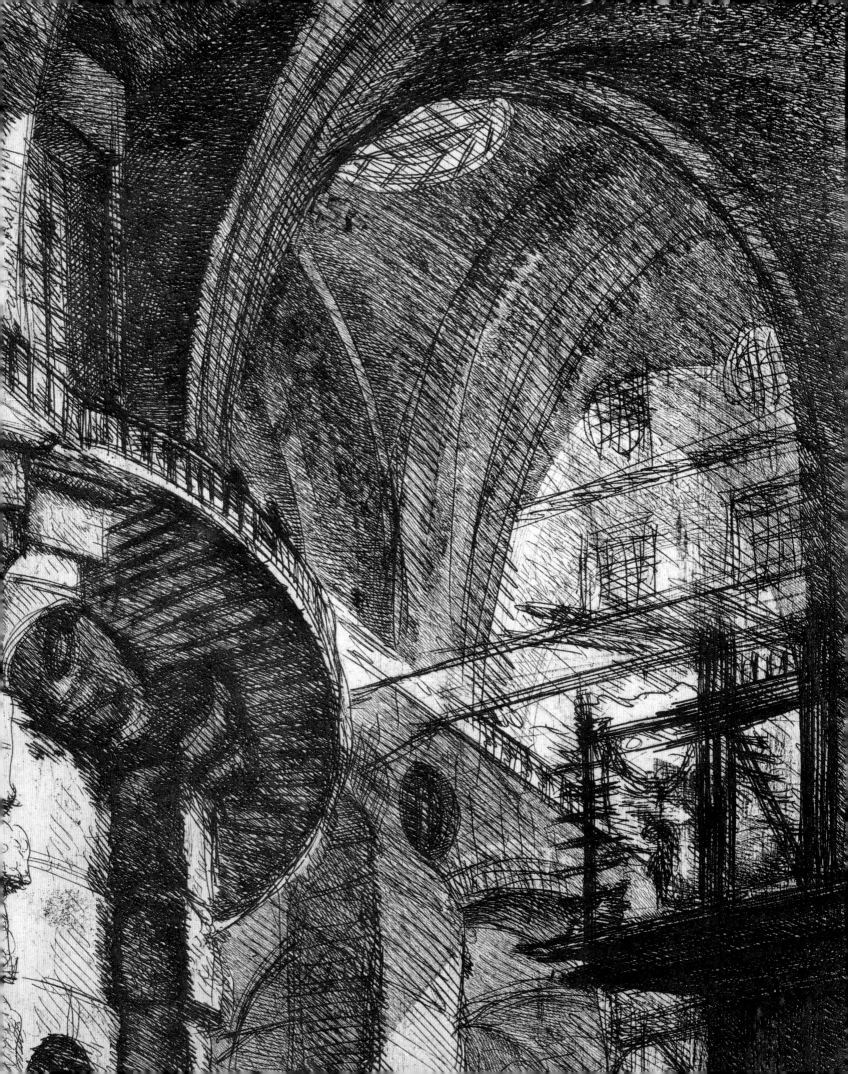

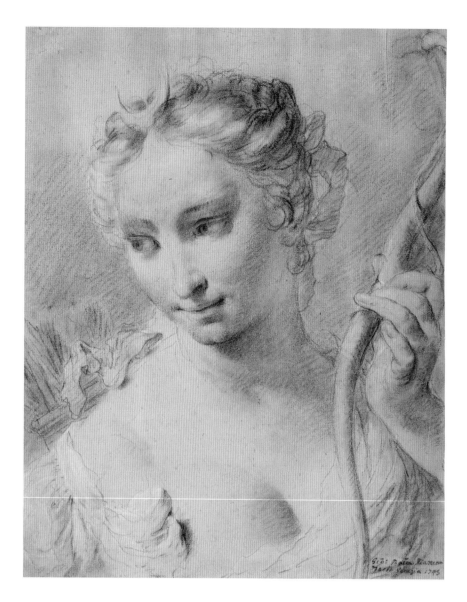

Giovanni Battista Piazzetta
Italian 1682–1754
Diana 1743
black and white chalk on faded blue
paper
39.5 x 31.4 cm
Felton Bequest, 1936 (359–4)

Giovanni Battista Piazzetta was a leading painter of religious subjects in Venice in the eighteenth century, at a time when the city was one of the cultural centres of Europe. He was also an exceptional draughtsman, who made his reputation with a series of heads drawn in chalk, known as *teste di carattere* – studies of people from everyday life. The immediacy and engaging quality of these drawings come from the way the figures lean forward into the picture plane, as though confiding in the viewer. Piazzetta often used his wife Rosa and son Giacomo as models, and the sense of intimacy in these portraits is palpable. Executed with a high degree of finish, the drawings were prized by collectors, and provided the artist with a steady income throughout his career.

Unusually for the *teste di carattere*, this drawing is of a mythological figure, Diana, goddess of the hunt. Piazzetta places the figure in a shallow pictorial space and, despite the close-up view, manages to depict all of the goddess's essential attributes. She is shown with her bow and arrows, and her association with night is made explicit by a crescent moon, worn as a crown in her hair. Piazzetta harnesses his great technical skill to convey Diana's other attribute – her beauty. By contrasting ribbons and fabric with the expanse of Diana's bosom, he evokes the warmth of her proximity. Her averted gaze and slight smile contribute to the drawing's light sensuality, as does the expressiveness of her hand, which elegantly holds her bow.

Diana is one of only two known dated works in the *teste di carattere* series, which indicates that it was particularly significant for Piazzetta. His work is also represented in the National Gallery of Victoria by two additional portraits, of his wife and son, also dating from the 1740s.

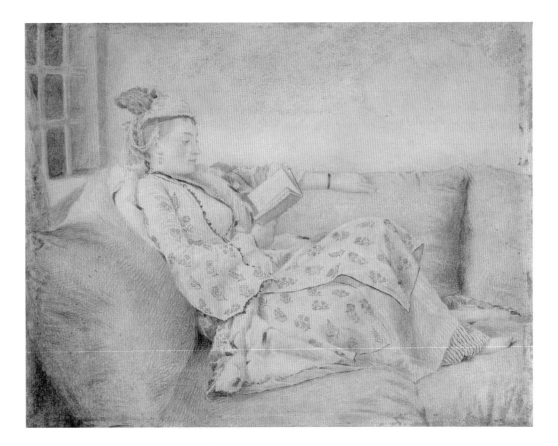

With its military power in decline by the beginning of the eighteenth century, the Ottoman Empire began to open up to visitors from western Europe. Merchants and diplomats were followed by an increasing number of curious travellers enchanted by the notion of 'Turquerie' and by the fabled exoticism of the court at Constantinople (now Istanbul). The publication of illustrated travel books and accounts, such as Jean-Antoine Guer's *Mouers et usages des Turcs* (1747), fuelled a growing fascination with Eastern customs and costume, and inspired the emergence of an unprecedented vogue for pictures, like this one, in which European sitters were portrayed *à la Turque*.

Foreign artists were among the first to settle in the newly fashionable East. One of them was Swiss painter and pastellist Jean-Étienne Liotard who arrived in Constantinople in 1738 in the company of his patron Sir William Ponsonby, 2nd Earl of Bessborough. He remained in the city for four years, immersing himself in the region's culture, art and language. Liotard's aristocratic connections gained him an entree into the cosmopolitan expatriate community. The exquisite execution and uncluttered simplicity of the artist's compositions in oils, pastels and chalks found immediate favour, and there was no shortage of influential patrons eager to commission portraits of themselves or their families in Turkish regalia. There was also a market for Liotard's exotic and evocative genre scenes. His passion for the Middle East did not diminish after his return to Europe; in fact, he continued to sport a lengthy beard and adopted Ottoman costume, quickly attaining celebrity status as 'the Turkish Painter'.

While in Constantinople Liotard made two drawings of a young European woman in Turkish clothes seated reading on a divan: this one, and another, now in the Musée des Beaux-Arts, Carcassonne. These two drawings are remarkably similar compositionally, although the artist has used an unusual technique in the National Gallery of Victoria's version that involved shading the reverse of the sheet with red and black chalk to enhance the subtle tonality of the work. Liotard often reworked his most popular or successful compositions; there are four known painted versions of this subject, one dating from the artist's Constantinople years, and the others executed following his return to Paris. Details of many of Liotard's commissions and the identities of his aristocratic sitters are well documented, yet, surprisingly, we do not know the identity of the young woman who posed for this luminous study.

Jean-Étienne Liotard
Swiss 1702–1789; worked in France, Turkey
Lady in Turkish dress, reading
1740–42
black and red chalk
17.6 x 22.8 cm
de Herdt 75
Felton Bequest, 1951 (2354-4)

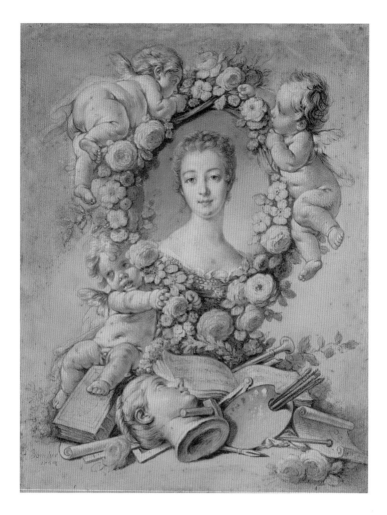

François Boucher
French 1703–1770
Madame de Pompadour 1754
pastel over sanguine and light grey-
blue washes
36.5 x 28.1 cm
Everard Studley Miller Bequest,
1965 (1482-5)

In 1745 Jeanne-Antoinette Poisson Le Normant d'Etioles, the married daughter of a minor and rather shady bureaucrat, was officially appointed *maîtresse en titre* – mistress to Louis XV. She was twenty-four years old. Installed at the court of Versailles, she also acquired a new title – Madame la Marquise de Pompadour. Though dubbed '*La Bourgeoise*' by her aristocratic peers, her charismatic bearing and cheerful openness soon won her friends and the lasting respect of social and political adversaries at court.

Madame de Pompadour became France's most important patron of the arts. Discerning, though wildly extravagant, she lavished dazzling sums from her personal allowance upon projects and commissions from many of the leading artists, designers and artisans of the day. Her influential brother, the Marquis de Marigny, Director-General of the King's Buildings, also provided further subsidy and ongoing official support for his sister's passionate involvement with the arts.

Madame de Pompadour was a stalwart patron and admirer of François Boucher between 1747 and her death in 1764. This allegorical portrait, commissioned by the Marquis de Marigny in 1754, celebrates that patronage and the diversity of her interests. She is depicted surrounded by a garland of flowers supported by three putti. Scattered at the base of the design are the symbolic attributes of the arts she so enthusiastically supported – painting, drawing, sculpture, architecture, writing and music. The artifice of the composition and elegance of Boucher's draughtsmanship characterize the features of Rococo design.

Boucher was one of the most prolific and versatile artists of the eighteenth century who enjoyed considerable success throughout his career. A full member of the Académie by 1734, he was appointed professor of drawing and engraving to Madame de Pompadour in 1751 and Premier Peintre du Roi (Chief Court Painter) to Louis XV in 1765. Skilled in a range of printmaking techniques, Boucher produced a number of significant etchings and book illustrations, and in addition to his impressive and influential painted oeuvre, made thousands of drawings, as well as designs for tapestries, porcelain and the theatre.

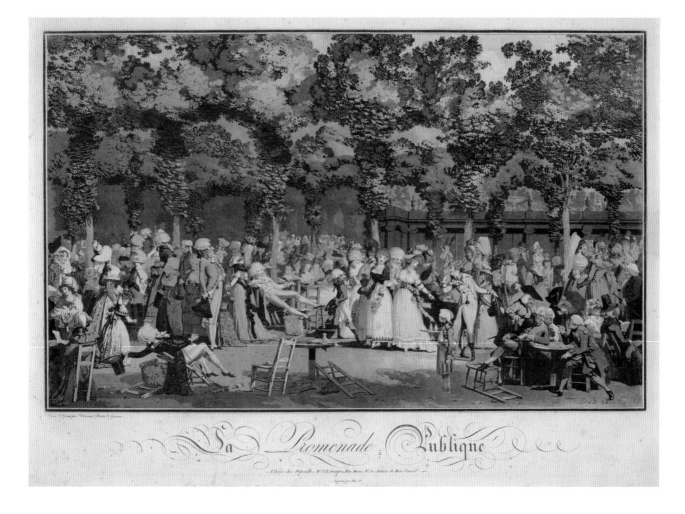

1792 saw the fall of the French monarchy and the establishment of a People's Commune. Fashionable society continued to show off its plumage, innocently unaware of the impending carnage that would follow the execution of Louis XVI in January 1793. In this extraordinary colour print Philibert-Louis Debucourt depicted the frivolous pursuits of the Parisian dandies and courtesans who gathered at the 'Garden of Equality' (formerly the Palais Royal). The artist rather provocatively included among his extravagantly attired 'promenaders' caricatures of recognizable society figures, including the future Louis XVIII shown blowing a kiss across the milling crowd, and the sprawling, pink-clad duc d'Aumont.

Debucourt's *The public promenade* was clearly inspired by the imagery, scale and technique of Thomas Rowlandson's influential satirical aquatint *Vauxhall Gardens*, published in London in 1785 and lauded on both sides of the Channel. Rowlandson's large handcoloured plate humorously depicted the throng of upper crust 'types' and modish pleasure seekers who rubbed shoulders at London's most famous night spot. Debucourt successfully adapted the image for a French version as early as 1787, but, when he revisited the theme in 1792, he introduced an innovative colour printing process that aimed to simulate the effect of handcolouring and to evoke the luminous transparency of watercolour wash. This process involved printing from four separate plates, and combined the skilful manipulation of several etching, stippling and engraving techniques with the subtle tonal enhancement achieved by the use of aquatint.

Unlike most of his printmaking contemporaries in France, Debucourt was also a skilled painter and a member of the Académie. Although a growing interest in the potential of intaglio printmaking led him to neglect painting after 1786, much of the impact of the artist's printed compositions is derived from his exceptional abilities as a draughtsman and designer. *The public promenade* represents Debucourt's greatest achievement as a printmaker. Engagingly satirical, prescient in its portrayal of a decadent and doomed nobility, and representing a technical tour de force, the work is now considered the most important colour print produced during the eighteenth century.

Philibert-Louis Debucourt
French 1755–1832
The public promenade (*La Promenade publique*) 1792
colour etching and aquatint, engraving
36.5 x 59.6 cm (image);
47.3 x 68.0 cm (sheet)
Fenaille 33 iii/iii
Felton Bequest, 1937 (410-4)

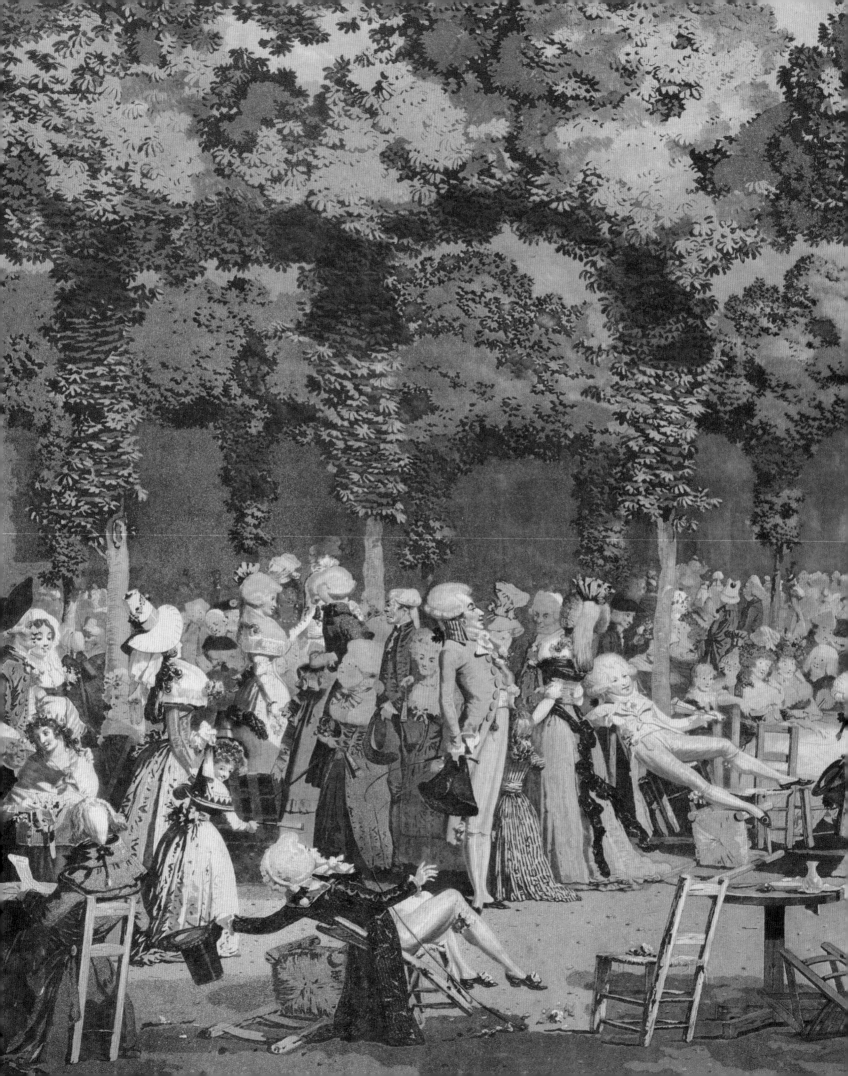

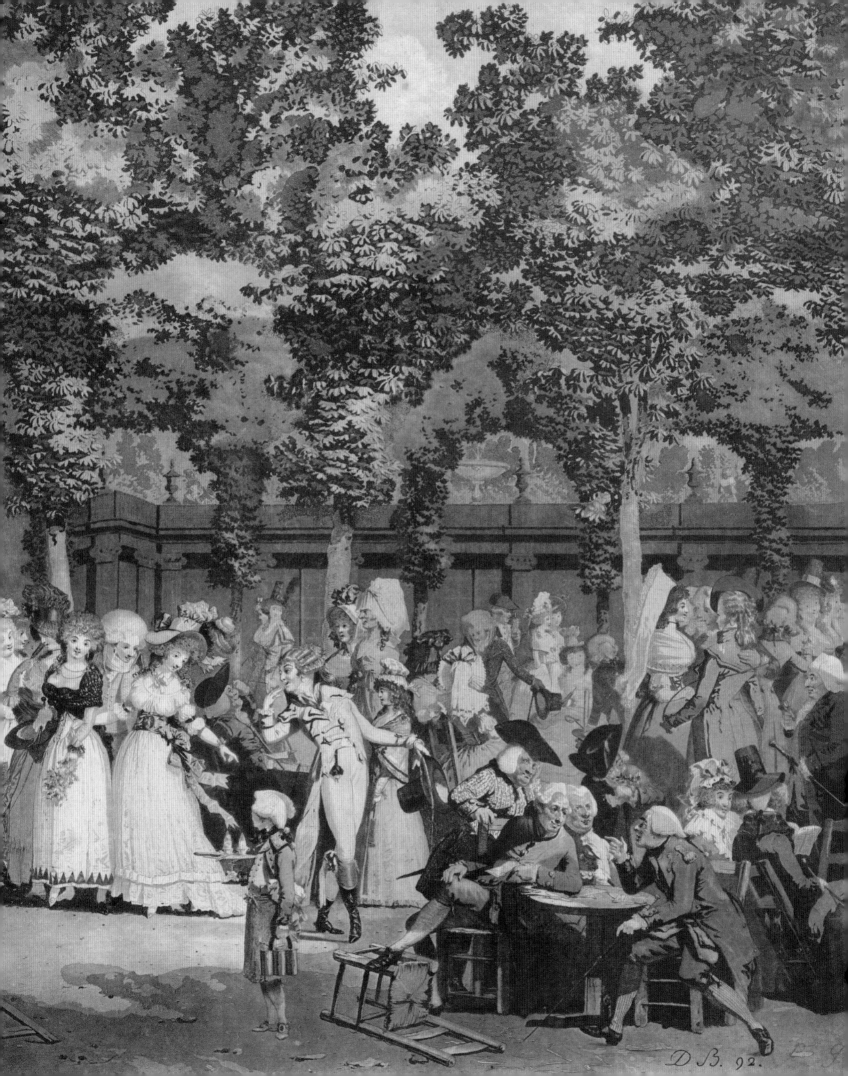

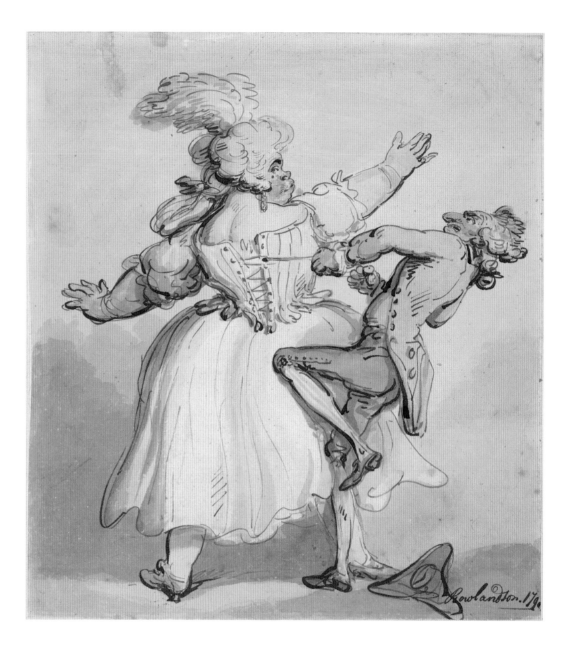

Thomas Rowlandson
English 1756–1827
A little tighter 1790
pen and ink and watercolour
over pencil
30.8 x 27.8 cm
Felton Bequest, 1920 (1056-3)

In the late eighteenth and early nineteenth centuries, known as the golden age of caricature in Britain, masters such as Thomas Rowlandson, James Gillray and George Cruikshank enthusiastically mocked the follies of their society. This pair of watercolours parodies the foibles of the fashionable world, and the results of the over-indulgence such society fostered.

A little bigger captures an awkward moment as a tailor strains to encompass his customer's great girth. Every feature is oversized – from his lips and florid jowls to his solid legs and sensible shoes – dwarfing the struggling tailor. In its companion piece, *A little tighter*, the corpulent woman, her features similarly exaggerated, suffers the opposite dilemma. The manservant grimaces, putting his whole weight into the effort of tightening the corset string. This popular fashion of forcefully restricting one's waist to achieve the perfect figure was frequently ridiculed in art and literature, where beautiful young women were often depicted literally bound by fashion. Here it seems that no amount of lacing will make this woman attractive.

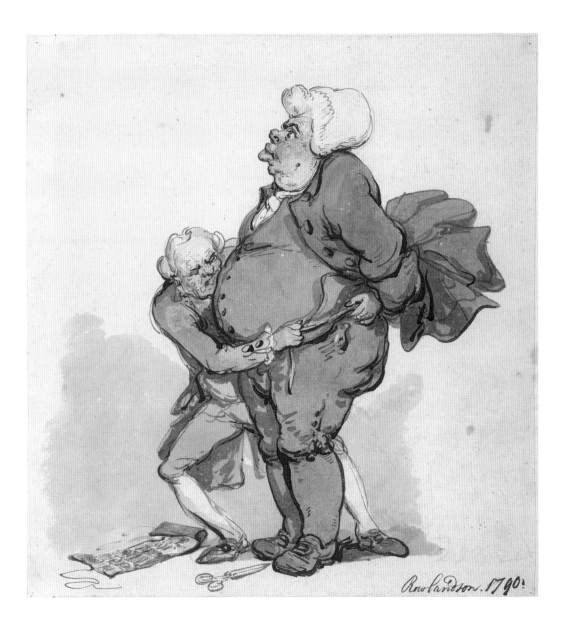

While immensely popular in his day, the earthy humour of Rowlandson's era was incompatible with Victorian morality, and his work was largely forgotten until the twentieth century. Even then, his bawdy eloquence overshadowed an appreciation of his sophisticated draughtsmanship and objective portrayals of contemporary life. Trained at the Royal Academy School, Rowlandson absorbed a range of influences from various sources, including French Rococo art, the satirical imagery of William Hogarth, and the work of Thomas Gainsborough and John Hamilton Mortimer. In addition to his prolific output of watercolours, Rowlandson produced many etchings and designs for reproduction as prints or book illustrations. *A little bigger* and *A little tighter* were published as etchings in 1791.

Thomas Rowlandson
English 1756–1827
A little bigger 1790
pen and ink and watercolour over pencil
29.8 x 27.8 cm
Felton Bequest, 1920 (1055-3)

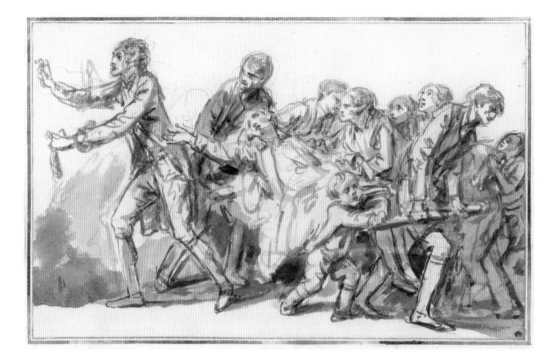

Jean-Baptiste Greuze
French 1725–1805
Figure group with man carried on a stretcher 1770s
brush and ink and grey wash over pencil with ruled brown ink border; laid down
22.6 x 36.4 cm
Bequest of Howard Spensley, 1939
(581-4)

Despite his ambition to gain recognition as a history painter from the Académie in France, Jean-Baptiste Greuze made his reputation as an artist of genre subjects. His paintings, which often explored the drama of familial relationships, were exhibited regularly from the 1750s at the Salon, the annual exhibition for established artists. The public and critics, including an important early supporter of Greuze, Denis Diderot, responded to the sincere and highly emotive character of his works. Often depicting moralizing narratives, Greuze's paintings tended to explore the consequences of immoral behaviour, in stark contrast to those of his contemporary François Boucher. While many of his didactic paintings result in compositions that appear to be static, Greuze's drawings are often surprisingly free.

An old inscription identifies this energetic brush and ink drawing as a study for one of Greuze's most celebrated subjects – *The father's curse: The ungrateful son* – which the artist painted in 1765 and again in 1777–78. Edgar Munhall has observed that, since the drawing differs so markedly from both of these paintings, the inscription's claim should be rejected as implausible. The subject remains elusive but, not surprisingly, the scene has been interpreted as a quarrel. A young man appears to be fleeing a family, his departure presumably the cause of the central figure's imploring gesture. Greuze succinctly conveys the violent emotions of his protagonists through their expressive faces and poses. The drama of the scene is reflected in the composition of the overlapping figures, who move in opposite directions to each other. Using wash sparingly, Greuze nonetheless creates dramatic contrasts of light and dark passages. The loose brushwork and broad application of wash recall Greuze's finest drawings from the mid 1770s.

A drawing depicting a man being carried on a stretcher, surrounded by a crowd, in the Musée Greuze at Tournus may be related to the National Gallery of Victoria's drawing.

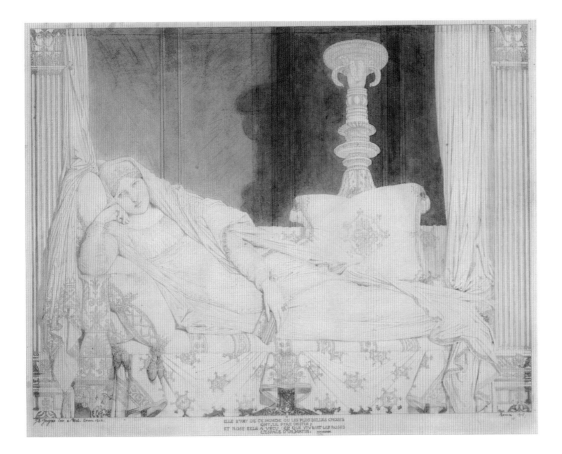

On 27 September 1815 Lady Jane Montagu, daughter of the Duke of Manchester, died in Rome at the age of twenty. Jean-Auguste-Dominique Ingres completed this moving and exquisitely rendered drawing of her 'tomb' the following year. Although the figure's recumbent pose and the stylized architectural setting recall the designs of Roman funerary monuments, it is unlikely that the construction of any memorial in stone was ever proposed. Instead, this highly finished drawing was intended to serve as the young woman's memorial. The composition and the accompanying inscription eloquently reflect the sadness of the subject's premature passing while, at the same time, celebrating the memory of her grace and beauty; an elegiac verse from *Consolation à M. du Périer* (*c*. 1590) by the French poet François de Malherbe translates as:

> She was of this world in which the finest things suffer the worst fate.
> Rose that she was, she lived as roses live: the space of one morning.

Ingres's portrait is engagingly direct, and executed with affectionate sensitivity. It seems that the artist had met Lady Jane Montagu and her family during their stay in Rome, and it is likely that he received the commission for this posthumous portrait from the young woman's grieving aunt, the Dowager Duchess of Bedford.

For several years during his first period in Rome, the artist lived very modestly, his income earned entirely by drawing portraits of wealthy English and French expatriates and tourists. True to his training in the studio of Jacques-Louis David, Ingres saw himself primarily as a painter of grand history subjects, and he resented the distraction posed to his true vocation by these small commissions. However, he cultivated an eager and influential clientele, securing a lasting reputation with portraits of extraordinary consistency and quality.

Evidently Ingres retained a lasting fondness for his composition *The tomb of Lady Jane Montagu*. The artist selected a later version of the drawing as one of several 'unpainted' works that he considered sufficiently significant to be published alongside his most important compositions. This second version of the design, now held by the Musée Ingres in Montauban, includes two mourning putti metaphorically drawing the curtains on the reclining sitter. This composition was engraved by E. A. Réveil for the collection *Oeuvres de J. A. Ingres*, published in Paris in 1851.

Jean-Auguste-Dominique Ingres
French 1780–1867; worked in Italy
The tomb of Lady Jane Montagu
1816
pen and brown ink and watercolour over pencil
44.5 x 55.8 cm
Felton Bequest, 1920 (1066-3)

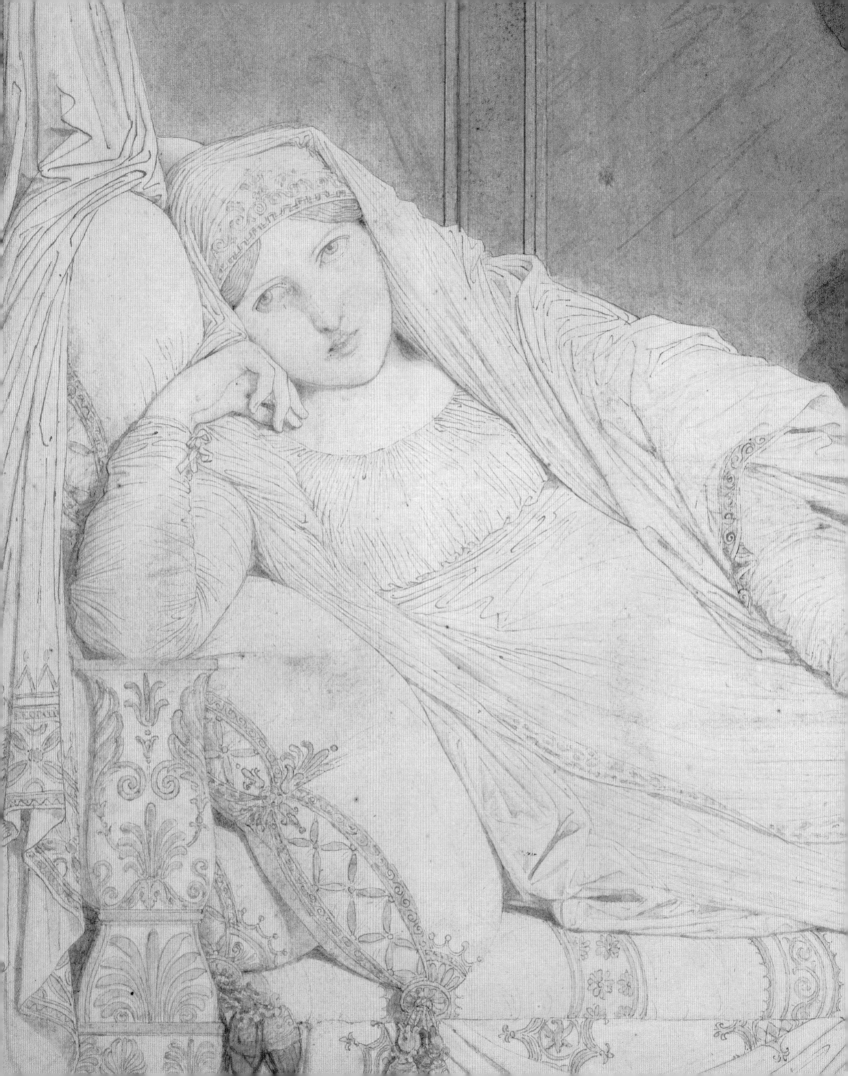

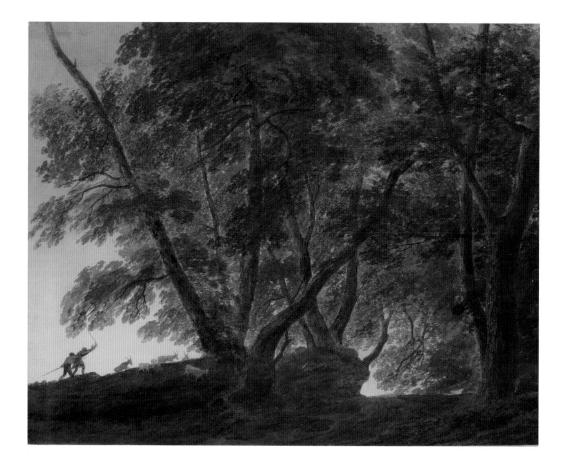

John Robert Cozens
English 1752–1797
*The goatherd: View on the Galleria
di Sopra above the Lake of Albano*
1778
watercolour over traces of pencil;
laid down on card with wash borders
43.9 x 55.0 cm (sheet);
49.6 x 60.6 cm (card)
Bell & Girtin 153
Felton Bequest, 1921 (1209-3)

In the mid 1700s the spectacular volcanically formed landscape surrounding the lakes of Albano and Nemi, to the south-east of Rome, became a place of pilgrimage for artists and 'Grand Tourists', who revelled as much in the area's associations with Roman history and classical poetry as in its natural grandeur.

The Galleria di Sopra was a popular tree-lined walk following the edge of the crater lake along the ridge between Albano and the Pope's summer residence, Castel Gandolfo. From one side, the walk offered magnificent views over the lake; from the other, a sweeping prospect across the Campagna that included Rome and glimpses of the distant sea. In the words of Thomas Jones, John Robert Cozens's friend and painting companion, the area was 'the most pleasing and interesting in the Whole World … It appeared a Majick Land'.

Cozens, the son of the distinguished painter and artistic theorist Alexander Cozens, was taught by his father, and through him developed a love of Italian scenery. Together with connoisseur and collector Richard Payne Knight, the young artist made his first journey to Europe in the late summer of 1776.

For eighteen months Cozens worked in and around Rome, captivated by the quality of light and the changing atmospheric moods of the Italian landscape. Clearly inspired by the example of revered seventeenth-century masters Claude Lorrain, Nicolas Poussin and Gaspard Dughet, he adapted and enhanced their classical compositional formulas in numerous depictions of fabled sites, including the Galleria di Sopra. This was a crucial period in the development of the artist's innovative and poetic watercolour style, in which he realized the hitherto unexplored potential of the medium to evoke a subjective and lyrical response to landscape subjects. Cozens continually refined his technique, but deliberately restricted his palette to almost monochromatic modulations of browns, greys and airy blues. His extraordinary manipulation of watercolour resulted in the creation of works on paper with the scale, presence and beauty of oil paintings.

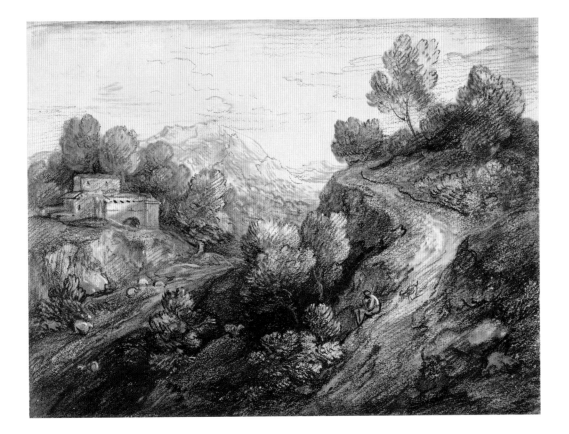

The key to this late drawing by Gainsborough is provided by an inscription on the work's old mount: 'Original chalk drawing by Gainsboro given by him to my Father Richd French after the style of Gaspar Poussin'. Known as Gaspar Poussin, Gaspard Dughet was one of the most distinguished Italian landscape painters of the seventeenth century, whose picturesque paintings of rugged mountain scenery were highly influential in England. From the early 1780s Gaspard's heroic style became increasingly important for the development of Gainsborough's landscape paintings and drawings. This drawing, with its Italianate buildings, distant mountains, winding hillside track and rocky, precipitous gully is more directly indebted to the paintings of Gaspard than to the scenery of England.

Gainsborough was a prolific draughtsman whose landscape drawings, apart from early works produced in the countryside surrounding his native Sudbury in Suffolk, were not directly observed scenes. Although he made many studies from nature – contemporary accounts tell of tree branches and animals brought into the studio – Gainsborough's landscapes were assembled from the imagination, and often constructed with the aid of models. Sir Joshua Reynolds described in his *Discourses on Art* how the artist worked from models 'composed of broken stones, dried herbs, and pieces of looking-glass, which he magnified and improved into rocks, trees and water'.

Gainsborough's inventiveness also extended to his technique and experimental use of materials. This work exemplifies his late chalk drawing technique in which he blended his black and white chalks with a stump (rolled cardboard or leather for smudging pigment) to create a masterly range of tones. Here the tonal contrasts are carefully orchestrated from the deep black shadows and crevices of the hill on the right to the faintly outlined, distant mountains, and to the white highlights on the buildings and valley floor. These tonal effects provide a rhythmic balance to the classically structured composition.

Thomas Gainsborough
English 1727–1788
Mountain landscape with classical buildings, shepherd and sheep
mid 1780s
black chalk and stump and white chalk
28.2 x 37.4 cm
Hayes 634
Felton Bequest, 1951 (2356-4)

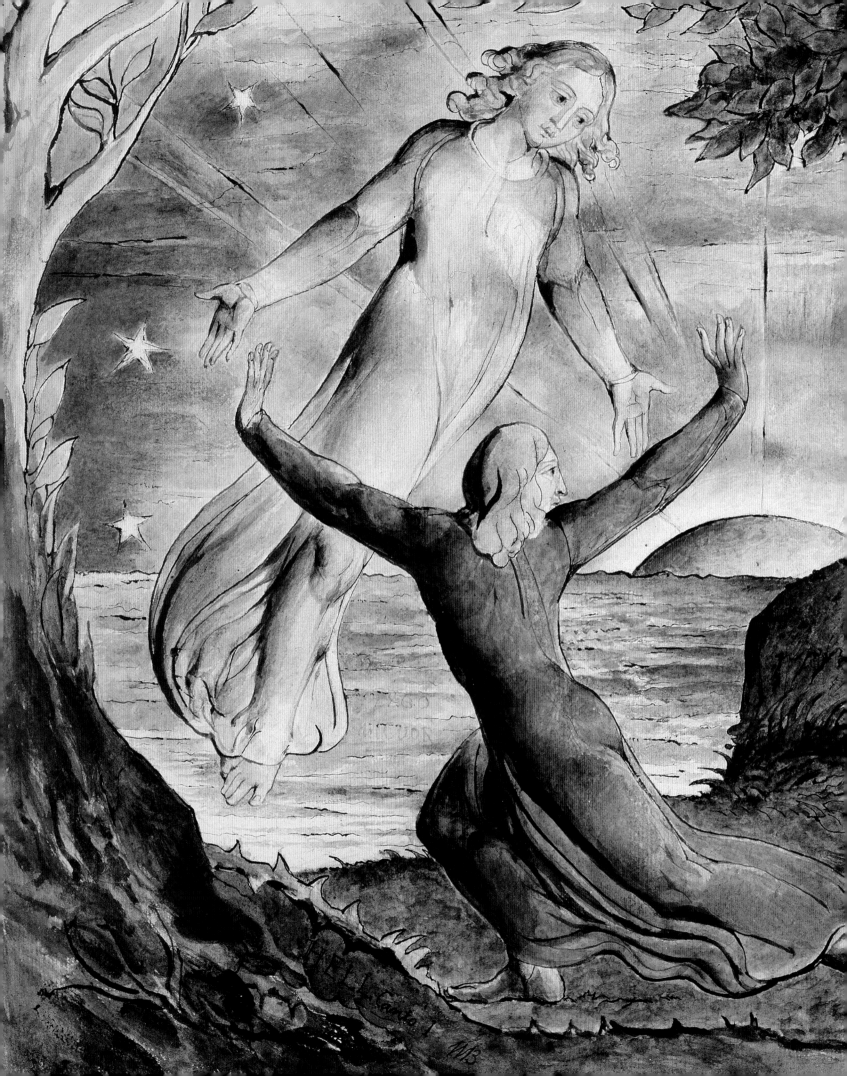

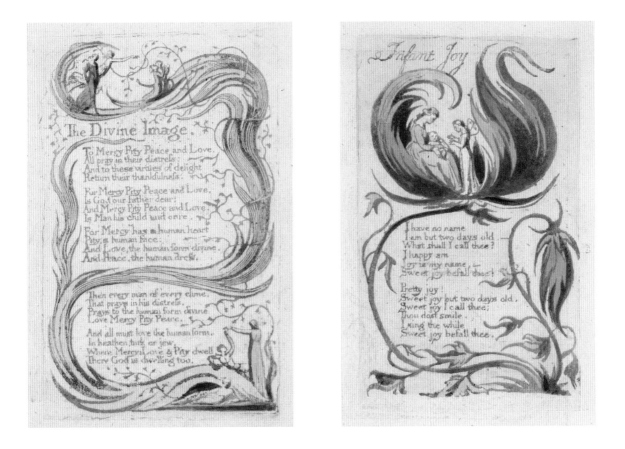

The visionary work of English artist and poet William Blake has been highly influential (his words to the hymn 'Jerusalem' are now an icon of English patriotism), yet it remains perplexing and little understood. England in the late eighteenth century was prosperous, yet unsettled by religious dissent and radical political and nationalistic debate, provoked by the Industrial and French Revolutions. Blake developed a non-conformist theology in which art played an essential role in illuminating the metaphysical realm. While struggling to support himself with his reproductive work, he explored this highly personal prophetic and apocalyptic mythology in his poetry, watercolours, engravings and illustrated books. He was occasionally helped financially by a few patrons and friends and, in his later years, gained a devoted circle of artistic admirers – Samuel Palmer, George Richmond and Edward Calvert – who sympathized with his plea for a spiritual art in an increasingly materialistic age. Such ideals later influenced the beliefs of the Pre-Raphaelite movement; Dante Gabriel Rossetti, in particular, was greatly inspired by Blake.

In his exquisite *Songs of Innocence* Blake adopted the format of an illustrated children's book. It comprises a series of simply worded poems, reminiscent of psalms or hymns that remind the reader of God's divine presence. Each poem is adorned with neo-classical images and marginalia entwined through the text, depicting tranquil pastoral images of childhood innocence. To create his books, Blake invented the technique of relief etching, inspired, he said, by a vision of his recently deceased brother Robert. This process inverts the usual method of preparing copper plates for printing, allowing the printing of text and image simultaneously (see Glossary). It thus gave Blake independence from the costly and market-driven publishing industry, but it was not financially successful. Issued throughout his life, each copy of *Songs of Innocence* is unique. This fragmentary version, comprising fourteen plates, is printed in green ink on both sides of the page and was handcoloured by Blake, or his wife Catherine, with the delicate pastel colours typical of his early period. It is one of only ten known copies of this early stage of the publication before Blake began binding *Songs of Innocence* together with the subsequent, more sombre, *Songs of Experience* (1794).

William Blake
English 1757–1827

The Divine Image
leaf 2 recto from *Songs of Innocence* 1789
copy X, handcoloured before 1794
relief etching printed in green ink
and finished with watercolour
11.1 x 7.0 cm (image);
18.9 x 13.6 cm (sheet)
Bindman 1978, 56;
Butlin & Gott 39c
Felton Bequest, 1988
(P122.2a-1988)

Infant Joy
leaf 2 verso from *Songs of Innocence* 1789
copy X, handcoloured before 1794
relief etching printed in green ink
and finished with watercolour
10.6 x 6.8 cm (image);
18.9 x 13.6 cm (sheet)
Bindman 1978, 44;
Butlin & Gott 39d
Felton Bequest, 1988
(P122.2b-1988)

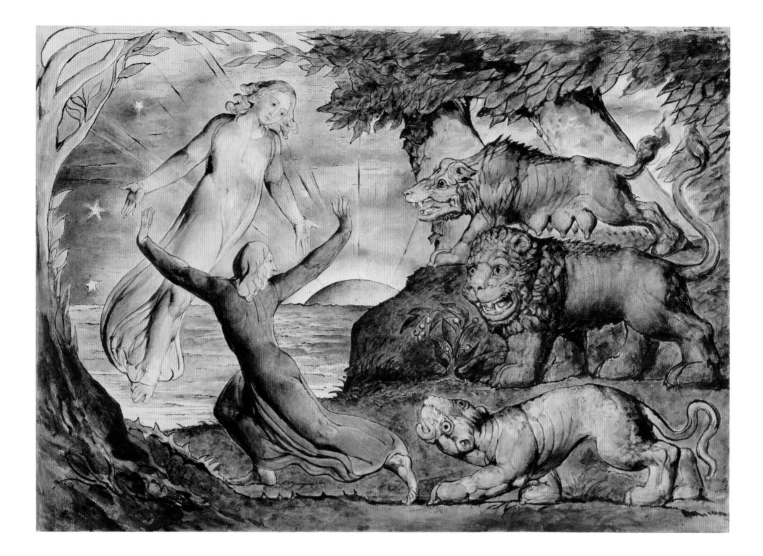

William Blake
English 1757–1827
Dante running from the Three Beasts
illustration to Dante's *Divine Comedy*
(*Inferno* I, 1–90), 1824–27
pen and ink and watercolour over
pencil
37.0 x 52.8 cm
Butlin 1981, 812.1; Butlin & Gott 3
Felton Bequest, 1920 (988-3)

The simple images of *Songs of Innocence*, such as *The Divine Image* and *Infant Joy,* contrast greatly with what has been termed the 'glorious culmination' of Blake's art, his illustrations to Dante Alighieri's *Divine Comedy*. Written in the early fourteenth century, this epic poem recounts Dante's imaginary pilgrimage through Hell and Purgatory to Paradise. Commissioned by his last patron, John Linnell, Blake produced 102 drawings illustrating the *Divine Comedy* between 1824 and his death in 1827. These drawings range from preliminary sketches to highly finished watercolours. Only seven of the compositions were engraved for Linnell's proposed publication. Blake's personal theology led him not only to illustrate but to comment upon, and even criticize, Dante's Catholic interpretation of salvation, stating that 'Dante saw Devils where I see none – I see only good'. The richly coloured *Dante running from the Three Beasts* depicts the opening incident in the story. Dante, fleeing the dark woods, inhabited by ferocious animals that symbolize worldly sins, encounters the Roman poet Virgil, who becomes his guide through the many terrifying circles of Hell and Purgatory. In Paradise Dante, now guided by his beloved Beatrice, meets St Peter and St James who are illuminated by the brilliant flames of redemption. The ethereal world is radiantly evoked by the translucent rainbow hues, while the figures are clearly influenced by the art of Michelangelo, just as others in the series pay tribute to Dürer.

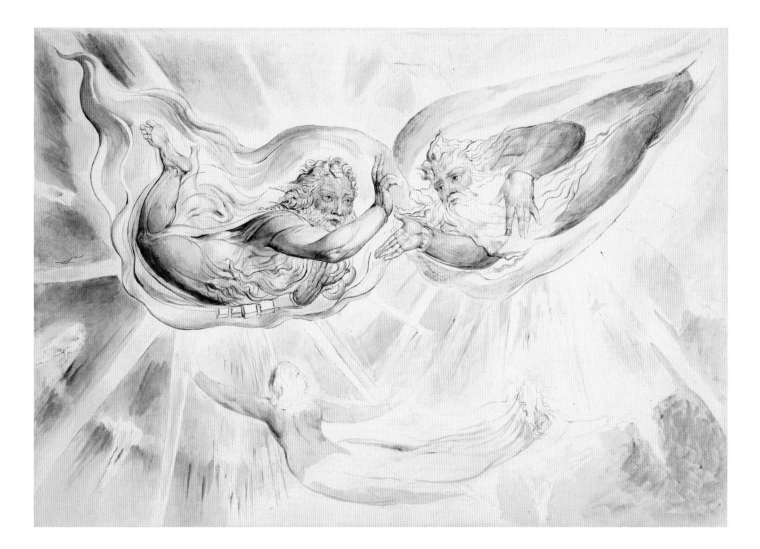

The National Gallery of Victoria's outstanding collection of Blake's work was largely formed when Linnell's collection was sold in 1918. Funded by the Felton Bequest, the Gallery acquired thirty-six of the *Divine Comedy* drawings executed between 1824 and 1827, the engravings to the *Book of Job* (1823–26), two watercolours for Milton's *Paradise Lost* (1822), and individual colour prints for the prophetic books. Received with disdain when first exhibited in Melbourne, Blake's art has been re-evaluated during the twentieth century, and his works are now seen as among the Felton Bequest's greatest acquisitions. In addition to occasional purchases during the century, the acquisition in the 1980s of *Songs of Innocence* (1789) and *Night Thoughts* (1797) enriched the holdings with exceptional examples of Blake's early work, previously lacking in the collection.

William Blake
English 1757–1827
St Peter and St James with Dante and Beatrice
illustration to Dante's *Divine Comedy*
(*Paradiso* XXV, 13–24), 1824–27
pen and ink and watercolour over pencil
37.1 x 52.7 cm
Butlin 1981, 812.95; Butlin & Gott 37
Felton Bequest, 1920 (1022-3)

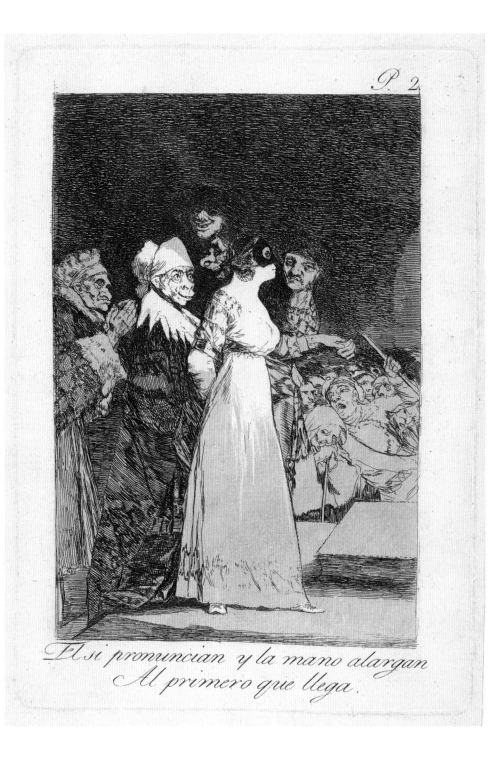

P. 2

_El si pronuncian y la mano alargan
Al primero que llega._

Francisco Goya y Lucientes
Spanish 1746–1828
*They say yes and give their hand to
the first comer (El si pronuncian y la
mano alargan al primero que llega)*
plate 2 from *Los Caprichos* (The
Caprices), first edition, 1799
etching and burnished aquatint
18.0 x 12.3 cm (image);
21.4 x 15.2 cm (plate);
23.8 x 17.0 cm (sheet)
Harris 37.III.1
Felton Bequest, 1976 (P2-1976)

The first printmaker of note in Spain, Goya's astonishingly original print oeuvre was barely known during his lifetime. The most celebrated Spanish painter of his day, he was renowned for his portraits and religious paintings, and appointed Pintor del Rey (Painter to the King) at the Bourbon royal court. In contrast to the public nature of much of his painting, Goya's prints embodied his private response to the turbulent times in which he lived. He survived the reigns of Charles III and Charles IV, the Inquisition, the French occupation of Spain and the resulting War of Independence, and Spain's brief period of constitutional government. However, the despotic reign of Ferdinand VII caused him to flee to Bordeaux, where he died. Goya's prints frequently condemned the social, political and religious mores of their day, and the majority of them were not published or could not be sold during his lifetime.

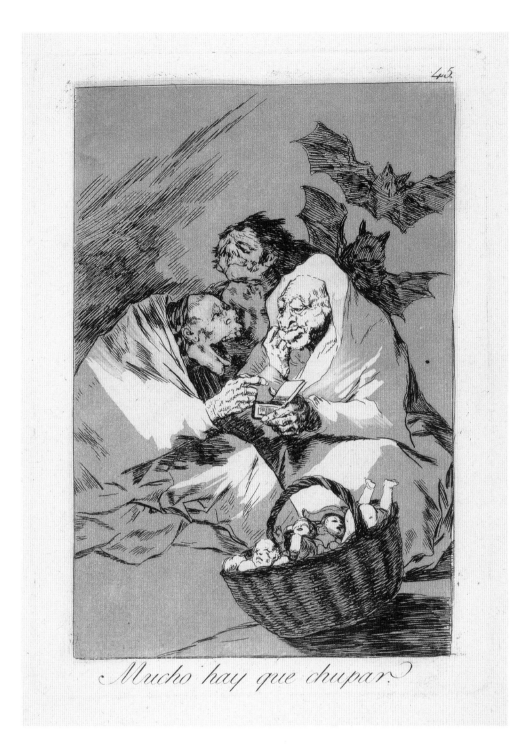

Mucho hay que chupar

In 1799 Goya announced the publication of *Los Caprichos* (The Caprices), a series of eighty imaginative prints in which he ridiculed human follies, vices, vulgarities, hypocrisies and superstitions. Borrowing from contemporary visual and literary sources, the fantastic images, with their ambiguous titles, reveal the artist's disillusionment with the nature of Spanish society. As a result of Goya's fierce satire, the series was withdrawn from sale after only two days, presumably to avoid prosecution. The evils of prostitution, amorous relationships, poor education, the corrupt clergy and various societal foibles are scathingly satirized and, in the second half of the series, attacked in images of witches and goblins and other supernatural creatures still widely believed in.

Francisco Goya y Lucientes
Spanish 1746–1828
There is plenty to suck
(*Mucho hay que chupar*)
plate 45 from *Los Caprichos*
(The Caprices), first edition, 1799
etching and burnished aquatint
18.4 x 12.6 cm (image);
20.6 x 15.0 cm (plate);
24.1 x 17.1 cm (sheet)
Harris 80.III.1
Felton Bequest, 1976 (P45-1976)

Titled from lines in a satirical poem by his friend Gaspar Melchor de Jovellanos, in *They say yes and give their hand to the first comer* Goya mocks women who unthinkingly seize the first opportunity to marry. This theme may refer to his ill-fated relationship with the Duchess of Alba, who appears in a number of these images. One of the earliest prints of the series, this plate demonstrates Goya's technical ability through its combination of delicately etched lines and skilfully manipulated aquatint, a tonal technique that he had perfected. A stream of light illuminates the masked beauty and the caricatured, ape-like countenance of her *duenna* who escorts her above the shadowy rabble. In the unsettlingly tilted composition *There is plenty to suck*, Goya takes this grotesquery to extremes, showing witches chatting over a basket of babies. The title plays on the word *chupar* (to suck, or to bleed or blackmail), and it has been suggested that the image may be a comment on the trade in abortifacients.

In 1808 Napoleon's forces invaded Spain, triggering the six-year War of Independence. As his personal record of the war and as homage to his people, Goya produced the extraordinary series *Los Desastres de la Guerra* (The Disasters of War), between 1810 and 1820. No artist, with the exception of Jacques Callot, had so profoundly portrayed the inhumanity and barbarity of war. The eighty-five plates graphically depict wartime atrocities – execution, torture, rape, the despoiling and robbing of corpses. They also show the terrible sufferings of the people during the devastating famine of 1811–12 when around 20,000 people died of starvation in Madrid. In *One can't look* civilians, including women and children, plead desperately with their murderers, whose ominous presence is indicated by bayonet-tipped guns. Goya's compositional and tonal mastery is evident in this print, in which the hiding place is pierced by light to reveal the horrifying moment before the massacre. A group of allegorical scenes, known as the *caprichos enfáticos* (emphatic caprices), concluded the series with a biting commentary on the Church and the repressive postwar reign of Ferdinand VII. Because of this political climate the series was not published until 1863, thirty-five years after Goya's death. *The Disasters of War* prints are timeless images of the true extent of the sufferings and cruelties of war, still relevant two hundred years after their creation.

Since 1918 the National Gallery of Victoria has developed its representation of Goya's prints, to now hold the complete etched cycles in first edition sets.

Francisco Goya y Lucientes
Spanish 1746–1828
One can't look (*No se puede mirar*)
c. 1810–20
plate 26 from *Los Desastres de la Guerra* (The Disasters of War),
first edition, 1863
etching, burnished lavis,
drypoint and burin
12.2 x 18.7 cm (image);
14.3 x 20.5 cm (plate);
24.3 x 33.4 cm (sheet)
Harris 146.III.1
Felton Bequest, 1966 (1684-5)

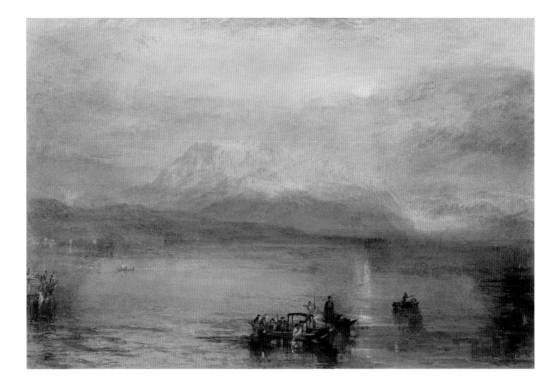

J. M. W. Turner
English 1775–1851
The Red Rigi 1842
watercolour, wash and gouache with
some scratching out
30.5 x 45.8 cm
Wilton 1525
Felton Bequest, 1947 (1704-4)

The young J. M. W. Turner made his first visit to Switzerland in 1802. Over the following decade the alpine landscape provided the subject for many of his oil paintings and watercolours. An enduring affinity with the spectacular scenery of the Alps inspired his subsequent visits in the early 1840s. Turner's late watercolours evoke the serenity and immensity of the Swiss landscape in some of the most compelling and radiant compositions of his career. One of Switzerland's most famous mountains, the Rigi towers over the lake to the east of Lucerne. At a mere 1780 metres, it is not one of the loftiest peaks in the Swiss Alps, but the glorious uninterrupted views afforded by its isolated location and the beauty of the surrounding scenery have long attracted adventurous tourists.

Turner was captivated by the picturesque town of Lucerne and its lake. He visited the location each summer between 1841 and 1845, staying at the lakeside inn, La Cygne (The Swan). From his vantage point on the lake's northern arm, Turner made numerous contemplative studies of the Rigi in pencil and watercolour. Sketching the mountain at different times of day, he captured dramatic and fleeting colour changes on its slopes, and recorded the altering moods of the scene under different light conditions.

The Red Rigi comes from the first of four sets of highly finished watercolours of alpine scenes produced by Turner between 1842 and 1848. The compositions recall the artist's Swiss sketches, but were actually based upon a group of freely drawn and expressive 'sample studies' produced in London. These studies were proffered by Turner's agent, Thomas Griffith, to prospective collectors in an attempt to woo commissions for 'finished' watercolours. In addition, Turner produced four finished specimens in advance of the remainder of the first set. These include the euphoric *Red Rigi*, depicting the mountain bathed in the warm glow of the setting sun, and its counterpart, the *Blue Rigi: Lake of Lucerne, sunrise* (private collection), an equally evocative study of the lake and distant slopes illuminated by the gathering dawn.

It is interesting to note that Turner's late alpine watercolours, now universally acknowledged as some of his most important works, were greeted by many contemporary collectors with a resounding lack of enthusiasm. Of the twenty-six finished compositions completed between 1842 and 1845, twenty were acquired by only two enlightened supporters, H. A. J. Munro of Novar and John Ruskin, who each owned this watercolour.

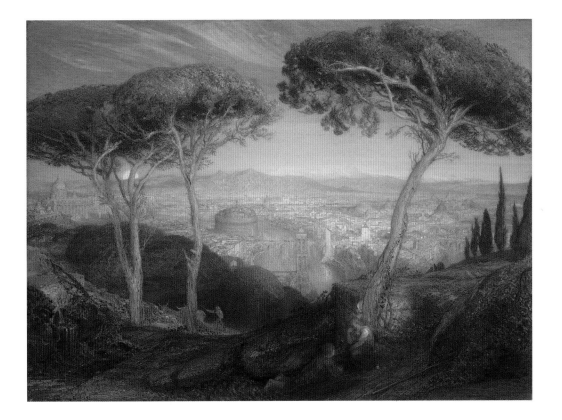

After marrying in 1837, Samuel Palmer and his wife Hannah Linnell travelled to France, then south to Italy where they stayed for two years. For much of that time the couple lived in Rome. The grandeur of the ancient city and its surrounding landscape made a profound and lasting impression upon Palmer; the happiness he experienced during his stay is evoked in glowing, elegiac compositions that he produced at the time, and in deeply nostalgic works like this one, created thirty-five years after his return to England.

Although worked from memory, the atmospheric splendour of this idealized twilight prospect of the 'Golden City' remains undiminished. Indeed, the complex composition improves upon several earlier versions of the subject painted in Italy. The fastidious stippling adds vibrancy to the surface of the work, which glows with a dappled luminescence reminiscent of Palmer's early visionary landscapes. Palmer chose a dramatic verse by Lord Byron to accompany this watercolour when it was exhibited at the Old Watercolour Society in London, in 1873:

> Oh Rome! My country! City of the soul!
> The orphans of the heart must turn to thee,
> Lone mother of dead empires! And control
> In their shut breasts their petty misery.
> What are our woes and sufferance? …
> —Byron, *Childe Harold's Pilgrimage*, canto IV (1818)

Palmer is perhaps best remembered for his intensely romantic early work. The originality that characterized the mystical landscape paintings and drawings of his early years won the artist influential admirers, including his mentor William Blake and future father-in-law John Linnell. Between 1826 and 1832, Palmer lived in the Kentish village of Shoreham, leading 'The Ancients', a group of young artists who shared his veneration of the poets Virgil and Milton and his passion for rural tradition.

Despite critical acclaim, Palmer struggled financially; for many years he attempted to broaden his market by producing mainstream topographical compositions that lacked the distinctive visionary character of his best work. In the 1850s, however, Palmer's compositions recovered much of their earlier intensity. He discovered etching, and during his late years created a series of illustrations to his beloved Milton and Virgil.

Samuel Palmer
English 1805–1881
The Golden City: Rome from the Janiculum 1873
watercolour and gouache with pencil, black chalk and gum arabic
51.4 x 71.0 cm
Lister 668
Presented by members of the Varley Family, 1927 (3470-3)

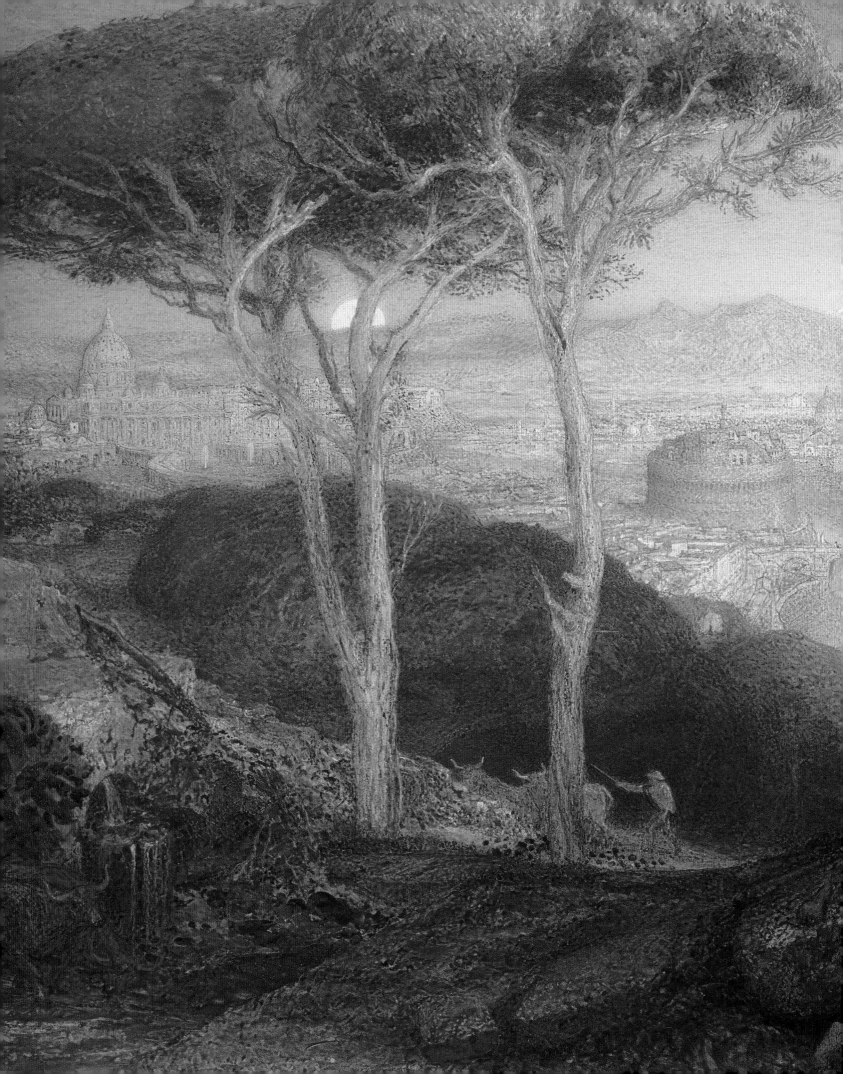

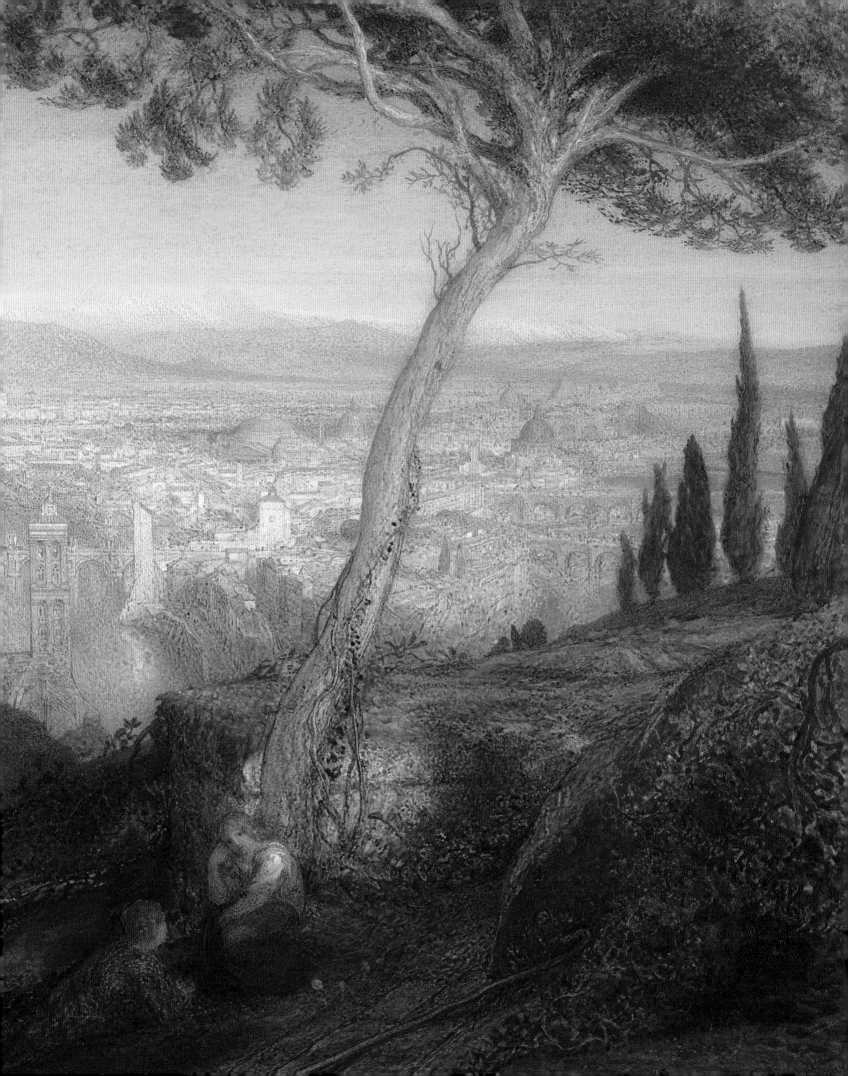

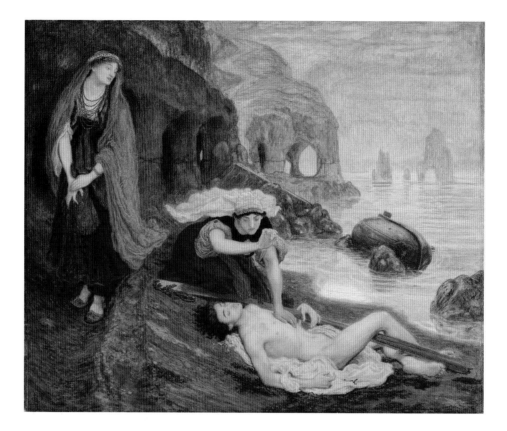

Ford Madox Brown
English 1821–1893
The finding of Don Juan by Haidée
1869
watercolour and gouache
over pencil
47.5 x 57.6 cm
Felton Bequest, 1905 (210-2)

… like a withered lily, on the land
His slender frame and pallid aspect lay,
As fair a thing as e'er was form'd of clay
… walking out upon the beach, below
The cliff, towards sunset, on that day she found
Insensible – not dead but nearly so, –
Don Juan, almost famish'd, and half-drown'd.
—Byron, *Don Juan*, canto II (1819)

So meet Byron's great lovers Don Juan and the beautiful Haidée, who, aided by her maid Zoe, rescues the shipwrecked castaway. The two inevitably fall in love, only to be thwarted by Haidée's father, the pirate Lambro. With her lover expelled from their idyllic island, Haidée dies, broken-hearted.

The experience of illustrating *The Poetical Works of Lord Byron* (which was published by Edward Moxon in 1870) inspired Ford Madox Brown to paint this luminous work. Two additional versions in oil are now in the Musée d'Orsay, Paris, and the Birmingham Museums and Art Gallery. Most of Brown's imagery was drawn from English life and literature, and his few representations of foreign subjects were largely inspired by the writings of Lord Byron.

Brown applied a multitude of minute strokes of watercolour and gouache to create the brilliant shades of the sky and sea, illuminated by the setting sun, which casts into shadow the rich colours of the exotic garments, the seaweed-strewn shoreline and the eroded cliffs. Although the more richly clad figure is sometimes thought to be Haidée, in the text it is Haidée who tenderly awakens Don Juan. Here Zoe's withdrawn stance is counterposed by her mistress's urgent gestures. The horizontal line of Haidée's flowing veil and raised arm draws attention to Don Juan's naked form, her rosy hand contrasting with his deathly pale skin.

Born in Calais, Brown was raised and studied on the Continent before settling in London in 1844. Profoundly influenced by the Pre-Raphaelites, he was inspired by their desire to restore a simplicity and sincerity to British art. In later years, he was closely involved in the Arts and Crafts Movement, supplying designs for stained-glass windows and furniture for Morris & Co., and designing his own frames.

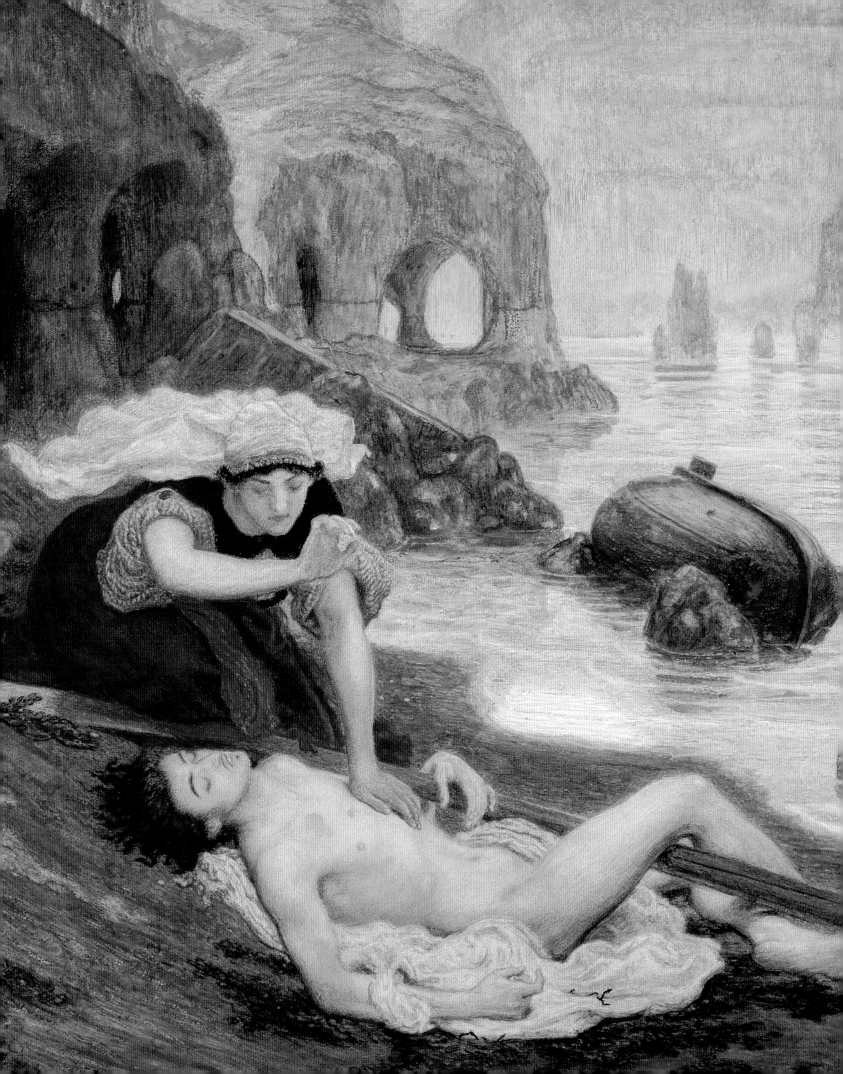

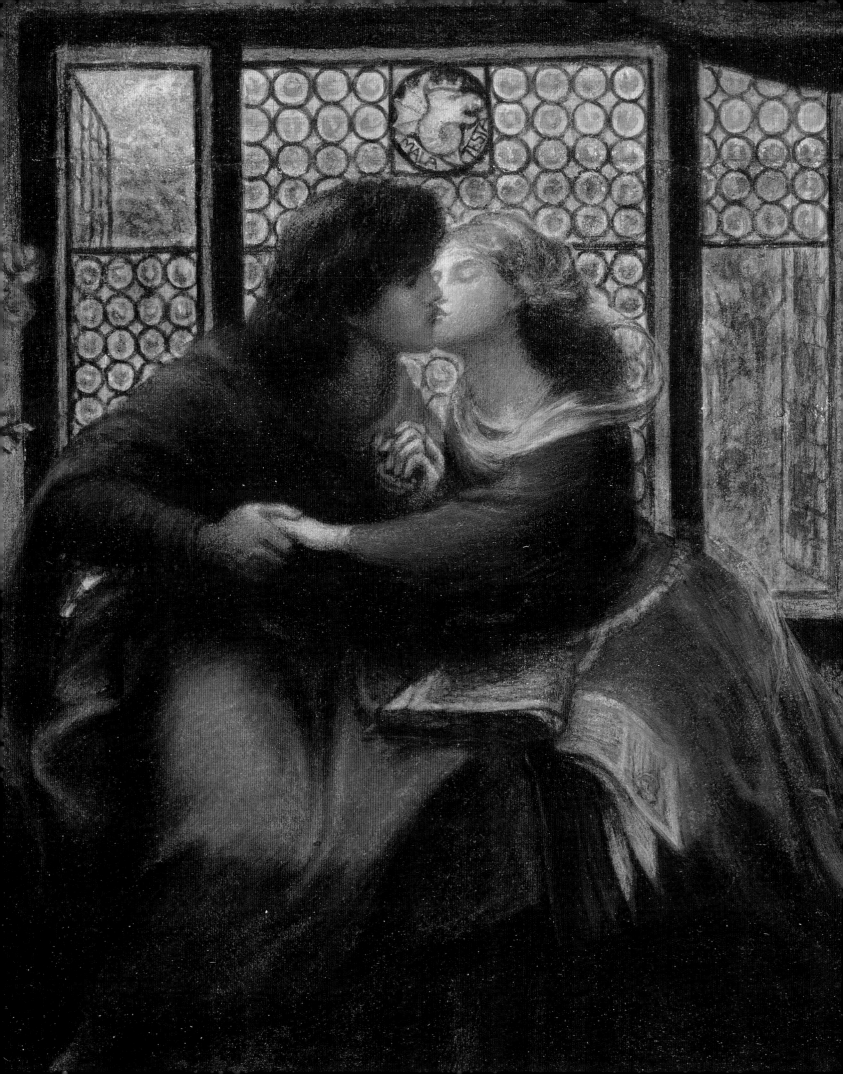

The forbidden love of Francesca da Rimini and her brother-in-law Paolo Malatesta is one of the great love stories of European literature. Dante encountered the souls of the two lovers in Hell, and fainted with compassion upon hearing their tragic story. This watercolour depicts the fateful moment when

> One day
> For our delight, we read of Lancelot,
> How him love thrall'd. Alone we were, and no
> Suspicion near us … then he, who ne'er
> From me shall separate, at once my lips
> All trembling kiss'd. The book and writer both
> Were love's purveyors. In its leaves that day
> We read no more …
> —Dante, *Divine Comedy, Inferno,* canto V

Just as the story of the illicit love between the knight Lancelot and King Arthur's wife, Guinevere, inflamed the passion of Paolo and Francesca, so the subject of romantic love in medieval literature captured the imagination of writers and artists of the Victorian period. Dante Gabriel Rossetti, one of the founding members of the Pre-Raphaelite Brotherhood and a poet himself, was fascinated with the story of Paolo and Francesca, having grown up immersed in the work of Dante, after whom he was named. His father, a professor of Italian, Rossetti's siblings and he himself published translations and commentaries on Dante's writings.

This watercolour, which glows like a medieval stained-glass window, is an elaborated version of the left-hand panel of a triptych painted in 1855 (now in the Tate, London). The central panel of the Tate triptych depicts Dante and Virgil gazing in distress towards the right panel, in which the intertwined lovers float through the flames of Hell, their eternal punishment following their murder by Francesca's enraged husband, Paolo's brother. The National Gallery of Victoria's watercolour shows the lovers seated in an alcove before a bottle-glass window. The illuminated book slips, unnoticed, off Paolo's lap as he embraces red-haired Francesca, who is modelled on Rossetti's deceased wife and muse, Elizabeth Siddal. The watercolour was originally considerably smaller and was attached to another larger sheet, which allowed for the embellishments of the roses at their feet and side, and the coat of arms and draped ceiling above.

Dante Gabriel Rossetti
English 1828–1882
Paolo and Francesca da Rimini
1867
watercolour, gouache and gum arabic over pencil on two sheets of paper
43.7 x 36.1 cm
Surtees 75 R2
Felton Bequest, 1956 (3266-4)

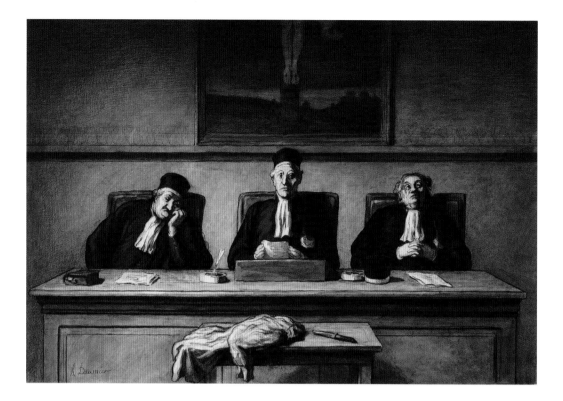

Honoré Daumier
French 1808–1879
The incriminating evidence (*Les Pièces à conviction*) c. 1865–68
pen and ink, watercolour, wash, black and coloured crayon, and gouache
32.4 x 47.0 cm
Maison II.642
Felton Bequest, 1924
(1336-3)

The high drama enacted daily in the courtrooms of the Palais de Justice in Paris provided the inspiration for some of Honoré Daumier's most caustic satirical studies. In the late 1840s Daumier executed a series of thirty-nine lithographs, *Les Gens de justice* (Men of Justice), in which he eloquently derided the rapacity and hypocrisy of lawyers and the antipathy of a somnolent judiciary. He revisited and refined this successful theme throughout the 1850s and 1860s, ultimately producing around two hundred lithographs, paintings and highly finished drawings of legal subjects.

Daumier did not draw directly from life. Rather, his subjects represent a synthesis of his acute observations. The artist's compositions are peopled with archetypal figures whom we can all recognize. Daumier avoided constructing overly complex narratives in his satirical prints and drawings, recognizing the great power of symbolic gesture and facial expression to communicate an 'eternal truth'. In *The incriminating evidence* three judges 'consider' a pile of bloody evidence placed before the bench; above them hangs a painting of the Crucifixion. The key to the dire situation is masterfully implied by the triumvirate's glazed and apathetic expressions.

Daumier was no stranger to the workings of the law. As a boy he found work running errands for a notary, observing at first hand the various legal types that he would later pillory so effectively. He also witnessed his father's frustrated attempts to settle financial disputes in court, and in 1831 found himself in the dock after the journal *La Caricature* published the notorious satirical lithograph in which he portrayed King Louis-Philippe as a grotesque, pear-shaped Gargantua. In 1832 Daumier was imprisoned for six months.

Daumier was, by all accounts, a modest and unassuming character. Throughout an unstable and repressive era he remained a committed defender of the republican principles of economic, political and social equality, democracy and the freedom of speech. Although he claimed to have 'not a particle of ambition' and to be lazy by nature, between 1832 and 1872 Daumier's output included some 4000 lithographs for journals and books, designs for 1000 wood engravings, 500 paintings, 1000 drawings and many sculptures in clay!

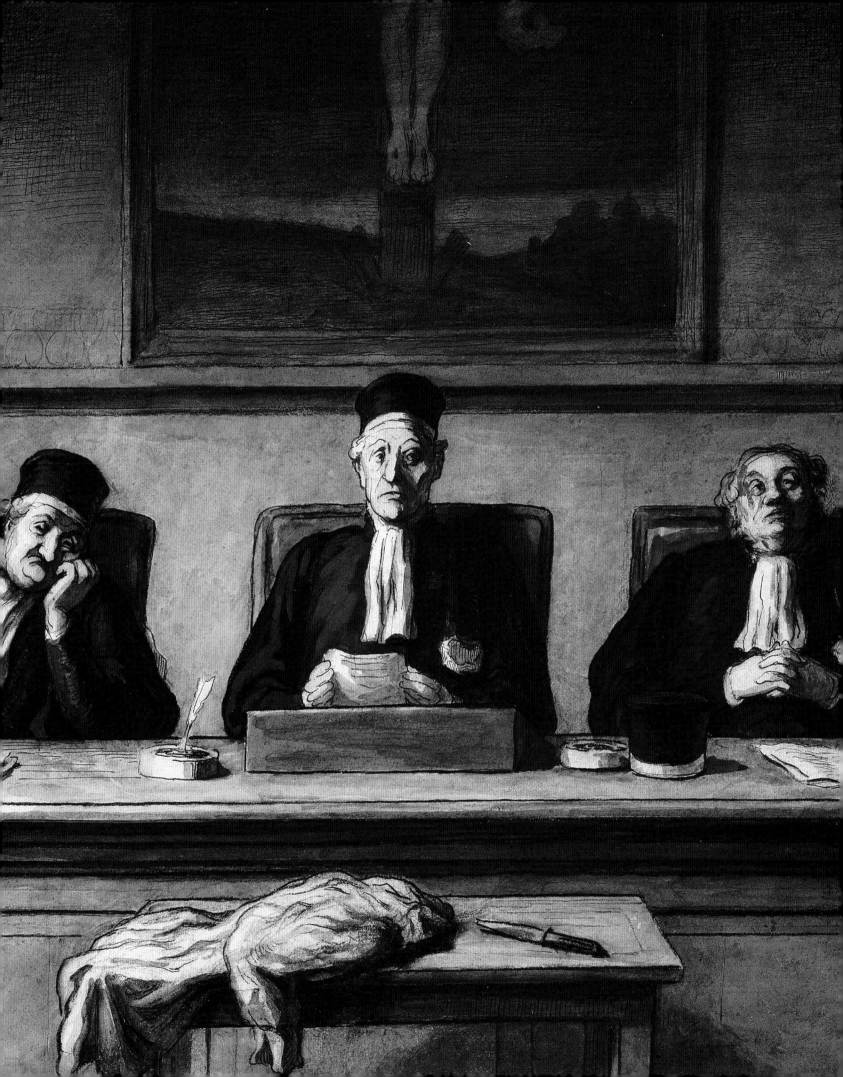

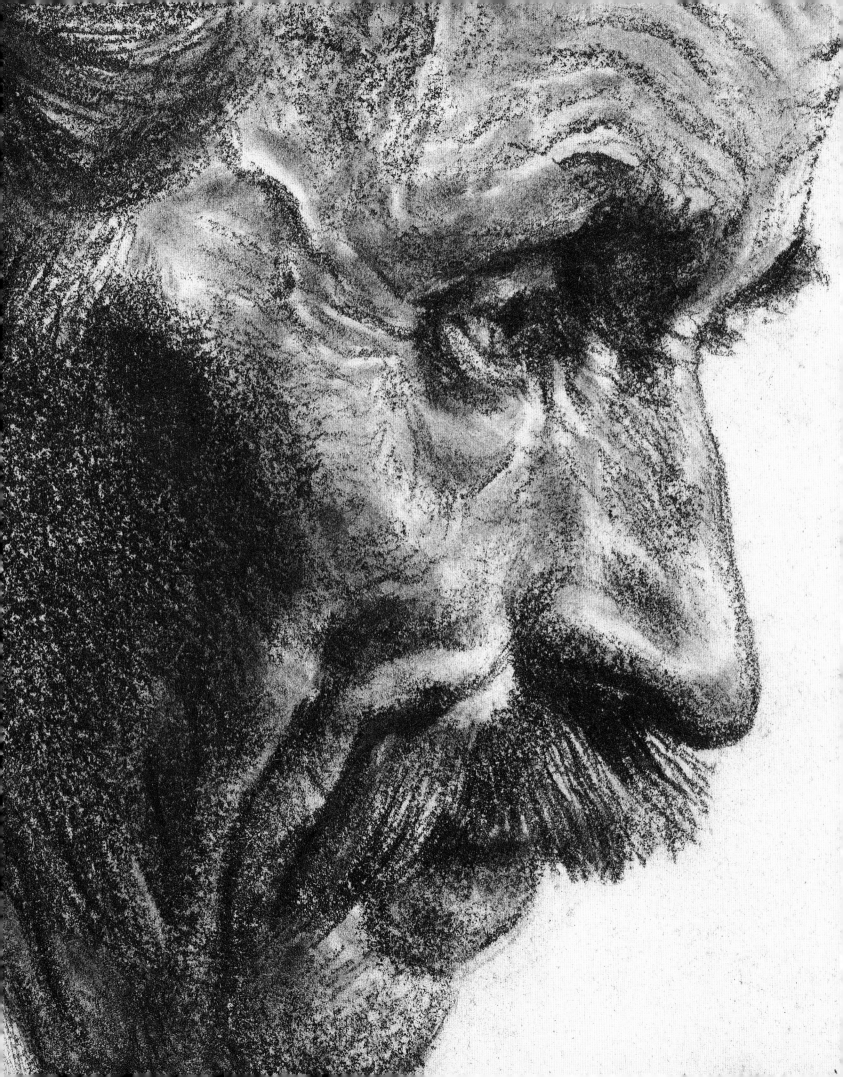

Adolph Menzel made this drawing in 1886, the year he was appointed Chancellor of the Arts and Sciences by the Prussian government. In the previous year, on the occasion of his seventieth birthday and at the height of his career, Menzel was honoured with a large exhibition of his work at the Royal Academy of Arts in Berlin. A painter of modern history subjects, he had made his name as court painter to Emperor Wilhelm II of Prussia. The results of this public career only occasionally hint at Menzel's unique gifts as an artist that are fully revealed only in the private realm of his drawings.

Throughout his long life, Menzel drew continuously in sketchbooks, and these drawings demonstrate his remarkable powers of observation, as well as his eye for the unexpected and the unusual. Whether employing compositions that emphasized a fragment at extreme proximity or the whole object at a distance, Menzel's drawings are often suggestive of chaos, showing, for example, an unmade bed, the overflowing bookcase of a friend, or a bundle of documents in an old trunk. Similarly, his drawings of Berlin, his home for seventy-five years, chart the transformation of the growing city, not through grand panoramas but through small, closely observed scenes. These emphasize the spaces in between buildings, or the strangely abstract, desolate sight of an overflowing gutter. Menzel's sketchbooks also record his sustained interest in the architecture of the Baroque and Rococo epochs. These studies of the elaborate ornamentation of church interiors exude an air of melancholy that speaks of the inevitable passage of time.

In the last decades of his life, Menzel devoted himself to drawing the human face. His subjects were predominantly older models, with lined, expressive faces. His portraits, such as in this drawing of a man, were made using a soft pencil, which Menzel applied with delicacy or force depending on his desired effect. By emphasizing each wrinkle and fold of the skin, Menzel brilliantly conveys the accumulated years of the man's life experience.

Adolph Menzel
German 1815–1905
A man's head 1886
pencil
20.9 x 12.8 cm
Purchased, 1895 (2-2)

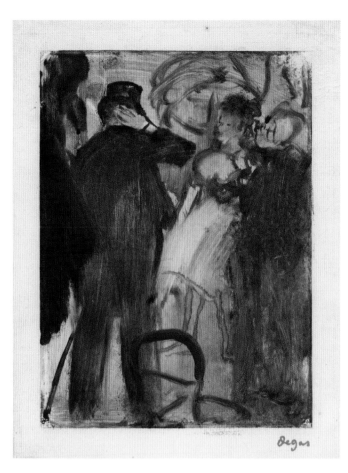

Edgar Degas
French 1834–1917
The most embarrassed was the Marquis Cavalcanti (*Celui qui tournait le plus, c'était le marquis Cavalcanti*) c. 1880–83
monotype
21.3 x 16.0 cm (plate);
27.3 x 19.6 cm (sheet, irreg.)
Janis 222
Purchased, 1974 (P2-1974)

This is one of a series of monotypes made by Edgar Degas as illustrations for the novel, *La Famille Cardinal* (The Cardinal Family), written by his friend, Ludovic Halévy. The novel tells the story of its eponymous family: Monsieur Cardinal, whose political aspirations are ably supported by the 'redoubtable' matriarch Madame Cardinal, and their two daughters, Virginie and Pauline, both ballet dancers at the Opéra. In illustrating the novel, Degas chose to focus largely on the encounters that occurred in the passages 'with nooks and corners dimly lighted' behind the stage, rather than on other elements of the story. Consistent with Degas's predilection for theatre and ballet subjects at this time, this thematic focus may be the reason why the monotypes were rejected in favour of more literal illustrations that reflected the breadth of the narrative. Degas's illustrations were not reproduced with Halévy's text until the posthumous 1938 edition of the book.

Degas's atmospheric evocations of life backstage have been likened to photography in the way that they capture brief and informal moments in time. This monotype depicts an exchange between Madame Cardinal, standing beside one of her daughters (probably Virginie), and the Marquis Cavalcanti. Cavalcanti's awkward gesture of embarrassment may be a response to being discovered conversing with the unchaperoned girl by her protective mother – a recurring theme throughout the novel and one involving various gentlemen.

Although he disliked the term intensely, Degas was closely associated with the Impressionist movement and participated in a number of the group's exhibitions. His oeuvre was distinguished from that of his colleagues by its 'realist' approach to subject matter drawn from contemporary urban life. He was introduced to the monotype technique in the mid-1870s by Vicomte Ludovic Napoléon Lepic, an engraver and member of the Société des Aquafortistes (Society of Etchers). Describing his monotypes as '*dessins faits avec l'encre grasse et imprimés*' (drawings made with greasy ink and put through a press), Degas enjoyed the immediacy of expression that the process encouraged, as well as its emphasis on tonal composition. The majority of monotypes for *La Famille Cardinal* were made in the 'light field' manner, wherein Degas painted directly onto the plate. This work also incorporates areas such as the skirt of the dancer's costume, in which the ink painted onto the plate has been wiped back in a manner known as 'dark field'.

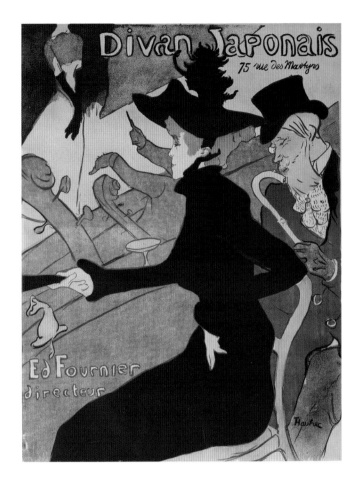

In the last decades of the nineteenth century, Paris offered a glittering array of public amusements including cafes, *café-cabarets*, dance-halls, theatres, circuses and fancy-dress balls. Centred around the bohemian, working-class suburb of Montmartre, these entertainments and their stars provided colourful, unconventional subject matter for the prints, drawings and paintings of Henri de Toulouse-Lautrec.

In this poster, advertising the Café du Divan Japonais, Lautrec depicts Jane Avril, the famous cancan dancer, austerely clad in black, seated beside the bearded and monocled author and critic, Édouard Dujardin. On the stage behind, recognizable by her slender frame and trademark long black gloves, Yvette Guilbert performs her famous repertoire. Opened in 1882, the Café du Divan Japonais changed hands in 1893 when it was taken over by Édouard Fournier. Commissioned by Fournier in January of that year, this poster was a great success; however, the venue's popularity soon waned, and by July it was closed.

Decorated with bamboo chairs, lanterns, silks and fans, and with kimono-clad waitresses, the Café du Divan Japonais exemplified the current craze for *Japonisme*. Fascinated by Japanese art, and particularly *ukiyo-e* woodblock prints, Lautrec infused his work with its distinct aesthetic, which includes strong, expressive outlines; flat, decorative colours free from tonal modelling; and dramatic, asymmetrical compositions. All of these features are demonstrated here: the abrupt cropping of Guilbert's head (a detail that may also refer to the cafe's notoriously low ceiling), the angled view across the orchestra pit's protrusions to the stage, the flattened design and simplified zones of colour. Each of these elements was perfectly suited to colour lithography, a technique formerly denigrated for its commercial applications but which experienced an explosion of interest in the 1890s, with Lautrec its supreme innovator and outstanding master. Produced as posters, prints, illustrations, theatre programs and songsheets, his lithographs have come to epitomize the glamour and decadence of *fin-de-siècle* Paris.

Henri de Toulouse-Lautrec
French 1864–1901
Divan Japonais 1893
colour lithograph
78.5 x 59.5 cm
(image and sheet)
Delteil 341
Felton Bequest, 1948
(1846-4)

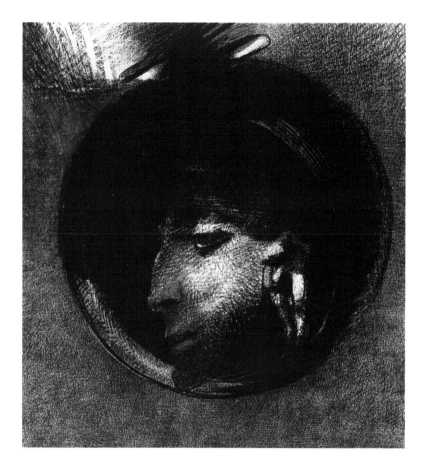

Odilon Redon
French 1840–1916
Auricular cell (*Cellule auriculaire*)
published in *L'Estampe originale*
(The Original Print), album II, 1893
lithograph on chine collé
26.8 x 24.9 cm (image);
59.1 x 43.1 cm (sheet)
Mellerio 126 (ii/ii)
Purchased, 1978 (P35-1978)

Odilon Redon's dark dreamlike images epitomize the late nineteenth-century aesthetic of Symbolism, a movement that encompassed literature, music, theatre and art. Inspired by contemporary interest in mysticism, spiritualism and the occult, Symbolism aimed to evoke and suggest rather than to describe or represent. While subjective, Redon's images are not purely imaginative but demonstrate the artist's thorough knowledge of Western art and his study of the natural world: they also reflect his response to current events, literature, scientific developments and theological ideas. Redon's work appealed largely to the Parisian avant-garde, and appreciation of his mysterious images varied enormously; some critics were scathing and confused, while others effusively proclaimed his genius.

Although he also produced sumptuous drawings, pastels and oil paintings, Redon is perhaps best known as one of the great exponents of lithography, which was undergoing a revival in France at the time. He initially adopted the technique as a means of replicating and publicizing his bizarre, melancholic charcoal drawings, which he called his *Noirs* ('Blacks'). However, he quickly recognized the unique qualities of the medium and began exploring its tonal possibilities, capturing velvety textures and intense blacks not previously seen in lithography.

Auricular cell was commissioned for *L'Estampe originale*, a quarterly publication of original prints produced between 1893 and 1895, one of many such artistic portfolios that appeared throughout the 1890s. The head recalls Eugène Delacroix's portrayal of the demonic spirit Mephistopheles in his 1828 illustrations for Goethe's *Faust*, while its elongated earlobes also demonstrate Redon's interest in Buddhism and Asian spirituality. The enigmatic title is suggestive of the current theory of synaesthesia, espoused by the writer Charles Baudelaire – a belief in the importance of the interaction of all the senses to achieve universal harmony. This may be indicated by the focus on the disembodied floating head. Redon's great passion for music may also be reflected in the aural emphasis.

As a leading Symbolist, Redon was revered by a younger generation of French artists, particularly those associated with the Nabi and Fauve movements, including Paul Gauguin, Pierre Bonnard, Édouard Vuillard and Henri Matisse.

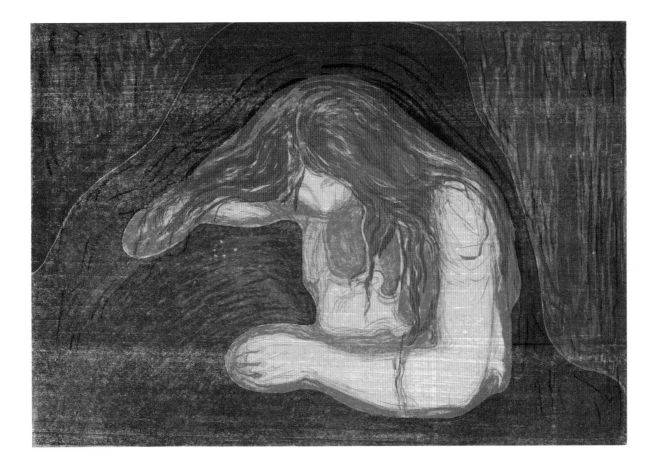

The female vampire was one of the many personifications of the *femme fatale* during the nineteenth century, a figure who fascinated Edvard Munch with her ability to captivate and subjugate men with her sensual beauty. Munch first painted this composition in 1893, and included it in his cycle of paintings, drawings and prints known as *The Frieze of Life*, in which he explored psychological issues relating to two of the fundamental human experiences, love and death. Munch himself said that the image simply portrayed a woman tenderly kissing a man on the neck, although the original title *Love and Pain* suggests a more complex interpretation. The foreboding shadow that looms in subsequent versions creates a claustrophobic aura, made explicit by its later title. The female leans over the complicit male, her diabolical red hair flowing like blood over his buried head and enveloped form.

Having begun printmaking in 1894, Munch produced a lithograph of this image in the following year, printing from a single stone and enhancing a number of impressions with handcolouring. In 1902 he returned to the image and experimented with applying colour using stencils. However, he rejected this process in favour of using relief printing over the lithographic image. This impression is created from the original lithographic key stone (printed in grey), a second stone (red) and a woodblock that has been sawn into four sections, inked separately with blue, green and yellow inks, but reassembled like a jigsaw puzzle and printed as one block. This ingenious method of colour printing, together with Munch's celebration of the woodblock's intrinsic qualities – evident in the printed woodgrain and the vigorous gouging of the block – inspired German Expressionist printmakers a few years later.

One of the great Symbolist artists, Munch spent influential years in Paris (1889–92), and most of the following sixteen years in Berlin, before returning to his native Norway.

Edvard Munch
Norwegian 1863–1944
Vampire 1895–1902
colour lithograph and colour woodcut
38.7 x 55.5 cm (image);
52.1 x 65.9 cm (sheet)
Schiefler 34.IIb; Woll 41.VI
Purchased, 1955 (3150-4)

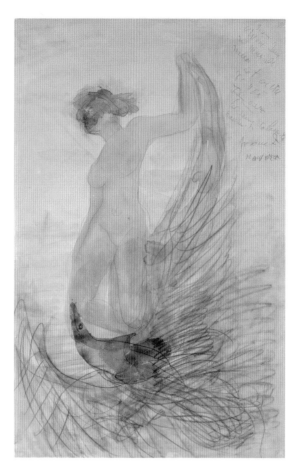

Auguste Rodin
French 1840–1917
Nude with drapery c. 1904–5
pencil and watercolour
50.3 x 32.3 cm
Purchased from Admission Funds,
1971 (P6-1971)

The drawings that Auguste Rodin made in the last twenty years of his long career are a surprise in many ways. From the 1890s until his death in 1917, the renowned French sculptor concentrated almost exclusively on drawing the naked female figure from life. These pencil and watercolour drawings have a remarkably free quality, both in their approach to the figure and to the medium. Rodin's vast output from this period is characterized by its great originality and consistency of style. His quest to capture the uninhibited movements of his models saw him devise a new method of working. This entailed drawing the unposed model without looking down at the paper, his hand following what his eyes saw. Rodin chose non-professional models and abandoned academic poses, the results being drawings that possess an exuberance that is expressive of his models' youthful vigour. Rodin noted that these drawings were the result of the knowledge of the human figure he had acquired through his work as a sculptor.

The truth of this claim is clearly evident in *Nude with drapery*, where the placement of a few lines convincingly conveys the flesh and bone structure of the figure. Although spontaneity and an unselfconscious line were the key to Rodin's approach, the drawings evolved through a complex process, which often included reworking, and even tracing. After 1900 he introduced watercolour into his drawings, the wash loosely following the shape of the figure. As is the case with *Nude with drapery*, the addition of wash often provided a context for these floating nudes or even hinted at narrative content. A boat on the distant horizon confirms that the figure is rising from the sea. The fluid application of wash over her face, body and draperies enhance the effect of her watery surroundings. Rodin contrasts the serene movement of the figure with a frenzy of looping lines at her feet. The agitation of these lines is suggestive of animal energy – perhaps that of a bird, or a dolphin, or in a more abstract sense, the libidinous energy of the artist.

Although the chronology of Rodin's drawings is difficult to establish, *Nude with drapery* is thought to date from 1904–5. His drawing practice was to have an unexpected impetus in 1906 with the arrival in France of a dance troupe from Cambodia, whose performances inspired him to write: 'All you can say is that all movements of the body, if they are harmonious and right, can be inscribed within a geometric pattern whose lines are simple and few'.

Erich Heckel
German 1883–1970
Standing child (*Stehendes kind*)
1910
from the portfolio *Brücke 1911*
colour woodcut
37.5 x 27.7 cm (image, irreg.);
54.2 x 40.0 cm (sheet)
Dube 204.b2
Felton Bequest, 1974
(P150a-1974)
© Erich Heckel, 1910/VG BILD-
KUNST
Licensed by VISCOPY, 2003

A catalyst in the development of German Expressionism, Die Brücke (The Bridge) was an association of artists founded in Dresden in 1905 by four young architecture students, one of whom was Erich Heckel. The aim of the group was to reinvigorate art with an authenticity of expression that the members felt was lacking in contemporary society and in contemporary art. They were quickly joined by like-minded artists. In order to capture the essence of their subject matter, they simplified form, tone and perspective, and employed strong outlines and pure, flat colours that were applied expressively, seemingly crudely. Influenced by the prints of Edvard Munch, Paul Gauguin and early German artists, the artists of Die Brücke were drawn to printmaking, which became an integral part of their oeuvres. They were revolutionary in their technical innovations, creating prints of a vibrant and raw originality. Their prolific output was pivotal in the renaissance of German printmaking during the early years of the twentieth century.

The model for Heckel's iconic colour woodcut, *Standing child*, was twelve-year-old Fränzi who, with her sister Marzella, often modelled for Die Brücke. In the roughly gouged image, the angles of her undeveloped figure contrast with the curved hills depicted in the background, which is, in fact, a painted backdrop. These curves are echoed in the arching eyebrows, and the rounded forms of her belly and groin. Using an irregularly shaped block that tapers on the upper right, Heckel focused his attention on Fränzi's face, whose mask-like features are clearly influenced by the sculptural simplicity and angularity of African and Oceanic art. Heckel was familiar with the art of these tribal cultures through his visits to the Ethnological Museum in Dresden and through his brother who worked in German East Africa. This emphasis on childhood innocence and on non-European, so-called 'primitive' cultures reflects the yearning of the German Expressionists for a re-establishment of the harmony between humankind and nature that had been destroyed by modern urban life. Fränzi's knowing glance and secretive smile, however, suggest an awareness of her budding sexuality.

Standing child appeared in the sixth of Die Brücke's annual portfolios, which were produced for passive members (subscribers) of the group, and which were an essential source of both income and publicity for the artists. The 1911 portfolio was devoted to Heckel, and comprised a lithograph, a drypoint and this outstanding woodcut. The complete portfolio, in pristine condition, is in the National Gallery of Victoria's collection.

Amedeo Modigliani's meeting in Paris in 1909 with Romanian sculptor Constantin Brancusi inspired the painter to return to what he considered his true calling – sculpture. Brancusi's artistic independence and his radically simplified forms, evocative of tribal art, made a deep impression on Modigliani. Initially he carved a series of over twenty heads from sandstone, then embarked on a study of the female figure in an ambitious undertaking that he called 'colonnes de tendresse' (columns of tenderness). The project was conceived as a group of caryatids – stylized representations of women that functioned as columns or pilasters in an architectural setting. These sculptures were planned for a secular temple devoted to the beauty of humankind. From 1909 until 1914–15 Modigliani explored his ideas for the project in a series of about fifty drawings.

These drawings chart Modigliani's progressive refinement of his conception of the ideal form through an analysis of the female figure in a restricted number of poses. The caryatid drawings include examples of highly decorative figures reminiscent of Egyptian art, as well as those with greatly simplified forms, such as seen in this sheet. The influence of African art, which had such a profound effect on the art of many of Modigliani's contemporaries, is evident in the poses of the figures and their mask-like faces. Modigliani's search for an ideal form, worthy of a temple devoted to ideal beauty, relied on his keen observation of living bodies. The sensuality of the figure's unfurling, abstracted forms is conveyed by such details as the volume of the thigh and the plump upper arms. The distinct hatching marks surrounding the contour of the caryatid figure are evocative of the motion of the sculptor's chisel.

In April 1913 Modigliani wrote to his friend and only patron at the time, Paul Alexandre: 'Fulfilment is on its way … I will do everything in marble'. The artist was embarking on a trip to Carrara, the finest marble quarry in Italy, where he hoped finally to realize his long-held ambition to sculpt his caryatids. Modigliani's grand ambitions were never realized, and he abandoned the project because of his fragile health after completing only one caryatid sculpture (now in the Museum of Modern Art, New York). The artist returned to painting portraits, for which he is primarily known.

Amedeo Modigliani
Italian 1884–1920;
worked in France
Caryatid c. 1913–15
blue and black crayon over traces
of pencil
64.6 x 49.9 cm
Bequest of Howard Spensley, 1939
(609–4)

Pablo Picasso
Spanish 1881–1973;
worked in France
Still life with a bottle of Marc
1911 (printed 1912)
drypoint, ed. 51/100
49.8 x 30.5 cm (plate);
71.8 x 54.8 cm (sheet)
Geiser/Baer 33b
(after steelfacing of the plate)
Felton Bequest, 1988 (P121-1988)
© Pablo Picasso, 1911/
Succession Picasso
Licensed by VISCOPY, 2003

Pablo Picasso was one of the most acclaimed artists of the twentieth century. His stylistic diversity was legendary, ranging from Cubist abstraction to neoclassical simplicity and expressive figuration. Exceptionally prolific, Picasso worked in a variety of media including painting, sculpture, graphics and ceramics, and was renowned for extending the technical boundaries of all of these art forms.

Between 1907 and 1914 Picasso and Georges Braque developed Cubism, the most revolutionary artistic movement of the twentieth century. Cubism not only introduced formal innovations but, significantly, a new approach to picture-making. Employing shallow pictorial space, faceted planes and the substitution of multiple viewpoints for traditional, single-point perspective, Cubist works introduced a radical new abstraction of form. Their insistent two-dimensionality drew attention to the work of art as an object in itself, rather than as a window onto an illusion.

A masterpiece of his so-called 'analytical' Cubist phase, this large print was executed by Picasso in the late summer of 1911. Seemingly abstract, the work, in fact, is related to a series of Cubist still-life paintings of objects arranged on bar tables. Close scrutiny of the composition reveals the oblique corner of a bar table in the lower centre, and the recurring arcs of glasses and bottle necks in the upper centre. These objects have been fractured and spatially merged with the background, creating a complex reconstruction of reality. External reality is also emblematically introduced through the inclusion in the composition of the words 'VIE MARC' (Vieux Marc was a rough brandy), and the pip markings of playing cards. These not only signify concrete objects but have also been interpreted as coded references to Picasso's life. At the end of 1911 Picasso took a new mistress, Marcelle Humbert (known as Eva), and the prominent heart and first four letters of her name – 'MARC' – may be clandestine references to her.

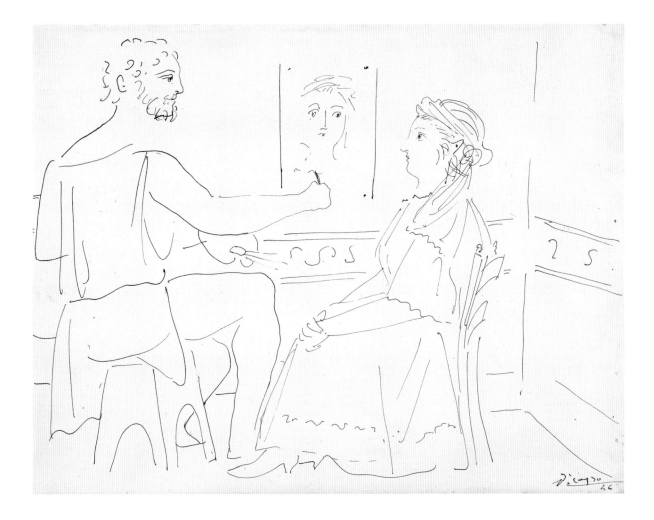

In 1926 the publisher Ambroise Vollard commissioned Pablo Picasso to illustrate Honoré de Balzac's novel *Le Chef-d'oeuvre inconnu* (The Unknown Masterpiece) (1831). Set in the seventeenth century, this fable tells of an elderly artist, Frenhofer, who spent ten years trying to encapsulate, in a painting, the essence of female beauty. When his masterpiece was finally unveiled, his uncomprehending friends saw nothing but confused colours and lines, meaningless to everyone except the artist.

This illustration, which is endowed with a sense of classical harmony, is one of a number of drawings for the novel that Picasso made while holidaying at the Mediterranean port of Juan-les-Pins. Here he produced several drawings on the theme of the artist and his model, initiating his lifelong exploration of the relationship between the artist, his model and the resulting creation. Employing various media, Picasso obsessively scrutinized his role and power as a creator, as well as his passion for his art and for his models and muses.

In *The pose of the model* Picasso suggests the god-like power of the artist by depicting him clad in classical robes, like Apollo, the Greek god of poetic (and artistic) inspiration. The distilled calligraphy adds a liveliness to an otherwise introspective and contemplative scene. Picasso's interest in classical art had been revived in 1917 when he travelled to Italy, visiting Rome, Naples, and the ruins of Pompeii and Herculaneum. Inspired by ancient Greek, Roman and Etruscan art, as well as by the art of neoclassical painters such as Jean-Auguste-Dominique Ingres, he developed a pure and unmodulated line. In later years he incorporated mythological characters, such as the minotaur, into his repertoire of classical images. These features reflect a renewed and widespread interest in the various forms of classicism during the 1920s.

Le Chef-d'oeuvre inconnu was finally published in 1931, and was illustrated with thirteen etchings, four reproductions of drawings (including this work) and numerous wood engravings after Picasso's designs. This series of illustrations can be seen as a forerunner to Picasso's acclaimed *Vollard Suite*, 1930–37, in which almost half of the etchings explore the theme of the artist (as sculptor) in his studio.

Pablo Picasso
Spanish 1881–1973;
worked in France
The pose of the model 1926
pen and ink
29.1 x 37.8 cm
Zervos VII.44
Felton Bequest, 1948 (1852-4)
© Pablo Picasso, 1926/
Succession Picasso
Licensed by VISCOPY, 2003

Henri Matisse
French 1869–1954
The white fox (*Le Renard blanc*)
1929
lithograph, ed. 9/75
51.5 x 37.0 cm (image);
66.1 x 50.8 cm (sheet)
Duthuit 514
Purchased, 1981 (P45-1981)
© Henri Matisse, 1929/
Succession Matisse
Licensed by VISCOPY, 2003

The stylishly dressed young woman in this exquisite lithograph has been identified as Lisette, one of Matisse's models of the late 1920s. Despite the portrait-like appearance of the print, the fashionable attire she wears is likely to have been selected by Matisse from his closet of dresses and costumes that he kept on hand for his theatrically arranged compositions. Since the late 1910s Matisse had been living in the French Mediterranean city of Nice, which had attracted him with its brilliant light and warmth, and the escape it offered from societal and familial pressures. During this time his work focused on sun-drenched landscapes, interior scenes and, in particular, orientally inspired odalisques – sensuous images of women in decorative settings, often shown naked or clad in Persian or Turkish costumes.

Matisse was an accomplished but intermittent printmaker. In 1929 he virtually abandoned his highly coloured paintings to focus on his prints, through which he analysed light, tone and line. These prints vary from images that are reduced to a few expressive lines to those that are tonally modelled, such as this, one of his most elaborately worked lithographs. The tactile elements of *The white fox* – the carefully arranged hair, the lace-edged dress adorned with a knotted string of pearls and a corsage, and the lusciously soft fur cloak that gives the work its title – are captured with innumerable delicate crayon strokes. Unlike the highly patterned screens and floral hangings that often seem to overwhelm the odalisques, the backdrop here comprises a simple vertical pattern that serves to focus attention on the patient expression on the model's tilted face, which is dominated by her large eyes. Matisse's consummate modelling is especially evident in the chiaroscuro of her partially shaded face, which is caught in the light emanating from the upper left. Monochromatic, like most of his prints, this lithograph's great tonal range conveys a captivating warmth and tranquillity.

This fine impression was originally owned by Marguerite Duthuit, Matisse's daughter.

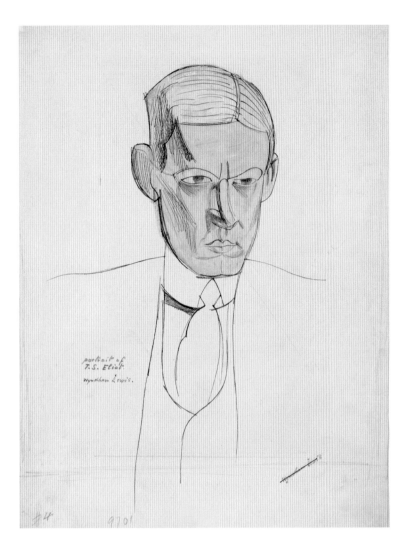

The crisp angular lines of Wyndham Lewis's portrait drawings of the 1920s and 1930s seem especially appropriate for his sophisticated sitters. These included leading modernist writers and poets such as Ezra Pound and T. S. Eliot, both close friends of Lewis, whom he drew and painted on many occasions. In this portrait of Eliot, Lewis conveys his friend's formidable intellect with an assured and sharp line. It is unclear when the portrait was executed, although dates from 1920 through to the 1930s have been proposed. The drawing was certainly substantially completed by 1937, when it was reproduced in Lewis's autobiography *Blastering and Bombardiering*, published that year. Lewis later returned to the drawing, adding colour wash to the face and elaborating details of Eliot's hair and coat.

Between 1902 and 1908 Lewis travelled widely throughout Europe where he came into contact with the most progressive artistic developments of the time that would subsequently culminate in Expressionism, Cubism and Futurism. These movements had a decisive influence upon Lewis, and led to the development of the English avant-garde art movement known as Vorticism. Artists and writers associated with the movement, such as Lewis and Eliot, sought to communicate the harsh reality of early twentieth-century city life by employing an abstracted, geometrical style. Lewis's drawings and paintings convey the fast and exciting character of the machine age, as well as its dehumanizing aspects.

The critical success of Eliot's poem *The Wasteland* (1922) and his influential editorship of the quarterly *Criterion* (1922–39) had a lasting impact on the literary scene in England. Although Lewis satirized Eliot's success in two of his novels, he continued to depict the poet sympathetically in his drawings and paintings. These portraits culminated in one of Lewis's masterpieces, a full-length naturalistic portrait that the artist submitted to the Royal Academy's annual exhibition in 1938. The painting's rejection and Augustus John's subsequent resignation from the Academy's committee in protest, caused a national scandal.

Percy Wyndham Lewis
English 1882–1957
T. S. Eliot 1930s
pen and ink, coloured washes
and pencil
35.2 x 26.4 cm (irreg.)
Michel 947
Felton Bequest, 1950 (2227-4)
© Courtesy of the estate of Mrs
G.A. Wyndham Lewis

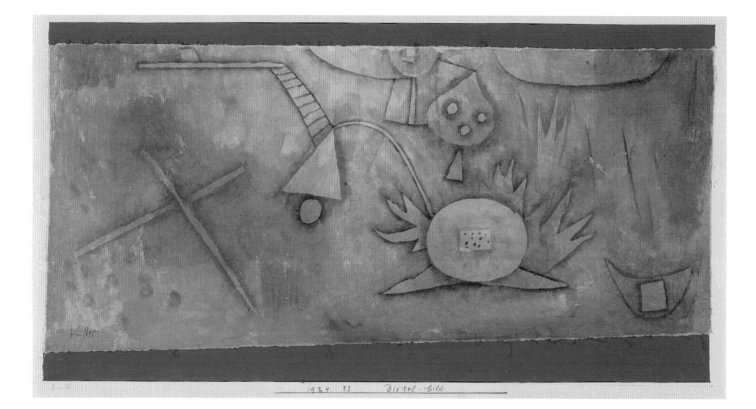

Paul Klee
Swiss 1879–1940;
worked in Germany
Thistle picture (*Distel-bild*) 1924
gouache and watercolour on linen
laid down on card, painted with
gouache
21.0 x 40.6 cm (image, including
gouache segments on card);
38.1 x 54.3 cm (card)
Paul-Klee-Stiftung 3441 (1924,73)
Purchased, 1953 (2999-4)

Paul Klee was a unique figure in the history of twentieth-century modernism. Closely associated with the important German school of architecture and applied arts known as the Bauhaus, where he taught from 1921–31, he was as influential for his theories and teachings as for his artistic practice. Klee was a prolific artist, who produced over 8000 works during his career that range stylistically from the abstract to the figurative. While his work is difficult to categorize, it is acclaimed for its whimsy, its dream-like qualities and its formal purity.

'Art does not reproduce the visible but makes visible', wrote Klee in 1918, articulating one of his fundamental artistic premises in the essay 'Creative Credo'. While nature was his ultimate model for artistic activity, Klee did not aspire to repeat its external forms, but rather to replicate its internal forces of creation. These forces, in combination with the artist's fertile imagination, led to the creation of the fantastic realms that are such a distinguishing feature of much of his work.

Thistle picture is an important example of this aspect of Klee's practice. Dating from his early years at the Weimar Bauhaus, the work presents a mysterious world of ambiguous, floating forms. Some of these, such as the central flower-like shape with jagged leaves, are suggestive of the natural world; others, such as the ladder, derive from the constructed world; while others still, such as the hovering bellows-shaped form that bears a schematic face, are purely imaginary. Although the meaning of the work is enigmatic, the sense of an 'other' world – perhaps underwater, perhaps aerial – is strongly conveyed, not only through the forms but also through the work's construction. The dominant colour is a subtly modulated blue-grey, which varies in translucency, opacity and tonality, creating an undulating spatial depth in which the forms float. The forms themselves are picked out in delicate washes of purple, brown, crimson and orange that have been brushed over paper stencils. The resulting shadowy haloes that surround the crisp outline of the forms contribute to their ethereal nature. A mysterious and evocative work, *Thistle picture* opens the viewer to the possibilities of realities other than the visible.

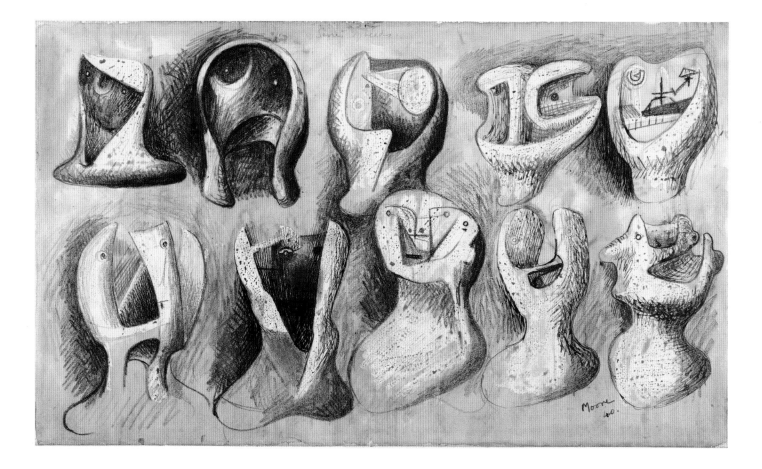

Henry Moore
English 1898–1986
Head studies for sculpture 1940
coloured pencils, pen and ink, pencil,
wash and white wax crayon
25.7 x 43.4 cm
Henry Moore Foundation 1493
Allan R. Henderson Bequest, 1956
(3421-4)
© Reproduced by permission of the
Henry Moore Foundation

Drawing was an essential stage in the working process of British sculptor Henry Moore until the 1950s, when he began to experiment increasingly with small-scale models. This sheet, *Head studies for sculpture*, demonstrates his method of filling his sketchbooks with designs showing preliminary ideas and evolving forms, from which one sketch might be selected to translate into three dimensions.

From his student days Moore was captivated by Pre-Columbian, African, Oceanic and other non-Western sculpture. During the 1930s he became interested in Surrealism. In particular, he admired the abstract, often aggressive, sculpture of Pablo Picasso and Alberto Giacometti, and the biomorphic objects of Hans Arp, whose work encouraged him towards a more organic form of abstraction. While the human figure was always his main source of inspiration, Moore became increasingly fascinated by natural forms. His work reflected his belief that the human body is echoed in all natural forms and spaces, from expansive landscapes to flotsam on a beach. The hollowed and exposed heads of this sheet can be seen as a response both to the Surrealist interest in the subconscious mind and to the natural shapes of shells, bones or weather-worn pebbles.

Although Moore usually represented complete bodies, during the late 1930s he also made a number of studies of individual heads. For these he employed various media, including brightly coloured pencils, which he often used with a white wax crayon base that repelled watercolour, thus creating a mottled, textured appearance. The most thoroughly worked study on this sheet – the second from the top left – relates to Moore's sculpture *The Helmet*, 1939–40, one of his earliest metal sculptures. The claustrophobic, helmet-like configurations that appeared in his art at this time were inspired in part by a photograph, reproduced in 1934 in the art journal *Cahiers d'art*, of two prehistoric Greek objects – bronze domed forms pierced by holes. Such dark images reflect the political turmoil of the period, their warlike, masculine forms at odds with Moore's lifelong obsession with the female figure.

This drawing was originally owned by the photographer Lee Miller, whose husband, the Surrealist artist and collector Roland Penrose, bought the lead cast for *The Helmet*.

After numerous false starts, Jean Dubuffet finally committed himself to art at the age of forty-three, holding his first solo exhibition at the Galerie René Drouin in Paris in 1944. In the winter of 1947 Dubuffet and his wife Lili escaped the chill of Paris by travelling for two months to El Goléa, an oasis in the Algerian Sahara. Fascinated by Bedouin customs and the Islamic culture that he had encountered on this trip, Dubuffet resolved to learn Arabic and to retrace his steps. On his return to Paris he completed a few paintings based upon his Algerian sketches and improved his language skills before returning to El Goléa where he immersed himself in the simple Bedouin lifestyle for six months. *Bedouin with gazelle* was produced in Algeria in 1948. It is one of the numerous, intriguingly 'childlike' gouaches and drawings in which the artist depicted the exotic inhabitants and scenery of the southern Sahara. Dubuffet made a third and final trip to the region in March 1949.

In 1945 Dubuffet coined the term '*Art brut*' (raw art) in Switzerland, where he studied and collected the drawings of psychiatric patients and other untrained 'outsider' artists. In his own artistic practice he had already rejected traditional academic values and stylistic criteria. Throughout his career Dubuffet advocated the study of marginal artists whose creations, he argued, conveyed a genuine primal vitality, stemming from original ideas untainted by cultural conditioning. In an iconoclastic written statement composed in 1949, '*L'Art brut préferé aux arts culturels* (Art brut in preference to the cultured arts), Dubuffet claimed that 'true art is always to be found where we least expect it … on every street corner'. Art brut embraced the qualities inherent in the naive art of children, amateurs and the mentally ill, as well as in found objects and graffiti.

Jean Dubuffet
French 1901–1985
Bedouin with gazelle 1948
gouache
45.3 x 54.6 cm
Felton Bequest, 1959 (107-5)
© Jean Dubuffet, 1948/ADAGP
Licensed by VISCOPY, 2003

Pablo Picasso's first published linocut, the magnificent *Portrait of a young woman after Cranach the younger, II*, is a powerful improvisation inspired by the 1564 portrait of an unknown lady by Lucas Cranach the younger (Kunsthistorisches Museum, Vienna). A postcard of this painting had been sent to Picasso by his dealer, Daniel-Henry Kahnweiler. Having settled in the south of France, Picasso did not have easy access to his Parisian print workshops, and he seized upon the linocut as a new technique to explore. Invented as a floor covering, linoleum is easy to cut – permitting smooth incisions uninterrupted by woodgrain – and simple to print. Although a number of artists had produced vibrant colour linocuts, particularly during the 1920s and 1930s, the material tended to be denigrated as fit only for amateurs until Picasso's spectacular examples were published. Having previously paid little attention to either relief or colour printing, in 1951 Picasso first produced monochromatic linocut posters advertising local events. Assisted by local master printer Hidalgo Arnéra (from whose collection this impression came), he soon expanded into two-colour prints. Then in 1958, at the age of seventy-seven, he created this five-colour masterpiece.

Continually stretching the expressive and technical possibilities of each medium he investigated, Picasso quickly discovered the inherent qualities of the linocut process, and exploited the lustrous colours created by layers of oily ink and the decorative abstraction of form achievable with the easily worked medium. Picasso was always involved with the art of the past but, in the last twenty years of his life, his work came to be dominated by his reverence for, and competition with, his eminent predecessors. His vigorous reworking of Cranach's painting reverses the orientation of the pose, yet it captures not only the opulent costume and abundant jewellery but the lady's essential features, which stand out, fragmented and abstracted, against the forceful patterning: her straight nose and slightly pursed lips, her pink cheeks, her elegant long neck and composed demeanour.

This ambitious work is Picasso's only major linocut that respects the traditional method of cutting individual blocks for each colour. Frustrated by the repetitive cutting and finicky registration required, Picasso abandoned the traditional procedure and began using the reductive printing process in which each new colour and addition to the design is cut into a single block of linoleum. Picasso was acclaimed for his brilliant use of this technique and so is usually, but inaccurately, credited with its invention.

The greatest printmaker of the twentieth century, and one of the most creative of all graphic artists, Picasso produced more than 2200 prints that span seven decades of his working life, including over a hundred colour linocuts made between 1958 and 1963.

Pablo Picasso
Spanish 1881–1973;
worked in France
Portrait of a young woman, after Cranach the younger, II 1958
colour linocut, printer's proof
64.4 x 53.4 cm (image);
76.9 x 57.5 cm (sheet)
Bloch 859; Baer 1053 Bi
Purchased, 1996 (1996.598)
© Pablo Picasso, 1958/Succession Picasso
Licensed by VISCOPY, 2003

Sam Francis
American 1923–1994;
worked in France
Blue, red and yellow 1964
gouache
58.9 x 76.2 cm
Felton Bequest, 1966 (1590-5)
© Sam Franics, 1964/ARS
Licensed by VISCOPY, 2003

In 1950, when most of America's aspiring abstract artists were flocking to New York, the young Californian painter Sam Francis moved to Paris and immersed himself in the city's artistic and literary life. Francis had turned to art as a form of therapy while bedridden with a spinal injury suffered during military service in 1943. After the war he studied painting at the University of California, Berkeley, before travelling to France on the 'GI Bill', an allowance that financed further education for World War II veterans.

Francis quickly found himself at the heart of the Parisian avant-garde, although he disclaimed affiliation with any particular artistic group or movement. In the earliest paintings of his Paris period, Francis restricted his palette to soft greys and white. His deepening attraction to the work of the great French colourists Henri Matisse and Pierre Bonnard, and exposure to the extraordinary late works of Claude Monet, saw the introduction of evocative 'all-over' surfaces composed of layers of vibrant primary colours, as can be seen in *Blue, red and yellow*. Francis was equally intrigued by the controlled fluidity and disciplined spontaneity of oriental calligraphy. He made the first of many visits to Japan in 1957; his subsequent paintings remained closely attuned to the Japanese aesthetic, and to a tradition that focuses upon the meditative qualities of art and the process of its production.

In the early 1950s the achievements of American Abstract Expressionists such as Mark Rothko, Clyfford Still and Jackson Pollock remained largely unrecognized in Europe. Francis understood and admired their work, and although his airy compositions evoked a sense of space and delicacy at odds with the aggressive abstractions of other American 'action painters', he provided an important link between contemporary artistic developments on both sides of the Atlantic. Francis returned to California in 1962, making regular trips to France and Japan until his death in 1994.

In 1958 the young American painter Jasper Johns had his first solo show in New York. His paintings of flags, targets and numbers immediately propelled him to prominence. Johns's deliberately impersonal images of commonplace, manmade objects and signs perplexed viewers and critics alike. The subject matter of these paintings, however, effectively reintroduced figuration into American art, which during the previous decade had been dominated by the work of the Abstract Expressionists.

Two years later Johns made his first print – a lithograph of a target – after being approached by Tatyana Grosman who ran a print workshop, Universal Limited Art Editions (ULAE), from her Long Island home. This printing and publishing establishment achieved legendary status in the American revival of lithography in the second half of the twentieth century. Through Grosman's encouragement a group of emerging artists associated with the Pop art movement pushed the artistic and technical boundaries of the medium and made printmaking an integral part of their practice. Johns was at the forefront of this activity, and from his earliest prints he used the lithographic stone's ability to retain traces of an earlier image drawn onto its surface.

The level of sophistication reached by Johns in the medium is evident in this lithograph, *Targets*. Created from two aluminium plates and nine stones, including six used in a previous work, Johns's target is printed in complementary colours with a black dot near its centre. The viewer's eye is drawn, however, to another dot within a white square in the lower part of the composition, over which a barely visible target is printed in transparent varnish and white ink. The after-image of the upper target that the viewer projects onto this space obscures the pale target in the lower square. This phenomenon has been explained as one that shows a real image being overwhelmed by an illusion.

Jasper Johns
American born 1930
Targets 1967–68
colour lithograph with rubber stamp, printer's proof 2/2
86.0 x 64.0 cm (image and sheet)
Field 41
Purchased through The Art Foundation of Victoria with the assistance of Henry and Dinah Krongold, Founder Benefactors, 1984 (P142-1984)
© Jasper Johns, 1967/VAGA
Licensed by VISCOPY, 2003

Andy Warhol
American 1927–1987
Jacqueline Kennedy III (*Jackie III*)
1965
from the portfolio *11 Pop Artists
III* 1966
colour screenprint, artist's proof
37/50
100.6 x 75.8 cm (image and sheet)
Feldman 11.15
Gift of Dr David Rosenthal, 1991
(P153-1991)
© Andy Warhol, 1966/ARS
Licensed by VISCOPY, 2003

I'm not saying that popular taste is bad so that what's left over from bad taste is good: I'm saying that what's left over is probably bad, but if you take it and make it good or at least interesting, then you're not wasting as much as you would otherwise. You're recycling work and you're recycling people, and you're running your business as a by-product of other businesses.
—Andy Warhol (1975)

After graduating from the Carnegie Institute of Technology, Pittsburgh, in 1949, Andy Warhol began his career in New York as an illustrator for fashion magazines. By the end of the 1950s he had become highly successful as a commercial artist, and well known for his delicate drawings commissioned by fashion houses. It was therefore ambitious of him to exhibit in a fine art gallery context, which he did in 1961. In doing so, he proclaimed his identification with the new wave of American painting, led by Jasper Johns and Robert Rauschenberg, who were also inspired by images in wide circulation. Warhol's paintings from 1961 featured mass-produced, ubiquitous objects such as dollar bills and stamps, as well as familiar products such as Campbell's soup cans and Coca-Cola bottles. These cool, deliberately detached works were shocking in their apparent rejection of artistic invention. Warhol's studio, called 'The Factory', was a further challenge to established artistic practice, with assistants generating ideas and executing works without acknowledgement of their contribution.

Fascinated by the ability of the mass media to create celebrities, Warhol included the cultivation of his own fame in his artistic practice. In his paintings of film stars such as Marilyn Monroe, Elvis Presley and Elizabeth Taylor, he sought to profit from and bask in the aura of their celebrity. Following the assassination of President John Kennedy in November 1963, Warhol produced a series of paintings based on photographs of Kennedy's grieving widow by Fred Ward in *Life* magazine. This screenprint, made from roughly assembled photographs, incorporates four of the images from a painting he had made in the previous year, *Sixteen Jackies*, 1964 (Walker Art Centre, Minneapolis). *Jackie III* was published as part of *11 Pop Artists III*, a portfolio that also included the works of Warhol's American contemporaries Jim Dine, Roy Lichtenstein, James Rosenquist and Tom Wesselmann. An exhibition of the same name travelled widely throughout Europe from 1966 to 1968, and spread the influence of Pop art, of which Warhol was the most provocative exponent.

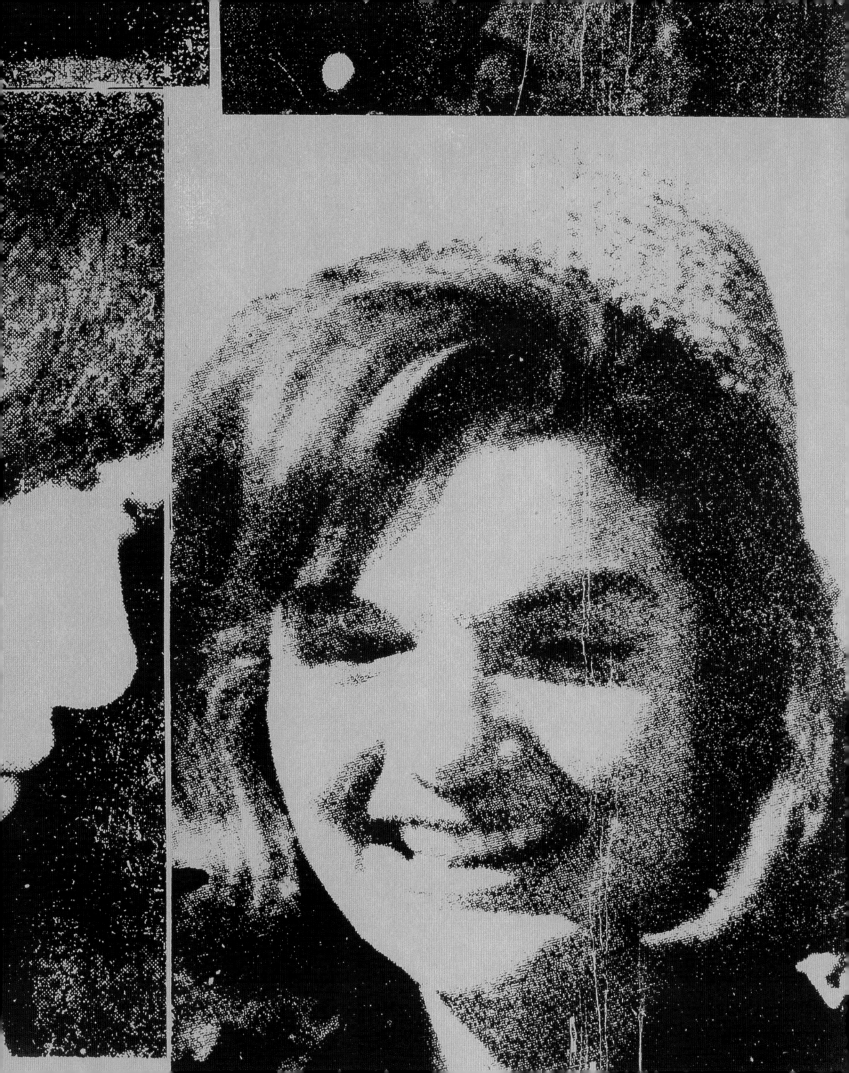

Bridget Riley first came to prominence in the early 1960s with her 'strobic' black and white works that were dazzling and disorientating in their optical effects. Because of their emphasis on geometric forms, their graphic dynamism and the resulting visual tension, these works were viewed at the time in the context of Op art, a contemporary movement that exploited optical phenomena to create images that flickered and vibrated. Despite the visual similarities of her compositions to Op art, Riley's early works were created not in order to play optical tricks but in response to personal emotions. Their aim was to express 'states of being, states of composure and disturbance'.

A pivotal moment in Riley's career occurred in 1959 when, after making a detailed copy of Georges Seurat's pointillist painting *Le Pont de Courbevoie, c.* 1886–87, she realized that the perception of a particular colour was affected by the colours adjacent to it. Eight years after this revelation, colour became the essential component of Riley's work, the primary aim being to communicate the often fleeting and intangible sensations experienced in the natural world:

> The eye can travel over the surface in a way parallel to the way it moves over nature. It should feel caressed and soothed, experience frictions and ruptures, glide and drift. Vision can be arrested, tripped up or pulled back in order to float free again. It encounters reflections, echoes and fugitive flickers which when traced evaporate.

In order to achieve these subtle sensations of perception, Riley creates compositions in which juxtapositions of colour are carefully balanced, the result of both mathematical calculations and intuition. She then establishes their arrangement through an extensive series of trials and preparatory studies. While colour selection and placement, as well as the scale and overall format of the composition, are determined by Riley alone, the application of paint is carried out by studio assistants (and has been since the production of her first painting in 1961). By removing all traces of the hand of the artist from her work, Riley aims to eliminate elements that might distract from the viewer's experience and perception of its visual effects.

Since introducing colour to her painting, Riley has worked with various abstract forms, producing series based on vertical stripes, variously oriented circles, parallelograms, and the curvilinear forms of *Twisted curve, olive dominance*. In this work, the shimmering juxtaposition of pink, mauve, grey and olive green operates in such a way that the eye sees orange in the place of pink whenever it is painted next to olive, making tangible Riley's mastery of what she describes as 'the miracle of colour itself!'

Bridget Riley
English born 1931
Twisted curve, olive dominance
1976
gouache over pencil
91.2 x 61.2 cm
Felton Bequest, 1976 (P150-1976)
© Bridget Riley 1976

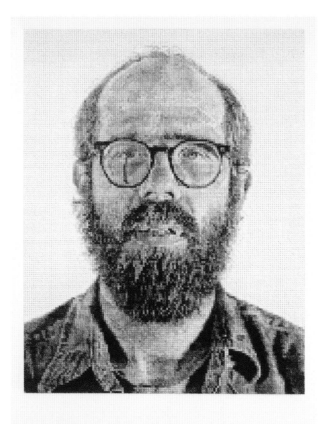

Chuck Close
American born 1940
Self-portrait 1977
etching, ed. 7/35
113.6 x 90.9 cm (plate);
137.8 x 103.7 cm (sheet)
Zona & Pernotto 12
Purchased, 1979 (P29-1979)
© Courtesy of the artist

In 1968 Chuck Close painted a large self-portrait based on a photograph of his face. The painting reproduced the original black and white photograph with startling veracity, albeit on an enormous scale. Close transferred his image onto the canvas using the traditional method of drawing a grid on both surfaces, and then painting the detail found in each square of the photograph onto the canvas. During the execution of the painting, the grid disappeared under a smooth surface of tones. The overall effect was disconcerting – a painting in which there are passages of both exaggerated clarity and soft focus. Close explained his interest in this method of working:

> I am trying to make it very clear that I am making paintings from photographs and that this is not the way the human eye sees it. If I stare at this it's sharp, and if I stare at that it's sharp too. The eye is very flexible, and the camera is a one-eye view of the world …

Close's time-consuming, and at times tedious, method of working enabled him to create an emotionally distant body of work. Like the Minimalist and Conceptual artists working in New York in the late 1960s, Close was responding, in part, to the highly personal and expressive paintings of the Abstract Expressionist artists such as Jackson Pollock and Willem de Kooning.

Close made the grid visible in his work after making his first print, a mezzotint, in 1972. This marked a shift in his practice towards emphasizing the conceptual framework of his images. On occasion he also included the exact number of squares (some of which exceeded 100,000 units) in his titles. In 1976–77 Close produced a group of self-portraits in a range of media including watercolour, pastel, pen and ink, etching and aquatint, which were all based on the same photograph. This etched version is made up of a grid of thousands of squares filled with lines that run diagonally from left to right. The contrast of squares – some crossed with just one line, and others entirely filled in – creates an active surface of pixilated appearance that to today's audiences may appear digital.

Close has continued to work within the strict parameters established by the experience of creating the 1968 self-portrait, ranging across media and expanding his subjects to include his family and friends.

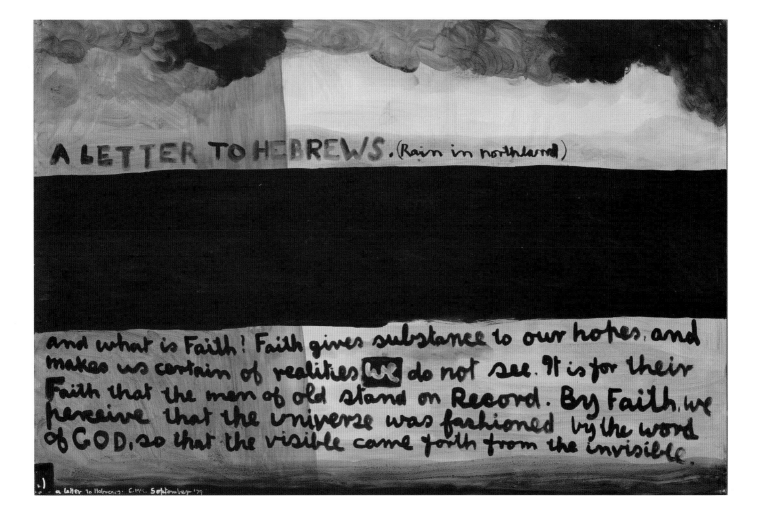

Colin McCahon
New Zealand 1919–1987
A letter to Hebrews
(Rain in Northland) 1979
synthetic polymer paint on six
sheets of paper
73.0 x 110.2 cm (each sheet)
McCahon Digital Archive 001304
Presented through The Art
Foundation of Victoria in memory of
The Reverend Stan Brown by The
Reverend Ian Brown, Fellow, 1984
(P6.a-f-1984)
© Courtesy of the Colin McCahon
Research and Publication Trust

The exploration of belief and doubt was central to Colin McCahon's painting. Although he was not aligned with a particular church, from the mid 1940s he began incorporating text from the Bible in his paintings; by the late 1950s it had become an integral part of his compositions. Drawing upon a number of sources, McCahon was particularly inspired by the New Testament, as well as by Maori myths and the work of contemporary New Zealand poets. He explained his use of words as a desire to be understood by his audience. His sense of place, deeply rooted in his love of the New Zealand landscape, also found expression in his paintings. His landscapes were often depictions of specific locations, but they were also used to convey symbolic meaning.

In *A letter to Hebrews (Rain in Northland)* McCahon combines both his landscape and textual modes. The stormy threatening sky of the upper panels is pierced by shafts of light and sheets of rain that traverse the work – on six pieces of abutted paper – from top to bottom. The superimposed text is taken from Paul's 'Letter to the Hebrews', chapter 11 (New English version), whose subject is the definition of faith. The landscape here represents one of spiritual darkness, symbolically illuminated in places; it forms an effective counterpoint to the affirmation of faith contained in the text. McCahon makes these questions relevant to his own time and place by subtitling the work 'Rain in Northland' referring to a region on the South Island of New Zealand.

McCahon's profound and lasting impact on the artistic life of New Zealand was the result of his work not only as a painter but also as a curator and teacher. He worked at the Auckland City Art Gallery from 1952 to 1964, including as Deputy Director, and lectured at the University of Auckland School of Fine Arts (Elam) in the 1960s, where he inspired a younger generation of artists. McCahon's highly original approach to painting has continued to receive a mixed response; however, his recognition among fellow artists and a growing number of critics has recently expanded to that of an international audience.

[black redaction]

and what is Faith? Faith gives substance to our hopes, and makes us certain of realities we do not see. It is for their Faith that the men of old stand on Record. By Faith we perceive that the universe was fashioned by the word of GOD, so that the visible came forth from the invisible.

Those who use such language show plainly that they are looking for a country of their own. If their hearts had been in the country they had left, they could have found opportunity to return. Instead we find them longing for a better country — I mean, the heavenly one. That is why GOD is not ashamed to be called their GOD; for he has a city ready for them.

By Faith Abraham, when the test came, offered up Isaac; he had received the promises, and yet he was on the point of offering his only son, of whom he had been told, 'Through the line of Isaac your descendants shall be traced.' For he reckoned that GOD had power even to raise from the dead — and from the dead, he did, in a sense, receive him back. By Faith Isaac blessed Jacob and Esau and shape of things to come. By Faith Jacob, as he was dying, blessed each of Joseph's sons and WORSHIPPED GOD, leaning on the top of his staff. By Faith Joseph, at the end of his life, spoke of the departure of Israel from Egypt and instructed them what to do with his body.

By Faith ABEL offered a sacrifice greater than Cain's, and through Faith his goodness was attested. For his offerings had GOD's approval; and through faith he continued to speak after death. By faith Enoch was carried away to another life without passing through death; he was not to be found, because GOD had taken him. For it is the testimony of Scripture that before he was taken he had pleased GOD. and without FAITH it is impossible to please him; for anyone who comes to GOD must believe that he exists and that he rewards those who search for him.

By Faith Noah, divinely warned about the unseen future took good heed and built an ark to save his household. Through his faith he put the whole world in the wrong, and made good his own claim to the righteousness which comes of Faith.

By Faith when Moses was born, his parents hid him for three months, because they saw what a fine child he was; they were not afraid of the king's edict. By Faith Moses when he grew up refused to be called the son of Pharaoh's daughter, preferring to suffer hardship with the people of GOD rather than enjoy the transient pleasures of sin. He considered the stigma [redacted] that rests on God's anointed greater wealth than the treasures of Egypt, for his eyes were fixed upon the coming day of recompense. By Faith he left Egypt, and not because he feared the king's anger; for he was resolute, as one who saw the invisible GOD. By FAITH, he celebrated the Passover and sprinkled the blood, so that the destroying angel might not touch the first-born of Israel. By Faith they crossed the Red Sea as though it were dry land, whereas the Egyptians, when they attempted the crossing, were drowned. By Faith the walls of Jericho fell down after they had been encircled on seven successive days. By Faith the prostitute Rahab escaped the doom of the unbelievers because she had given the spies a kindly welcome.

By Faith Abraham obeyed the call to go out to a land destined for him and his heirs and left home without knowing where he was to go.

By Faith he settled as an alien in the land promised him, living in tents, as did Isaac + Jacob, who were heirs to the same promise. For he was looking forward to the city with firm foundations, whose architect and builder is GOD.

By Faith, even Sarah herself received strength to conceive, though she was past the age, because she judged that he who had promised would keep faith; and therefore from one man, and one as good as dead, there sprang descendants numerous as the stars or as the countless grains of sand on the sea shore.

ALL THESE PERSONS DIED IN FAITH. THEY WERE NOT YET IN POSSESSION OF THE THINGS PROMISED, BUT HAD SEEN THEM FAR AHEAD AND HAILED THEM AND CONFESSED THEMSELVES NO MORE THAN STRANGERS OR PASSING TRAVELLERS ON THE EARTH.

Those who use such language show plainly that they are looking for a country of their own.

Need I say more? Time is too short for me to tell the stories of Gideon, Barak, Samson, and Jephthah, of David + Samuel and the Prophets. By Faith they overthrew kingdoms, established justice, saw GOD'S PROMISES fulfilled. They muzzled ravening lions, quenched the fury of fire, escaped death by the sword. Their weakness was turned to strength, they grew powerful in war, they put foreign armies to rout. Women received back their dead raised to life, others were tortured to death, disdaining release, to win a better resurrection. Others again had to face jeers and flogging, even fetters and prison bars. They were stoned, they were sawn in two, they were put to the sword, they went about dressed in skins of sheep or goats, in poverty, distress, and misery. They were too good for a world like this. They were refugees in deserts and on the hills, hiding in caves and holes in the ground. These also, one and all, are commemorated for their faith; and yet they did not enter upon the promised inheritance, because, with us in mind, GOD had made a better plan, that only in company with us should they reach their perfection.

Francesco Clemente
Italian born 1952; works in India,
United States and Italy
I 1982
colour woodcut, ed. 84/100
36.0 x 51.0 cm (image);
42.7 x 57.1 cm (sheet)
blocks carved by Reizo Monjyu and
printed by Tadashi Toda at Shiundo
Print Workshop, Kyoto, Japan;
published by Crown Point Press,
Oakland, California
Purchased, 1986 (P31-1986)
© Courtesy of the artist

From a distance this disarmingly direct self-portrait appears as a vibrant and translucent watercolour. Upon closer inspection, however, the defined contours of the many blocks from which the work has been printed become visible, and the image metamorphoses into an extraordinary colour woodcut. *I* is the result of a collaboration between Francesco Clemente, Crown Point Press in Oakland, California, and the Shiundo Print Workshop in Kyoto, Japan. In 1982 Kathan Brown, Director of Crown Point Press, initiated a decade-long collaborative project with master printer Tadashi Toda and master woodcarvers Reizo Monjyu and Shunzo Matsuda. These highly skilled craftsmen translated artists' designs (mostly watercolours) into print, using traditional Japanese printmaking methods.

In order to simulate the bleeding and subtle overlapping washes of the original watercolour design, fourteen meticulously cut blocks were used in the highly complicated printing process. Each film of watercolour ink was printed by hand, with a remarkable forty-five colours applied, using about a hundred layers to achieve the desired hues. Contemporary woodcuts are customarily cut, and often also printed, by the artist, although for centuries European artists, blockcutters and printers had collaborated in the production of woodcuts. The latter approach has always applied in Japan and China, where it continues to the present day. The use of carvers to prepare these blocks disturbed Western conventions and provoked considerable debate within the print community, as did the deceptive appearance of these prints. However, Clemente was intrigued by the collaborative process of translation from one medium to another – although the result closely resembles the original watercolour, the bright blue tears that flood Clemente's eyes in the watercolour are muted in the print.

A self-taught artist, Clemente was at the forefront of the Italian Neo-Expressionist or Transavanguardia movement in the late 1970s and 1980s, and developed an idiosyncratic figurative style inspired by an eclectic range of sources, including Renaissance art, Expressionism and Hindu imagery. His diverse cultural influences are also the result of his continual travel, and for many years he has divided his time between Rome, Madras and New York. During the 1980s Clemente painted a series of watercolour portraits of his family and friends, including writers Allen Ginsberg and William Burroughs and artists Keith Haring, Robert Mapplethorpe, Jean-Michel Basquiat and Andy Warhol. This expressionistic self-portrait, based on a watercolour from the series (now in a private collection), is only one of a multitude of images in which Clemente has incorporated his own face or body, through which he explores ideas of the universal 'self'. This is reflected in the title adapted from a remark by French poet Arthur Rimbaud, 'I is an Other'.

These works do not illustrate … they are an exorcism. The difference is that I discover the emotion through the work … the emotion comes after. I ask, what could this mean?'
—Bourgeois (1992/93)

Louise Bourgeois was born in Paris, and immigrated to New York in 1938 after marrying an American. Renowned as a sculptor, she has also created a body of paintings, drawings, prints and large-scale installations, all of which reflect the abiding motivation of her art: a desire to define her place in the world, particularly in relation to the people around her. This compulsion stems from the complex emotional and psychological relationships that existed within Bourgeois's family and her childhood understanding of and responses to them. In an effort to achieve emotional release and greater self-awareness, she addresses head-on in her work her own fears, anxieties, traumas and self-doubts.

Bourgeois created her first prints upon arriving in New York, and then abandoned the practice in 1949 until the early 1970s. She favours the intaglio techniques of drypoint and engraving, and works experimentally, printing many variant states and unique proofs. The ability to track the development of an image through various states allows her to document the history of the creative process, and, for an artist who frequently returns to ideas and images from the past as inspiration for new work, this is immensely valuable.

With an alternative title of *The arrows of stress*, this print was developed through thirty-one states and variant impressions, including the first version, a smaller etching known as *Ste Sébastienne 'small'* that was begun in 1990. The basis of the first version was a 1987 drawing. In this final state of the print, Bourgeois has removed the figure's head and added a series of repetitive contours that are intended to define the musculature and that are symbolic of the physical strength required to withstand these external attacks.

This image also refers to the Christian martyr, St Sebastian, who was killed with arrows after refusing to abandon his faith. The fleshy forms of Bourgeois's image depict the transformation to the female Sébastienne who, in her resemblance to Pre-Columbian fertility statues, with their exaggerated hips, buttocks and breasts, can be seen to represent the symbolic and omnipotent woman. This dramatic metamorphosis also aligns St Sebastian's ultimately triumphant struggle for freedom of thought and expression with the feminist cause.

The most acclaimed South African artist of the post-apartheid era, William Kentridge achieved international recognition in the mid 1990s. Born into a family of distinguished lawyers (his father represented, among others, Nelson Mandela and the family of murdered activist Steve Biko), he had grown up intensely aware of apartheid's injustices and his own privileged white upbringing. Following a degree in political science and African history, Kentridge worked alternately in the theatre and the visual arts, and developed a particular interest in printmaking. These fields later inspired his monochromatic charcoal drawings. His powerful graphic output plays a dominant role in his art, which incorporates many disciplines including theatre, opera, sculptural installations and film. The animated films, for which he is perhaps best known, arose from a desire to record the progressive stages of his drawings, and are created by filming their evolution as each sheet is reworked, erased and redrawn. The influences on Kentridge's art are wide ranging, and include Francisco Goya, English satirist William Hogarth, German Expressionism, early Soviet cinema, and the forceful drawings of black South African artist Dumile. The local Johannesburg landscape is also an important source of inspiration for him. While his work confronts his country's harsh history and continuing social and political complexities, it also transcends national boundaries.

In 1995–96, in conjunction with his theatre production *Faustus in Africa!* (Handspring Puppet Company), Kentridge produced *Colonial landscapes*, a series of large drawings. These were made in response to his reading of a late nineteenth-century book, *Africa and Its Exploration as Told by Its Explorers*, a two-volume publication illustrated with wood-engravings of the continent's various 'exotic' landscapes, cultures and wildlife. In *Herbaceous border* Kentridge reinterprets an illustration of a white hunter and his African guide pressing through towering reeds to hunt spur-winged geese. Although he uses the same compositional layering of vegetation, water and a high, distant river bank, Kentridge's landscape is unpopulated, and he lowers the viewpoint so as to position the viewer within the tangle of swampy plants. Drawn with an energetic application of charcoal and dense black pastel, the uninviting, even sinister, landscape is made more menacing by the surveillance and communication towers visible against the oppressive sky. A tracing of red lines that punctuates the image refers to surveyors' marks, recalling the damage inflicted upon the land by explorers, settlers and the mining industry, and upon its people by colonization and its aftermath.

William Kentridge
South African born 1955
Herbaceous border 1995
from the series *Colonial landscapes*
1995–96
charcoal and pastel
121.8 x 159.6 cm (irreg.)
Purchased through The Art
Foundation of Victoria with the
assistance of Mr Robert Raynor AM,
Honorary Life Benefactor, 1997
(1997.70)
© Courtesy of the artist

Damien Hirst
English born 1965
The Last Supper® 1999
five prints from the series of thirteen
colour screenprints, ed. 131/150
152.5 x 101.5 cm (each sheet)
Purchased through the NGV
Foundation with the assistance of
Andrea Ziegler, Governor, 2002
(2002.299)
© Courtesy of the artist

Art is like medicine – it can heal. Yet I've always been amazed at how many people believe in medicine but don't believe in art, without questioning either.
—Damien Hirst (1997)

One of the most controversial artists of recent years, Damien Hirst is best known for his glass vitrines containing animals preserved in formaldehyde, one of which won the Turner Prize in 1995. In his art Hirst repeatedly questions the significant role that pharmaceuticals play in our lives (and deaths). He has made minimalist paintings of grid-patterned dots that suggest pills or sweets (as children Hirst and his brother had their stomachs pumped for mistaking the two), and sculptures and installations of medicine cabinets that are laden with bottles and boxes. A restaurant in Notting Hill, London, co-owned by Hirst, is called Pharmacy, and designed by him to appear as such.

Hirst's fascination with medicine, life, death and belief is further explored in this series of colour screenprints, *The Last Supper®*. Hirst has appropriated distinctive pharmaceutical packaging and, employing graphic designer Jonathan Barnbrook, has replaced brand names with those of mundane British foods – steak and kidney, beans and chips, chicken, dumplings. These sit incongruously above the chemical names of drugs prescribed to treat life-threatening illnesses. Corporate logos have been usurped by Hirst's own name or initials. These darkly humorous works are an outstanding example of Hirst's Pop art inheritance, in which generic images of mass production are used to parody the commodification of the most fundamental human needs.

While provoking contemplation of current issues such as the debate concerning the fast food industry and genetic modification, Hirst also queries contemporary belief systems. The thirteen parts of this series recall the number of participants at the original Last Supper, at which Jesus offered his disciples bread and wine as symbols of his body and blood. This spiritual nourishment, promising eternal life, may be contrasted with the unquestioning belief in the power of medicine, which provides, for many, their final meal.

Omelette™
ondansetron

tablets 8mg

Each tablet contains
8mg ondansetron
as ondansetron hydrochloride dihydrate
Also contains lactose and maize starch

10 tablets

HirstDamien

DAMIEN & HIRST

Beans™

Chips™

400 micrograms

112 Chips

Mushroom™

30 tablets
Pyrimethamine
Tablets BP

25mg

PIE

HirstDamien

Chicken®

Concentrated Oral Solution
Morphine Sulphate

20mg/ml

**Each 1ml contains Morphine
Sulphate BP 20mg**

120ml

**Damien
Hirst**

GLOSSARY

IMPRESSION
A single sheet of any print. Used to avoid confusion with the word 'copy', which denotes a reproduction.

STATE
Each stage of the work on a plate, block, stone or screen that is recorded in an impression. Any additional work or alteration constitutes a new state. Print historians customarily describe states using Roman numerals thus: i/iii (that is, the first state of three), although alphabetic notations are sometimes used.

EDITION
Currently understood to mean the group of identical impressions printed from the plate, usually in its final state. This practice of artificially limiting the number of impressions to increase rarity and exclusivity only came into being in the late nineteenth century. Before this, editions were unlimited as prints were produced as needed to satisfy demand, often until the plate wore out. Editions are usually numbered by the artist in the format 4/25 (that is, number 4 from an edition of 25).

PROOF
Any impression that is not part of the regular edition. Used in particular to distinguish impressions taken while work is still proceeding on the plate, from which the artist or printer can determine changes to be made. Also used to denote impressions identical to the edition, such as the artist's or printer's proofs, which are owned by those individuals and are customarily not for sale.

MATRIX
The object (block, plate, stone or screen) onto which the image has been cut or drawn, from which the image is printed.

INTAGLIO
From the Italian word 'to incise'. The group of processes in which the image is printed from lines manually incised or chemically etched into a metal plate (usually copper). An intaglio plate is inked and the surplus wiped away, leaving the ink in the cut lines only (for an exception, see **Drypoint**). The plate is then printed under considerable pressure, which forces the paper into contact with the remaining ink. This pressure also leaves an indentation in the sheet that corresponds to the edge of the plate: this is the *platemark*. The various intaglio processes can be used individually or in combination.

- ### Engraving
 Intaglio process whereby the design is engraved into a copper plate with a *burin*, a sharp metal tool that is manually pushed through the copper, incising a V-shaped groove into the plate. The resulting line has clear, sharp contours and ends with a fine, tapering point. Because of the resistance of the metal against the burin during cutting, the engraved line has a deliberate quality that contrasts with the freedom of the etched line. Engravings were first made in Europe in the early to mid fifteenth century.

- ### Etching
 Intaglio process whereby, instead of being manually engraved, the design is etched with acid into a metal plate. The plate is first covered with an acid-resistant ground, through which the design is drawn with an etching needle. The lines thus drawn expose the metal, allowing it to be corroded ('bitten') when it is immersed in acid. The plate may be reimmersed multiple times to create deeper lines, which will print darker, with areas to print lighter protected from the acid with *stop-out varnish*. The etched line ends with a blunt tip and is less regular, precise and formal than an engraved line. As the etcher does not need to forcibly cut the lines into the metal, as an engraver does, a much freer line may be drawn. Etchings were first produced in the early sixteenth century.

- ### Drypoint
 Intaglio process related to engraving in which the design is scored into the copper plate with a sharp, pointed needle. Unlike the burin, which removes the displaced metal shaving from the groove, the drypoint needle pushes it to the sides of the groove. This metal shaving, known as the *burr*, gives the drypoint its distinctive character. When the plate is inked, the burr holds ink and prints as a rich, velvety line, which is very different from the clear, sharp line of engraving. Because the burr protrudes above the surface of the plate, it wears down quickly from the pressure of repeated printing, and thus drypoints yield only a small number of fine impressions.

- ### Aquatint
 Intaglio process that, like etching, relies upon the chemical action of acid to create indentations in the metal plate. However, unlike etching, which is used primarily for linear work, aquatint is employed to create areas of tone. Aquatint uses a variation of the etching ground, consisting of minute particles of powdered resin that are dusted onto the metal plate and then fused by heating. When the plate is etched, the acid bites around each of the particles, creating tiny indentations that hold the ink during printing. This granulated pattern of ink resembles a watercolour wash and can vary greatly in texture, depending on the coarseness of the resin particles. The artist can achieve gradations of tone by using stop-out varnish to protect those areas that are to remain light and by then reimmersing the plate in the acid so as to attain the darker tones.

- ### Relief etching
 Process invented by William Blake in the late eighteenth century. Rather than using the traditional etching process, covering the plate with acid-resistant ground and creating the image into this, Blake painted his design onto the plate with the ground, writing his text in reverse so that it would print the correct way. When immersed in acid, the design remained in relief above the bitten remainder of the plate. The plate was then printed as a relief print, rather than an intaglio.

RELIEF

The group of printmaking processes in which the printing surface stands in relief above the rest of the block (as with a rubber stamp). Requiring comparatively light pressure, relief prints can be printed using a press or smooth hand-held object.

- **Woodcut**
 Relief print made from a block of soft wood, cut along the grain of the wood, with the non-printing parts cuts or gouged away to leave the design standing in relief. Originating in China, and from there to Japan and other countries, woodcuts were first made in Europe in the fourteenth century.

- **Linocut**
 Relief print produced in the same manner as a woodcut but using linoleum, which has no grain and is easier to cut than wood. Produced as a floor covering from compressed cork on a material backing, linoleum was used to print posters in the late nineteenth century, and was taken up by many artists and art students in the early twentieth century.

- **Wood engraving**
 Relief process in which the image is incised into the end-grain of blocks of hard wood, such as boxwood. The lines that define the image are cut away (rather than left in relief, as with woodcuts). These lines appear as white (unprinted) lines against a black background when printed. In the 1770s Thomas Bewick became the first great exponent of the technique.

LITHOGRAPHY

The planographic (printing from the surface) process of lithography is based upon the principle that grease and water repel each other. The artist uses a greasy lithographic crayon or ink (tusche) to draw upon the matrix, which is traditionally of specially prepared limestone. The drawing is fixed to the stone's surface with a solution of gum arabic and nitric acid. To print, the surface is sponged with water and then rolled with a greasy ink. The wet areas of the stone's surface repel the ink, while the greasy marks attract it and yield the printed image. The image is transferred to a sheet of paper by running both the inked stone and the paper together through a press. Invented in 1792, the lithography process appeals to artists because they can draw on the stone with the same ease, and with similar materials, as if working on paper; alternatively, a transfer lithograph can be drawn on specially prepared paper and then transferred onto the stone.

MONOTYPE

Unlike other print processes, monotypes do not produce multiple images. They are created by the artist painting a design onto a smooth surface such as glass or a copper plate. A sheet of paper is laid over the plate and the image transferred by applying gentle pressure to the back of the paper. The technique was first known to be used by Giovanni Benedetto Castiglione in the 1640s, and Edgar Degas and others revived interest in it in the late nineteenth century.

SCREENPRINT

Produced by stencil printing through mesh screen (formerly silk, hence 'silkscreen', now usually a synthetic material) fixed tautly within a frame. With the area to remain uncoloured blocked out by paint or paper, the screen is laid on top of paper, fabric or other support, and a layer of ink forced through the mesh with a hard rubber squeegee. Photographic images can be incorporated by covering the mesh with a light-sensitive coating. When exposed to light through a negative or stencil, the exposed coating hardens and blocks the mesh; where unexposed, the coating remains soluble and washes out, allowing ink to pass through. Providing flat, sharply defined areas of colour, screenprinting was originally used for commercial purposes. This simple and cheap process appealed to artists in the 1930s, and it became a popular art form during the 1960s.

DRAWING AND ADDITIONAL TERMS

FRESCO

A technique, popular during the Renaissance, of decorating walls and ceilings by applying colour to wet plaster. As the plaster dries, the colour becomes a permanent part of the wall. This process requires careful planning, to plaster only as much of the wall or ceiling as could be painted before the plaster dries. An alternative technique involves painting dry plaster, but this process is less durable.

GOUACHE

Also known as *bodycolour*. Water-soluble pigment made opaque by the addition of white pigment (traditionally lead white or zinc oxide). Historically, gouache was often used in conjunction with *watercolour*, which is translucent and, unlike gouache, allows the light colour of the paper to show through.

MANUSCRIPT

From the Latin, literally meaning 'handwritten', the word is used to denote a book written by hand, rather than printed.

ILLUMINATION

From the Latin *illuminare* (to enlighten, illuminate), the word describes the decoration or embellishment of a manuscript with luminous colours, especially gold and silver.

PARCHMENT

Prepared sheep, goat or calf skin that was used for a support for writing (and sometimes drawing) during the Middle Ages, and occasionally later, before the use of paper in Europe from the twelfth century onwards. *Vellum* is the term for fine parchment made from the skin of young animals, particularly calves.

RECTO

The front, or more fully worked side, of the sheet, as opposed to its back, the verso.

VERSO

The reverse or back of the sheet, as opposed to its front, the recto.

For additional information, see Paul Goldman, *Looking at Prints, Drawings and Watercolours: A Guide to Technical Terms*, London: British Museum /J. Paul Getty Museum, 1988.

INDEX

The above is a listing of the artists whose works form the subject of this volume.